# Wonderful Mandalas and Patterns

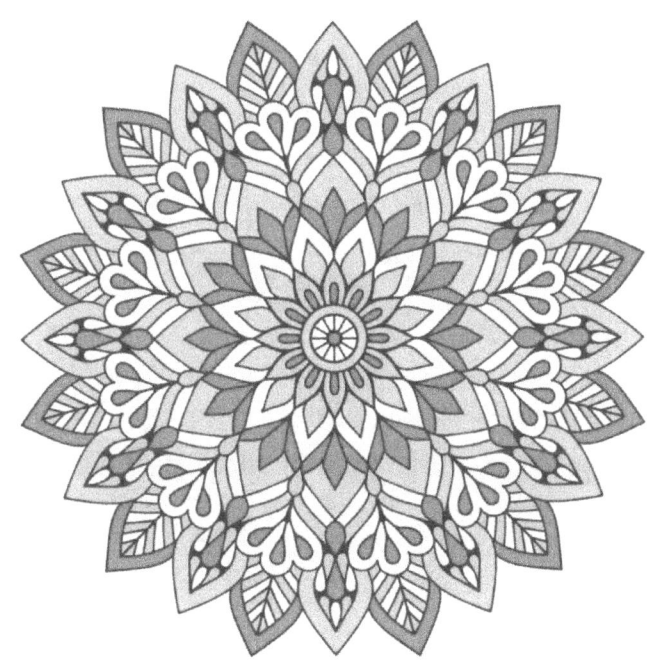

## An Adult Coloring Book for Serenity & Stress-Relief (+100 Original Designs)

Rubén Aguirreche

# Índex

| | |
|---|---|
| Mandalas | 4 |
| Patterns | 71 |

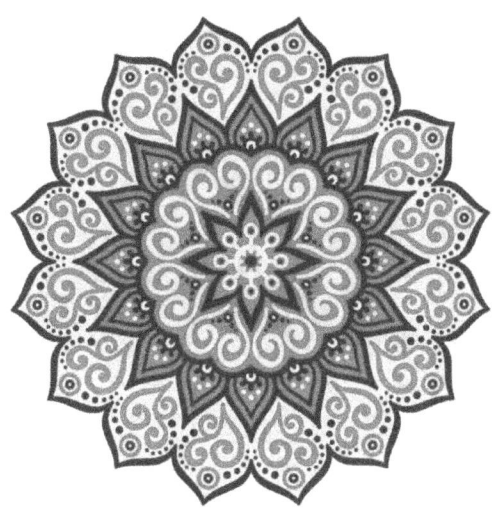

Coloring, painting and even weaving mandalas are considered one of the most effective anti-stress activities used today, in fact more and more people are joining the fashion of mandalas. Beyond being striking illustrations, **the mandalas are loaded with meaning and symbolism that enhance creativity, calm the mind and balance the chakras.**

The mandalas are spiritual symbols of Hindu origin, whose meaning in Sanskrit translates into "**circle or totality**". Although they have their origin in India, they are also present in different ancestral cultures such as: the Aztec, Mayan, Egyptian, Tibetan, Chinese, and even ancient medieval cathedrals.

Likewise, the mandala is related to the cycles that structure the microcosms, such as families and communities, as well as the renaissance cycle, the one of samsara and those of the celestial stars. *Many people consider that the mandala also manifests itself in multiple and varied aspects of human life and of the world in general.*

Although they usually represent certain concepts and experiences, colors and shapes have a personal and individual meaning, so the mandala will always symbolize something different depending on who created it or contemplates it.

**This book will allow you to relax and connect with your spiritual self, with beautiful and original designs.**

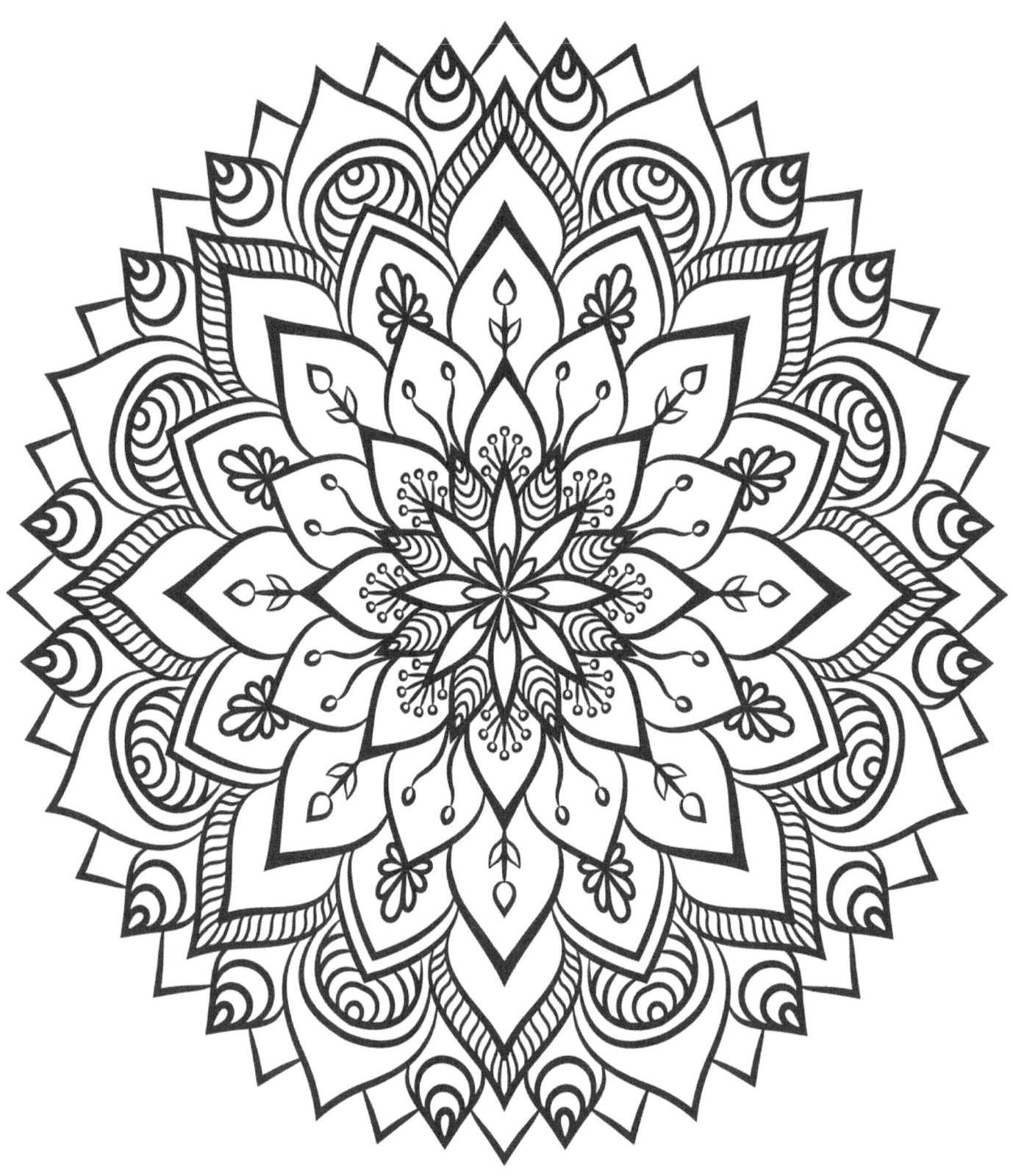

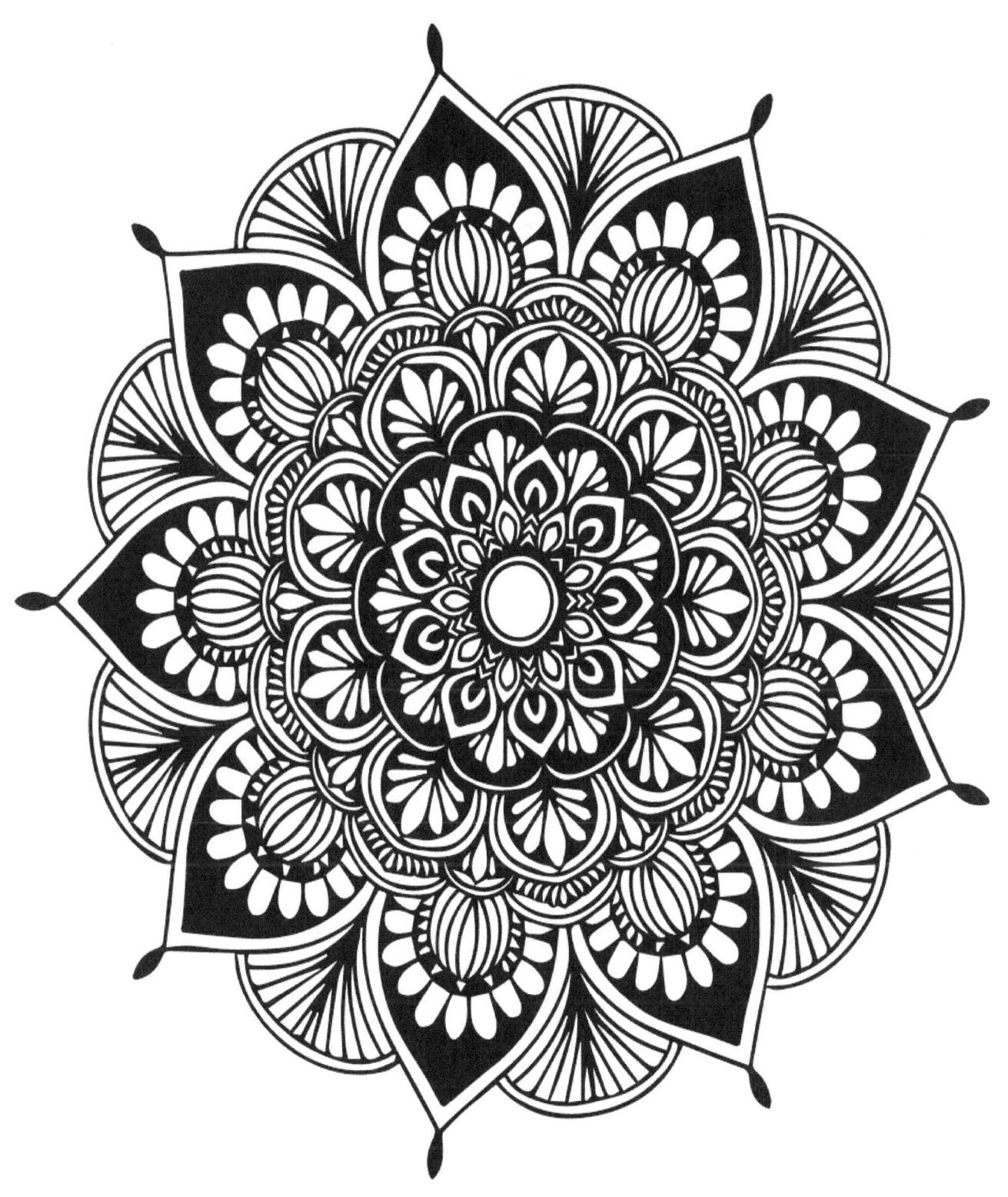

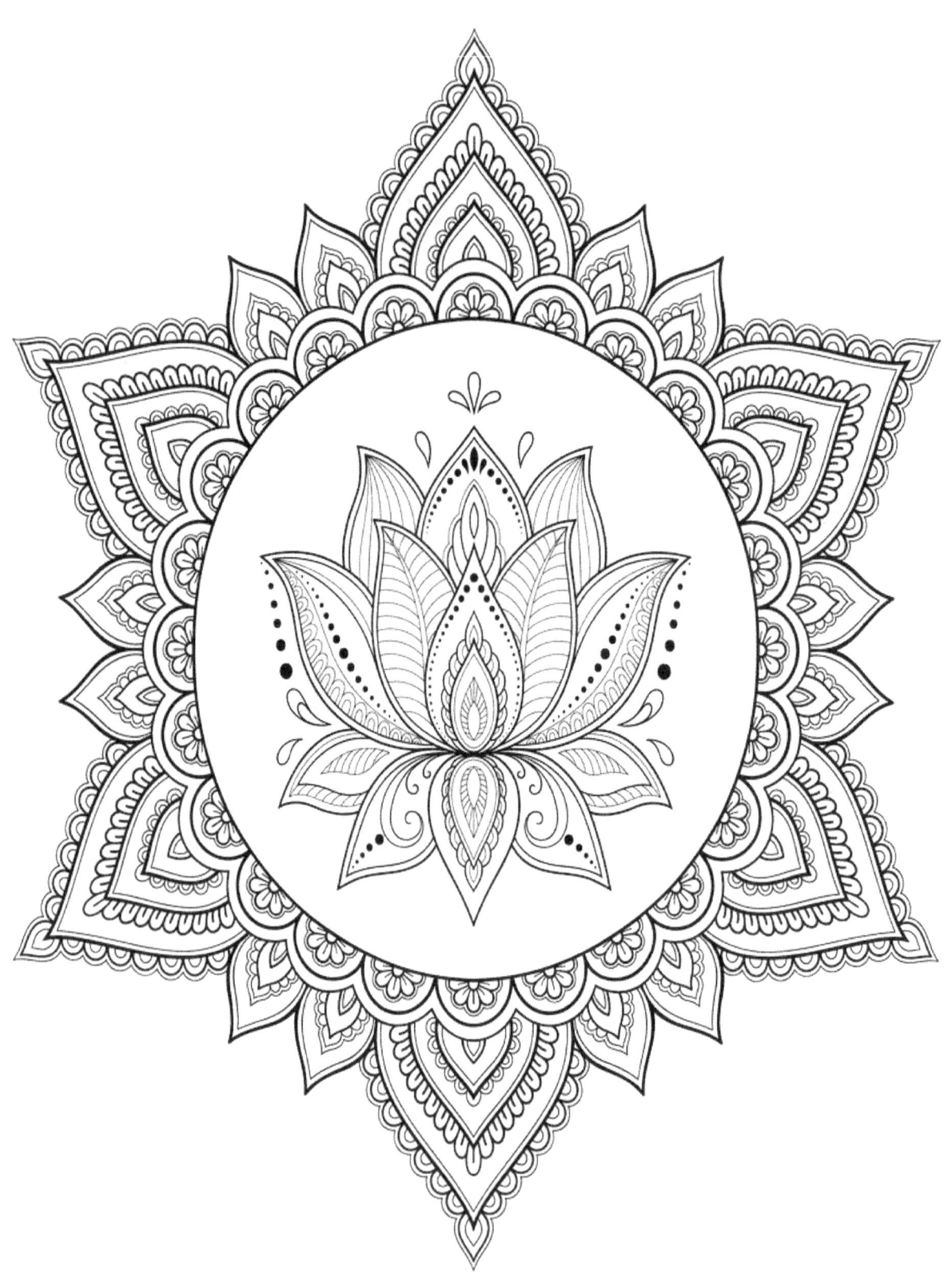

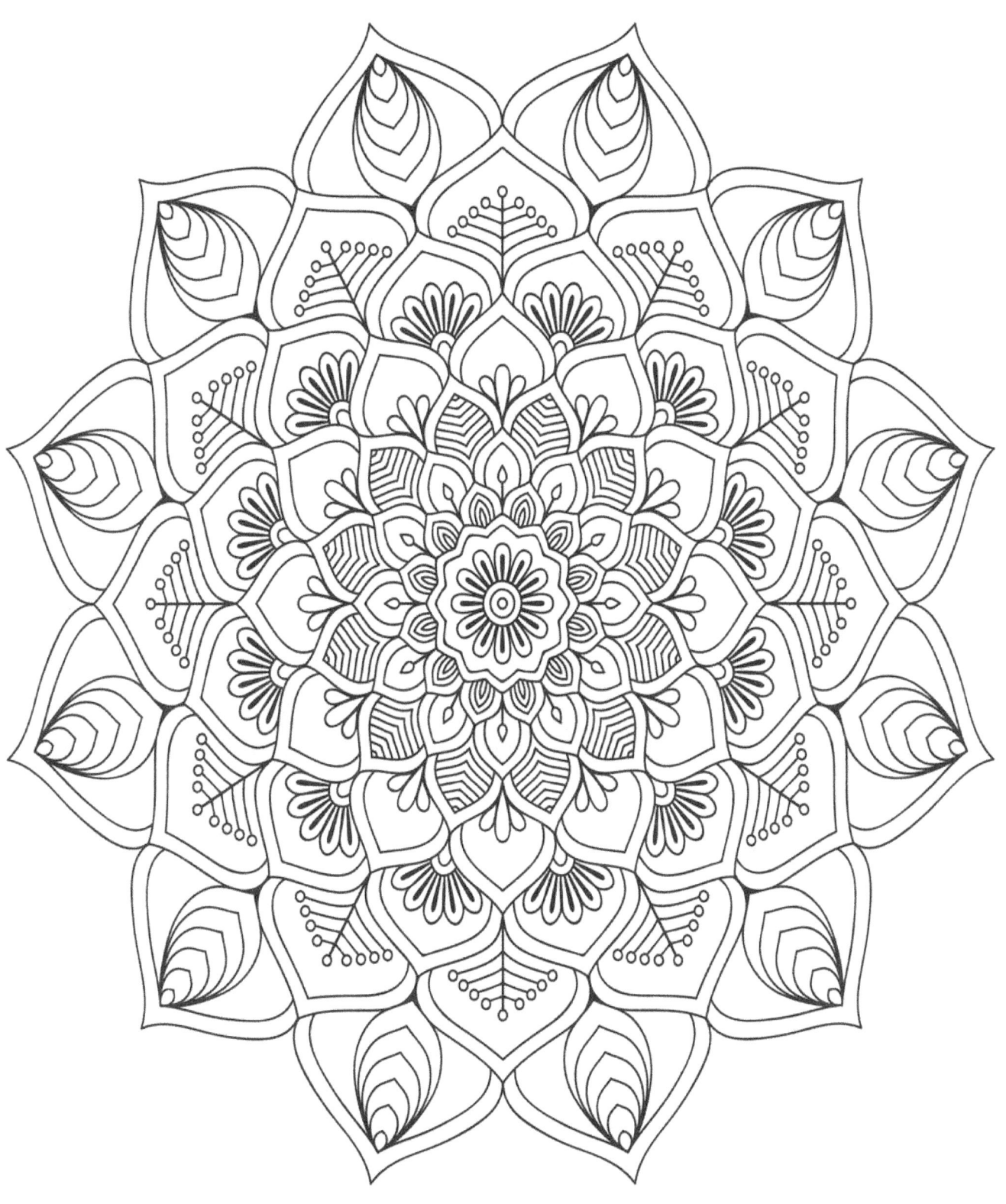

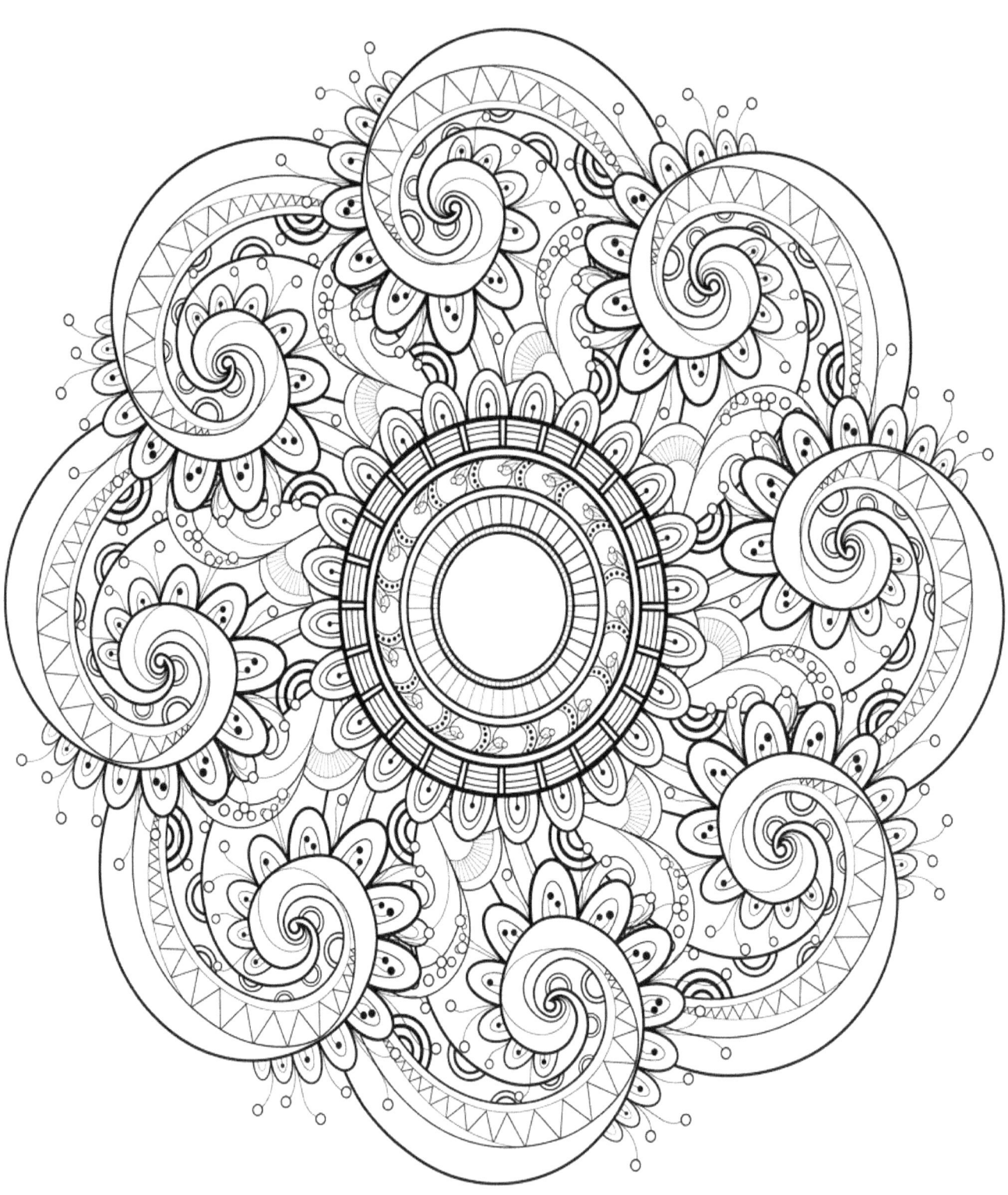

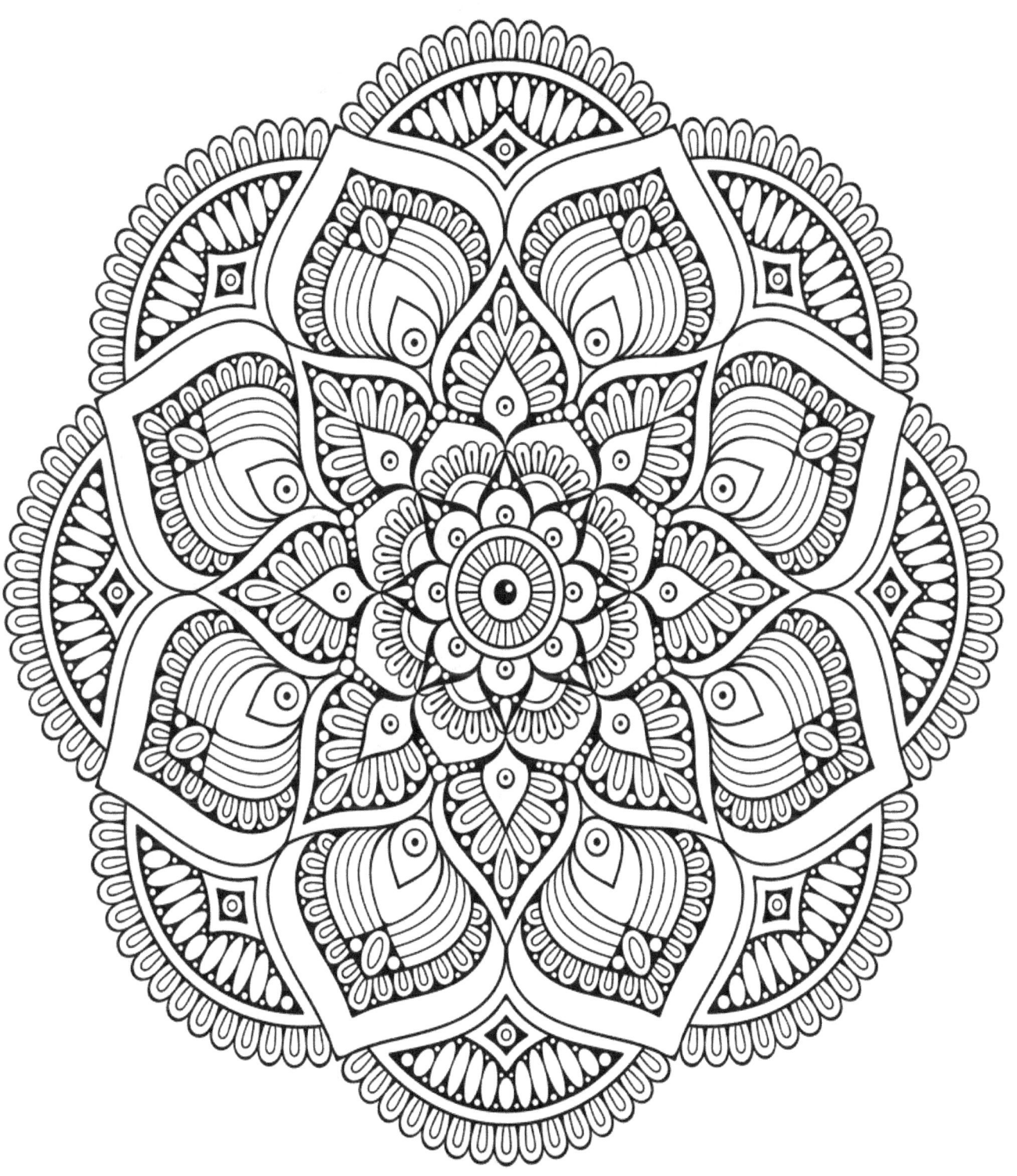

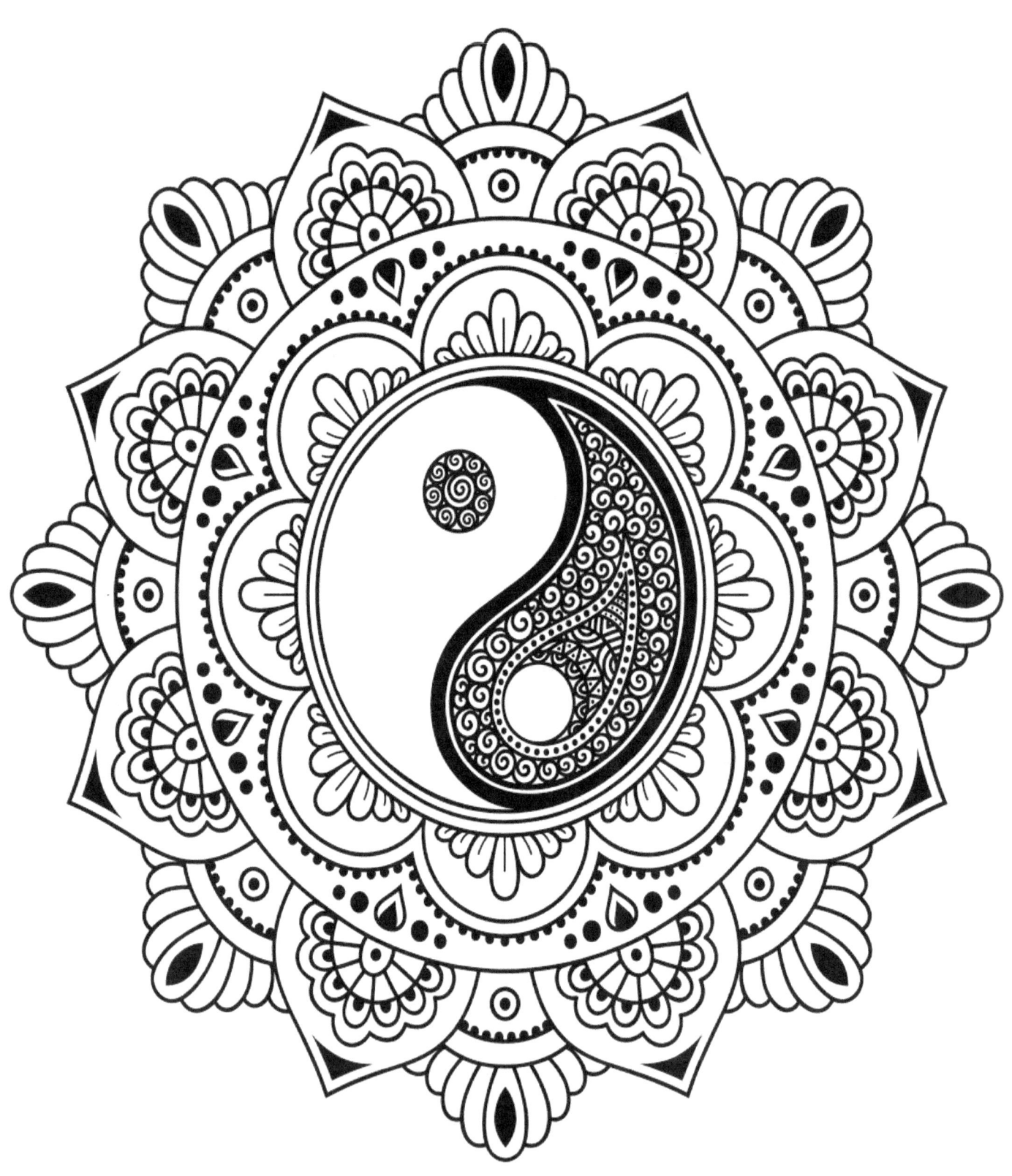

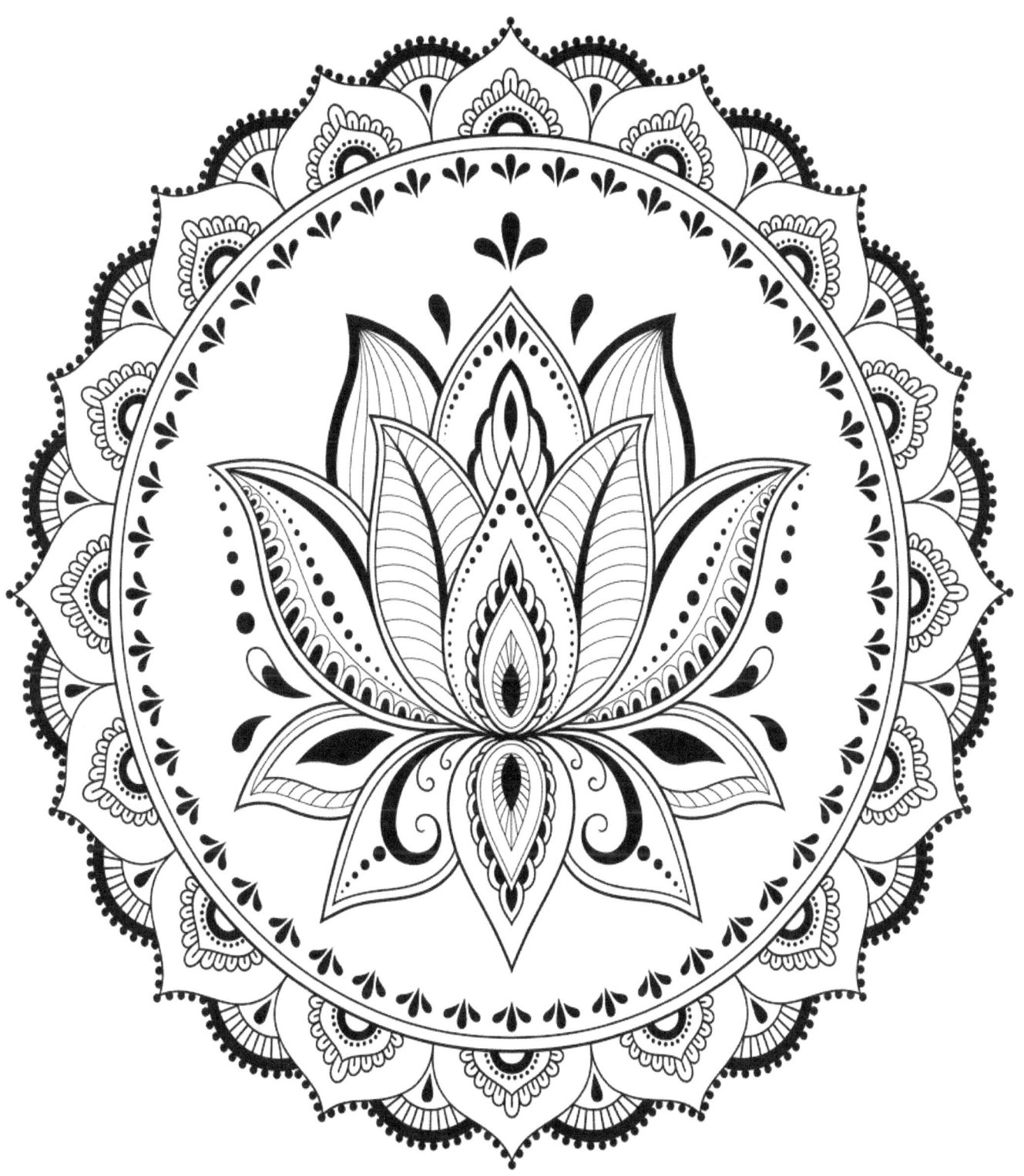

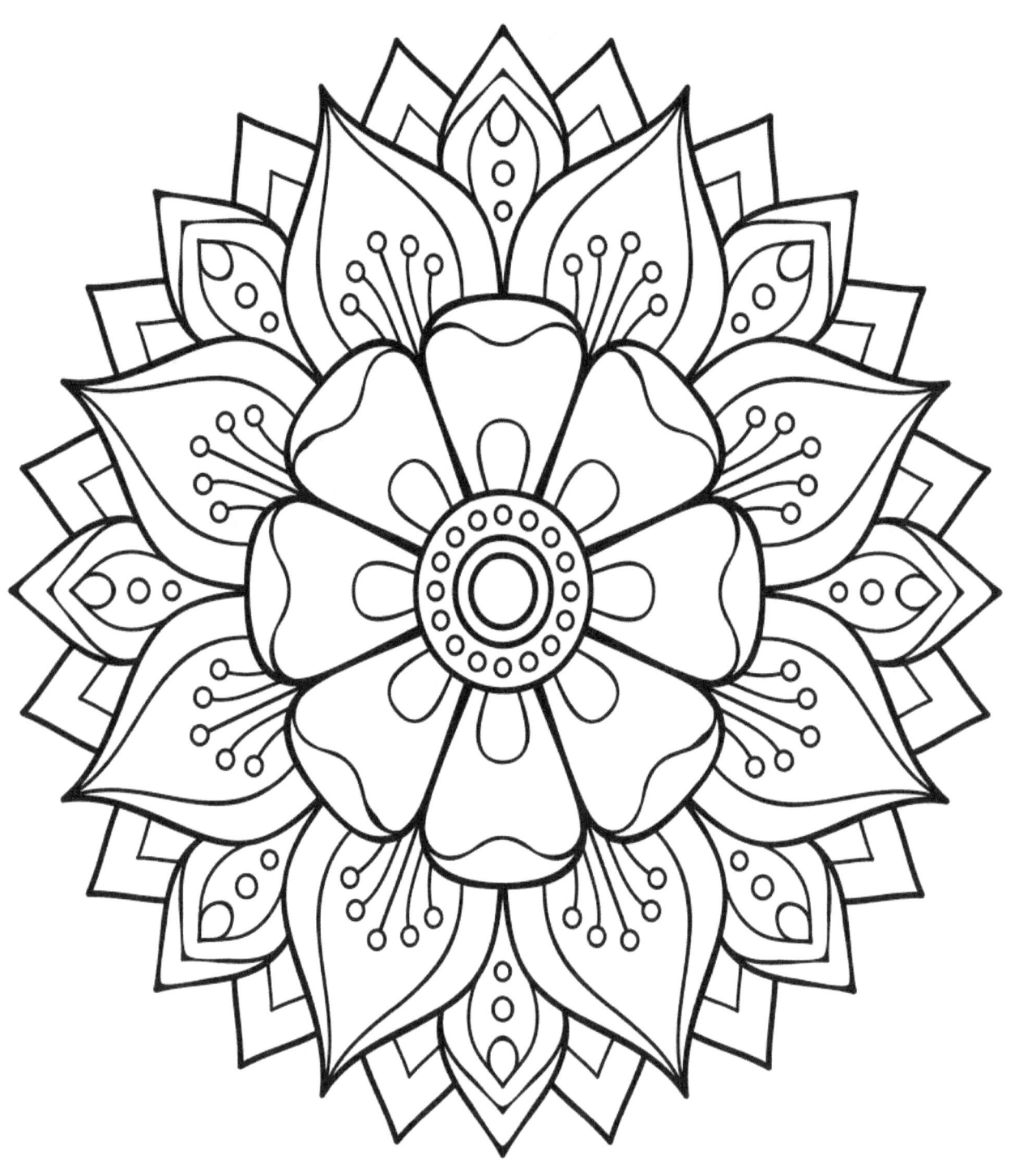

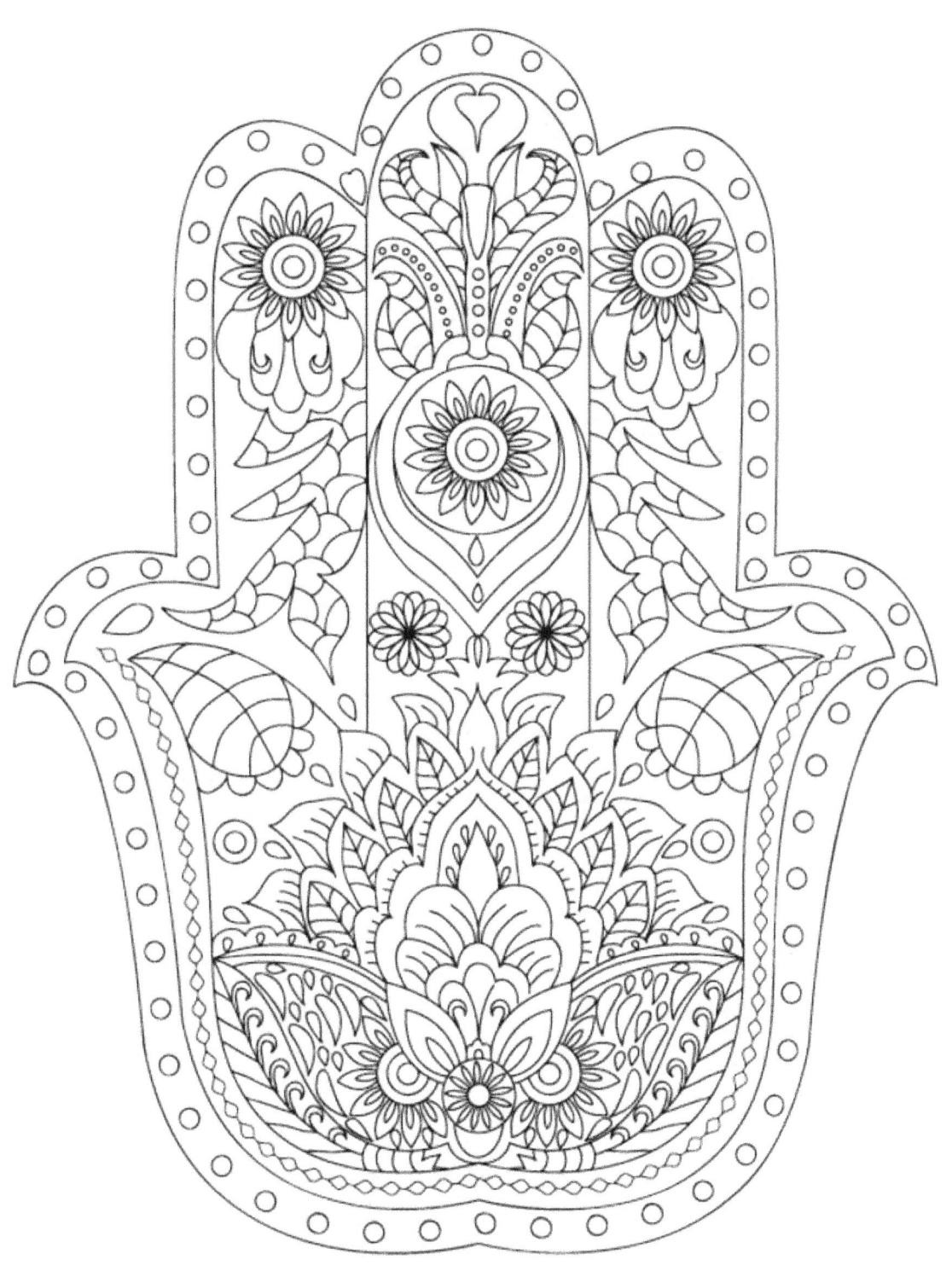

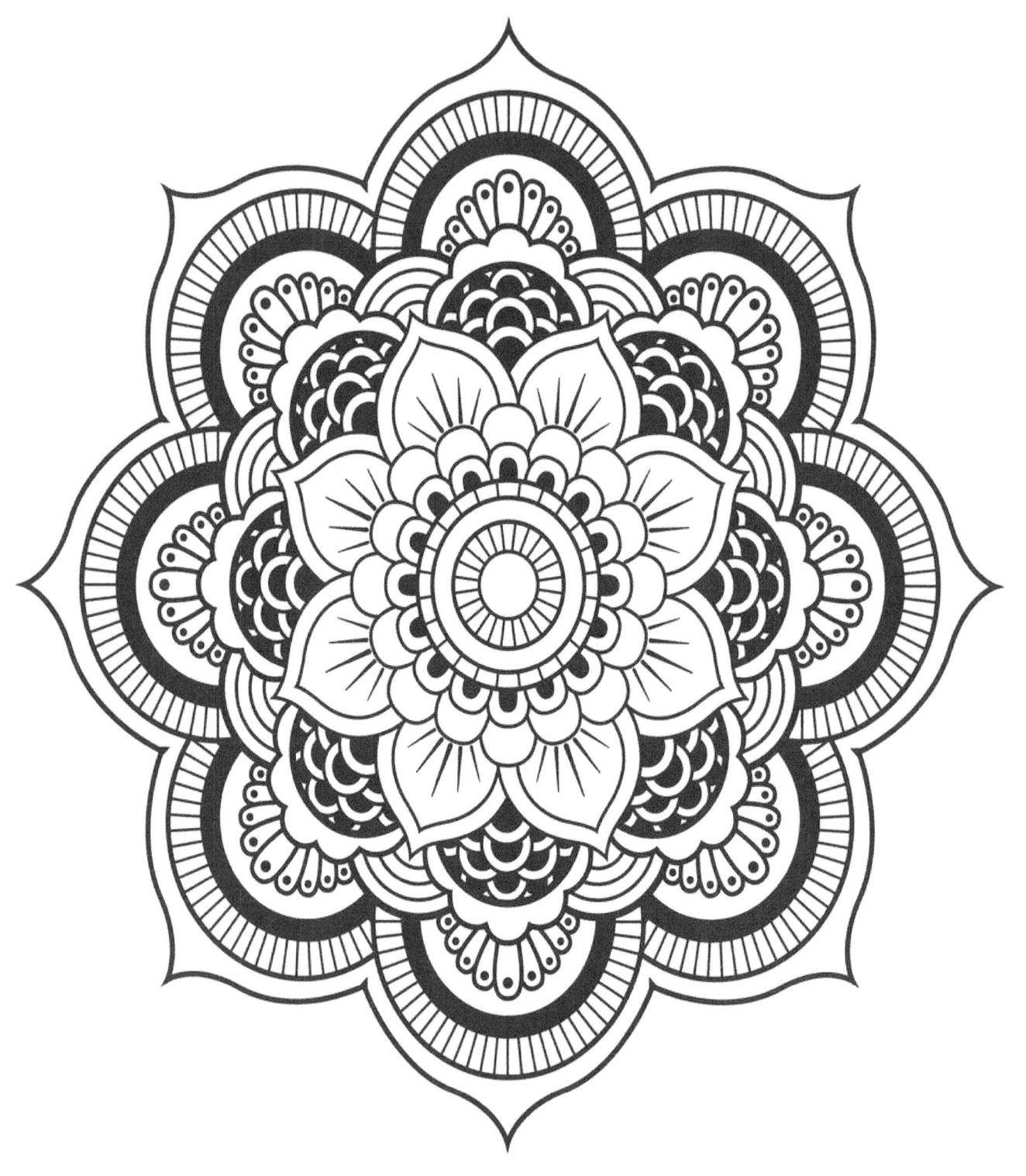

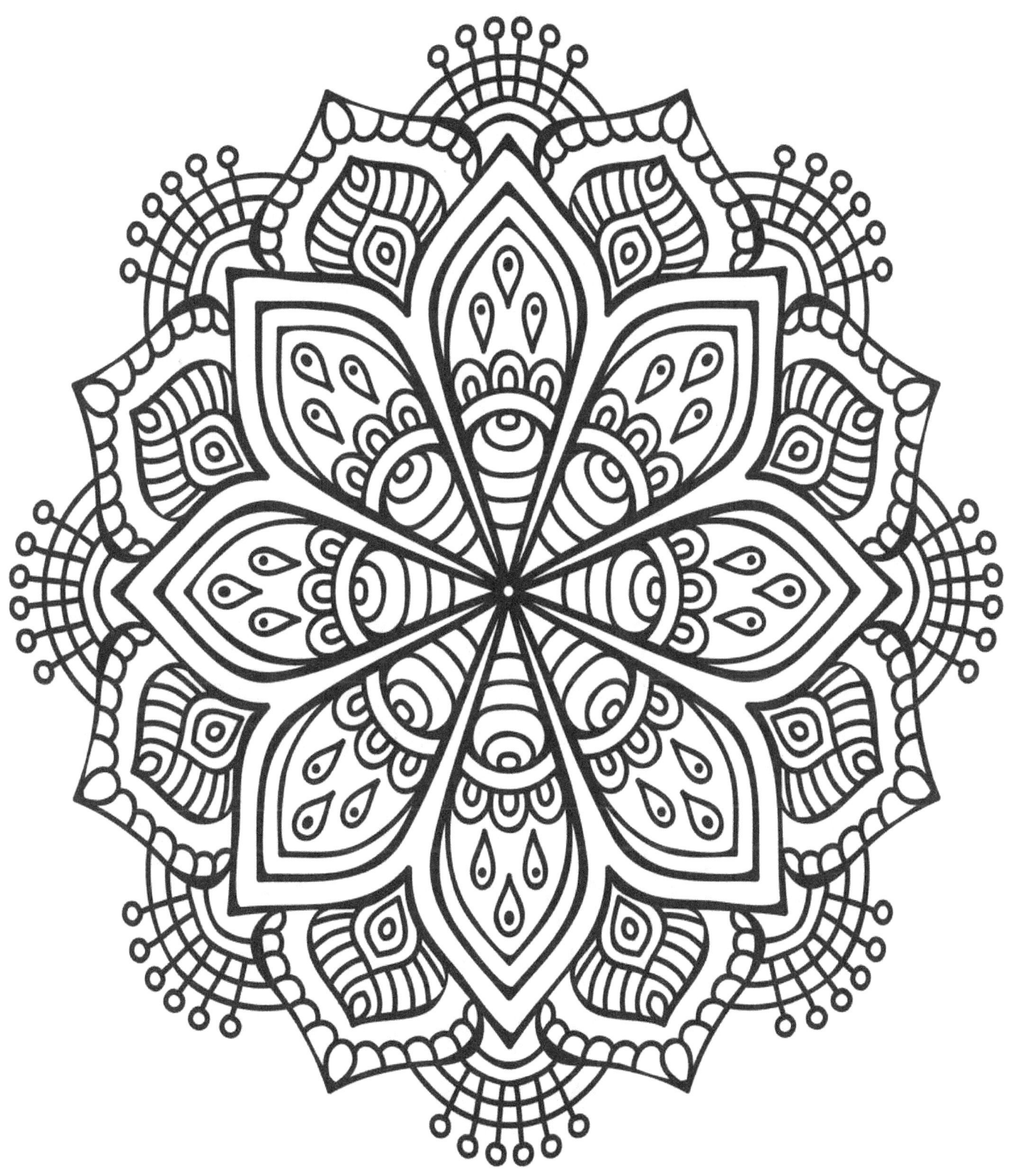

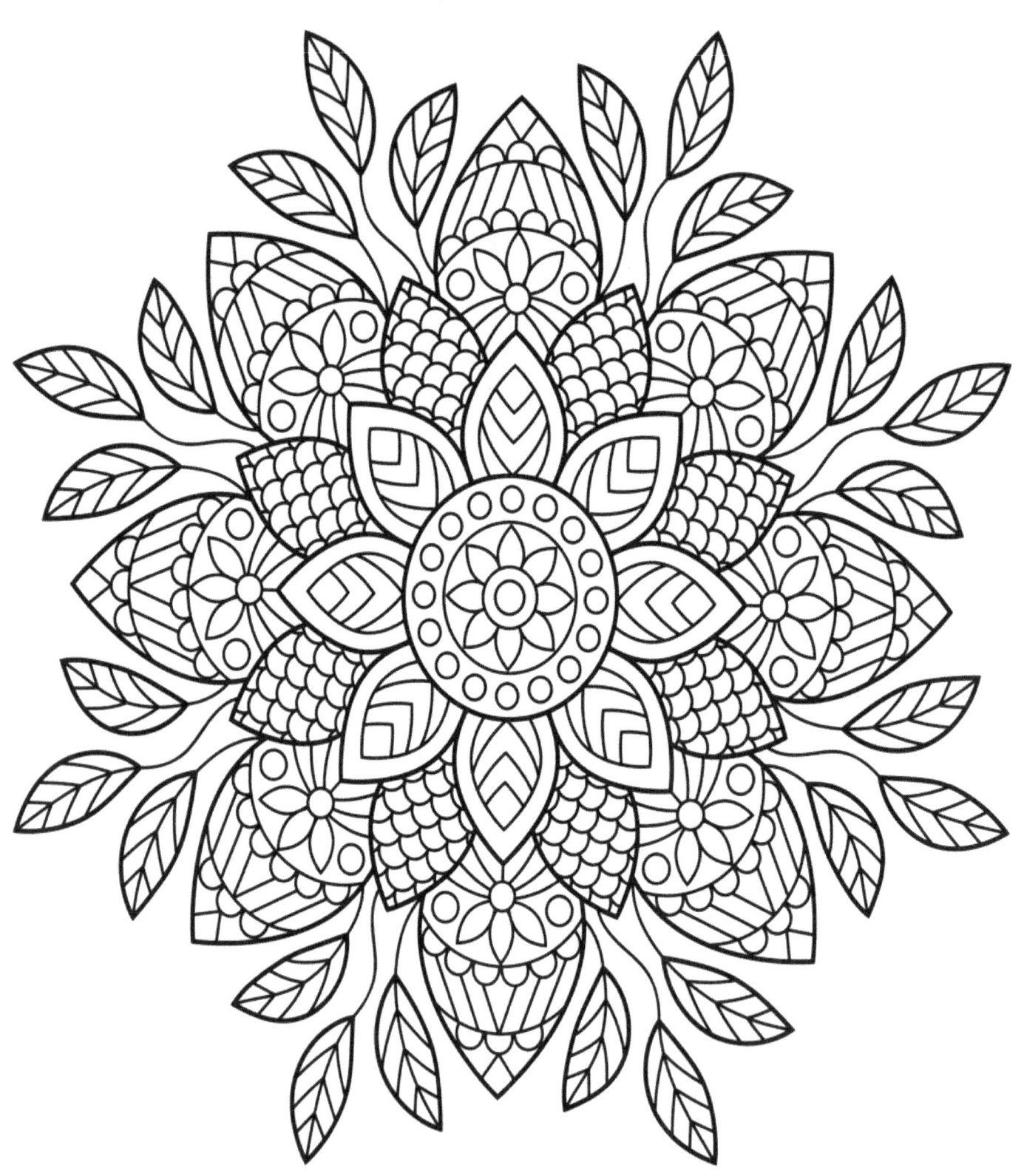

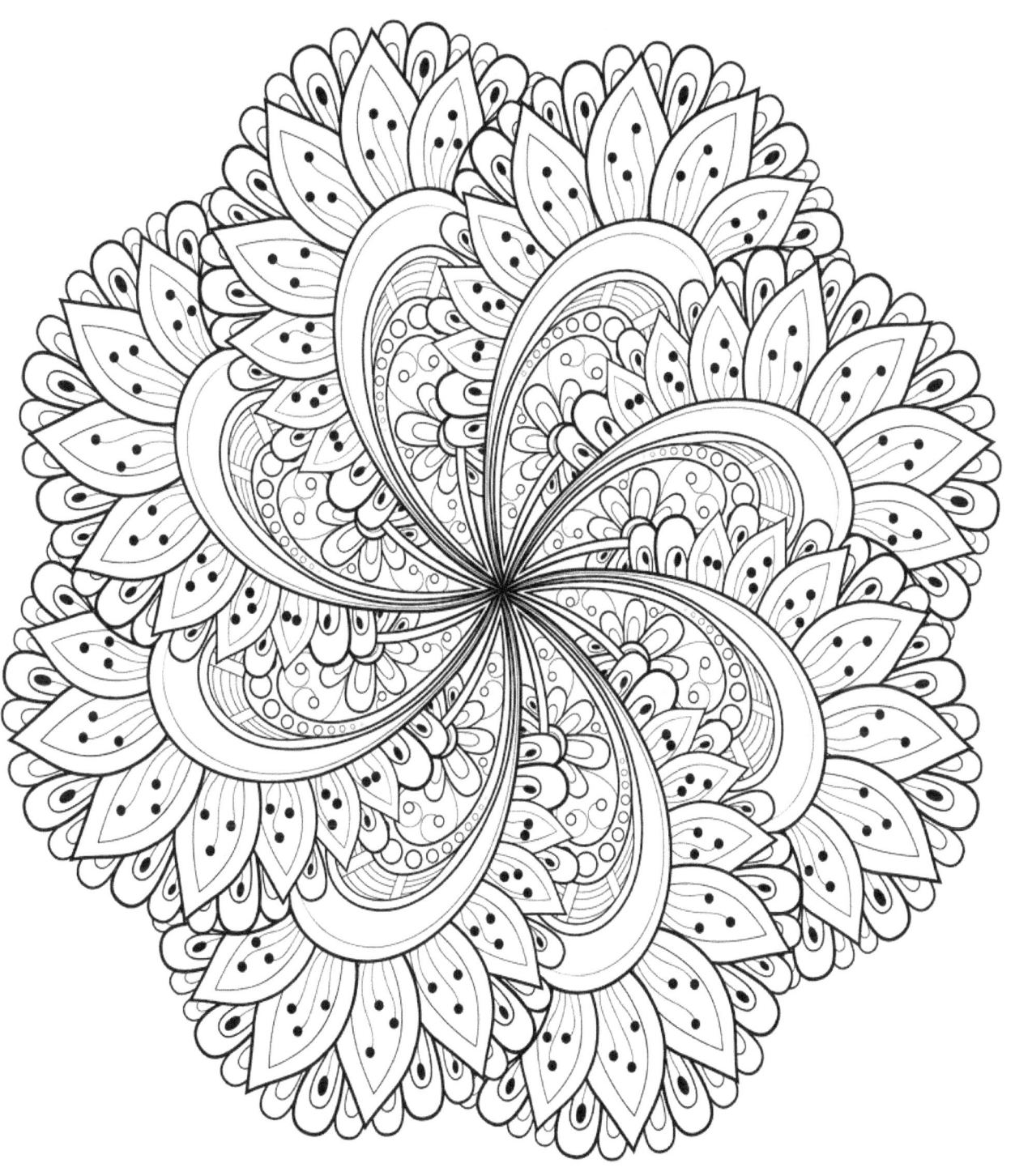

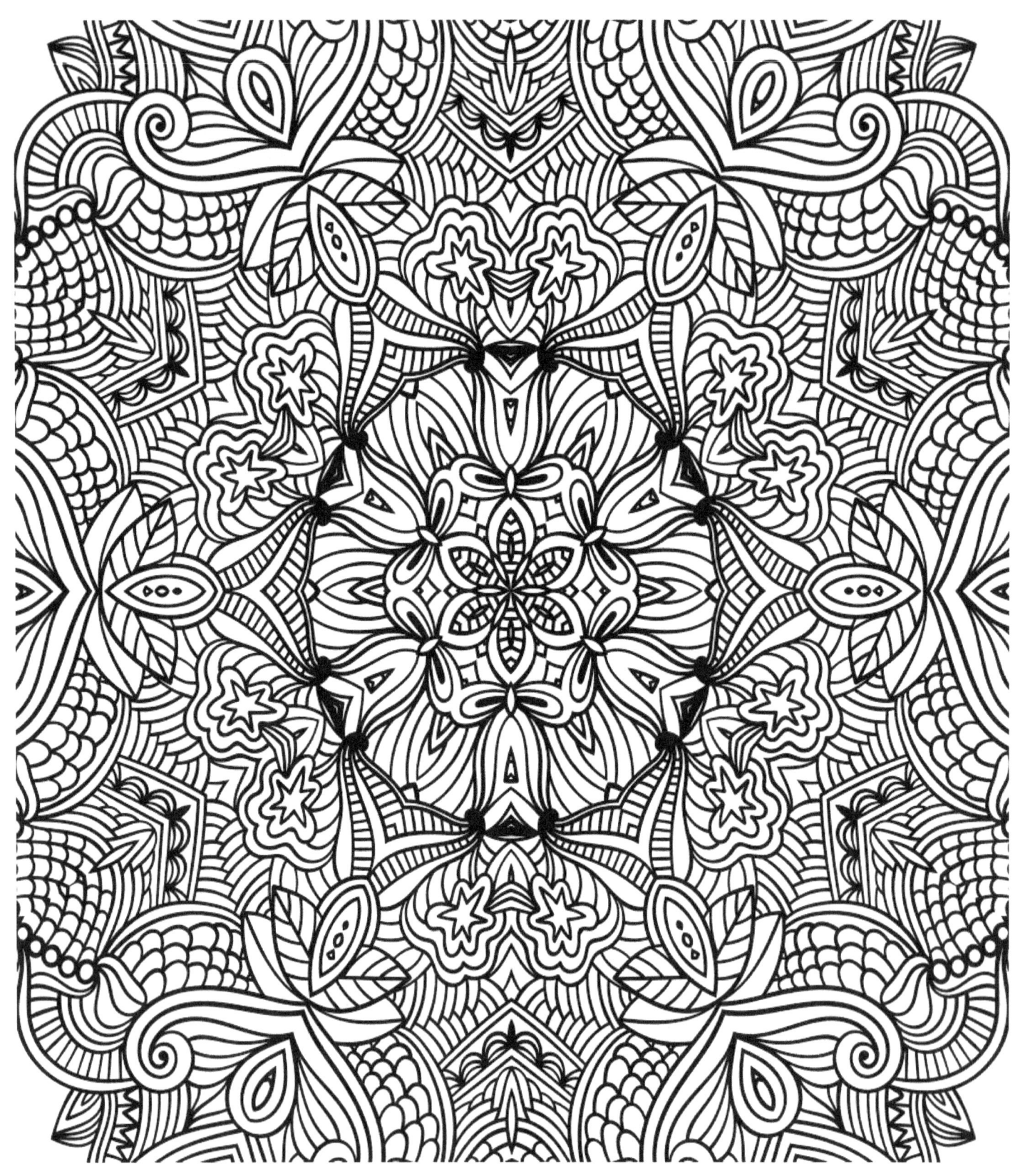

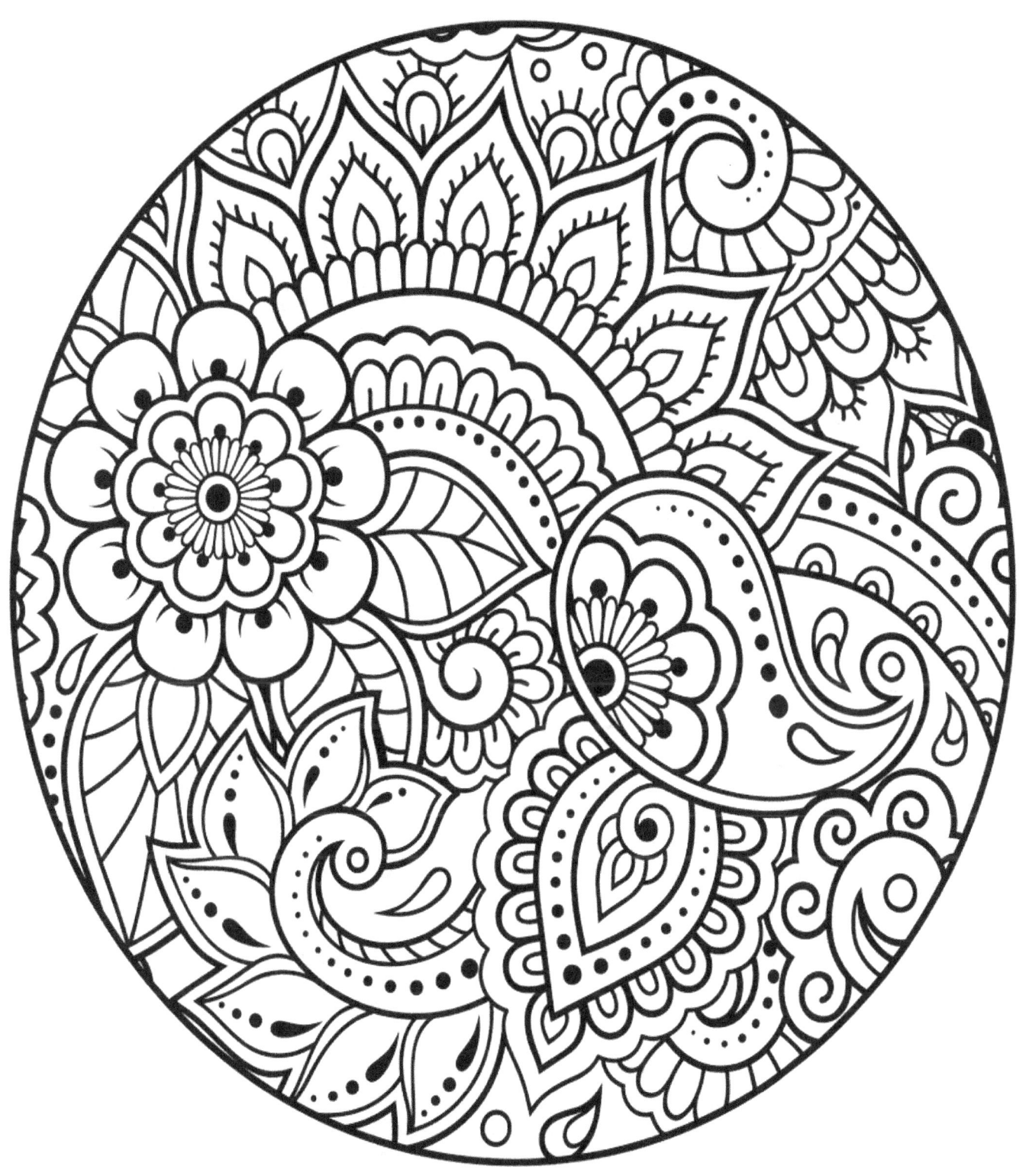

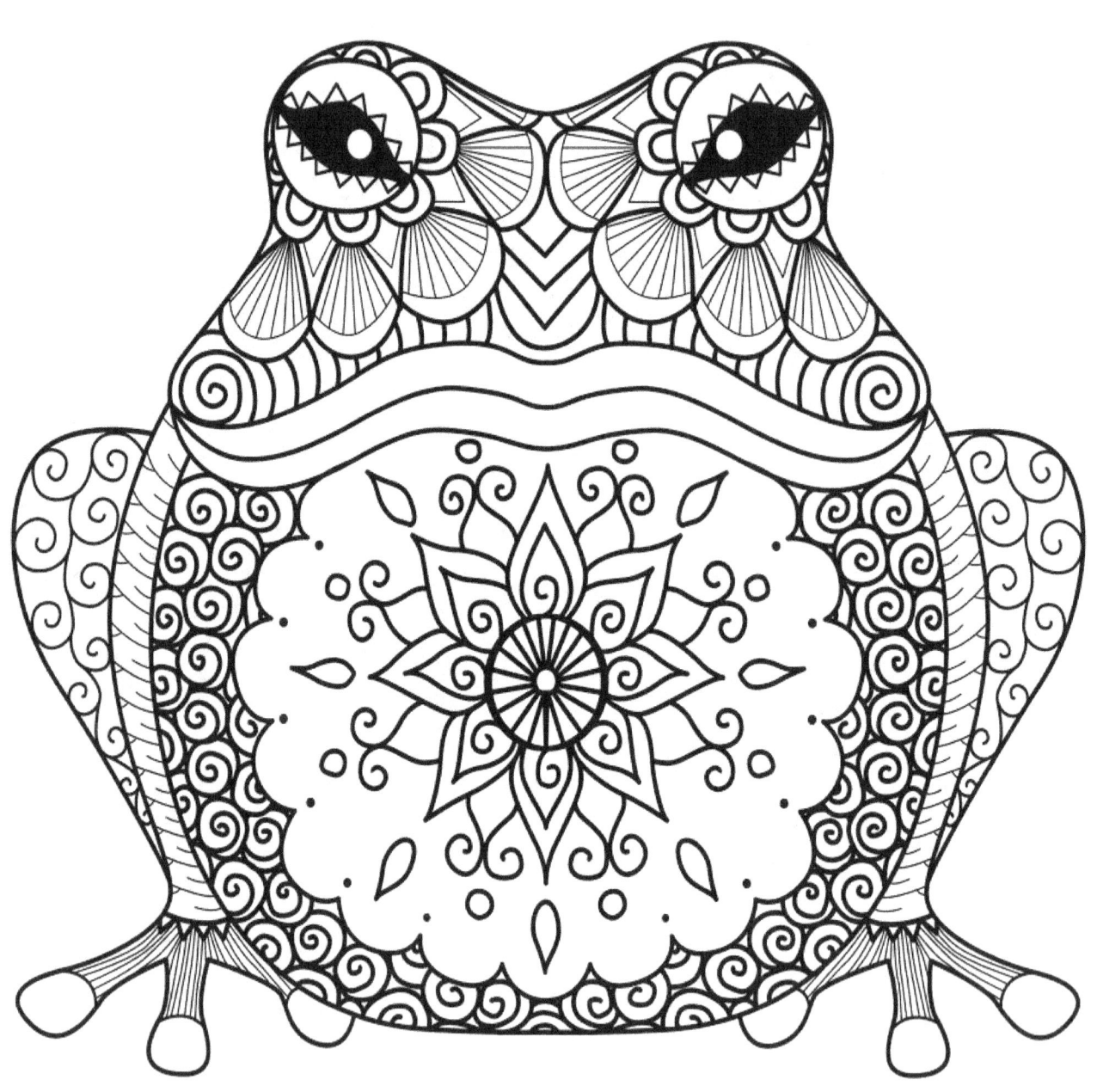

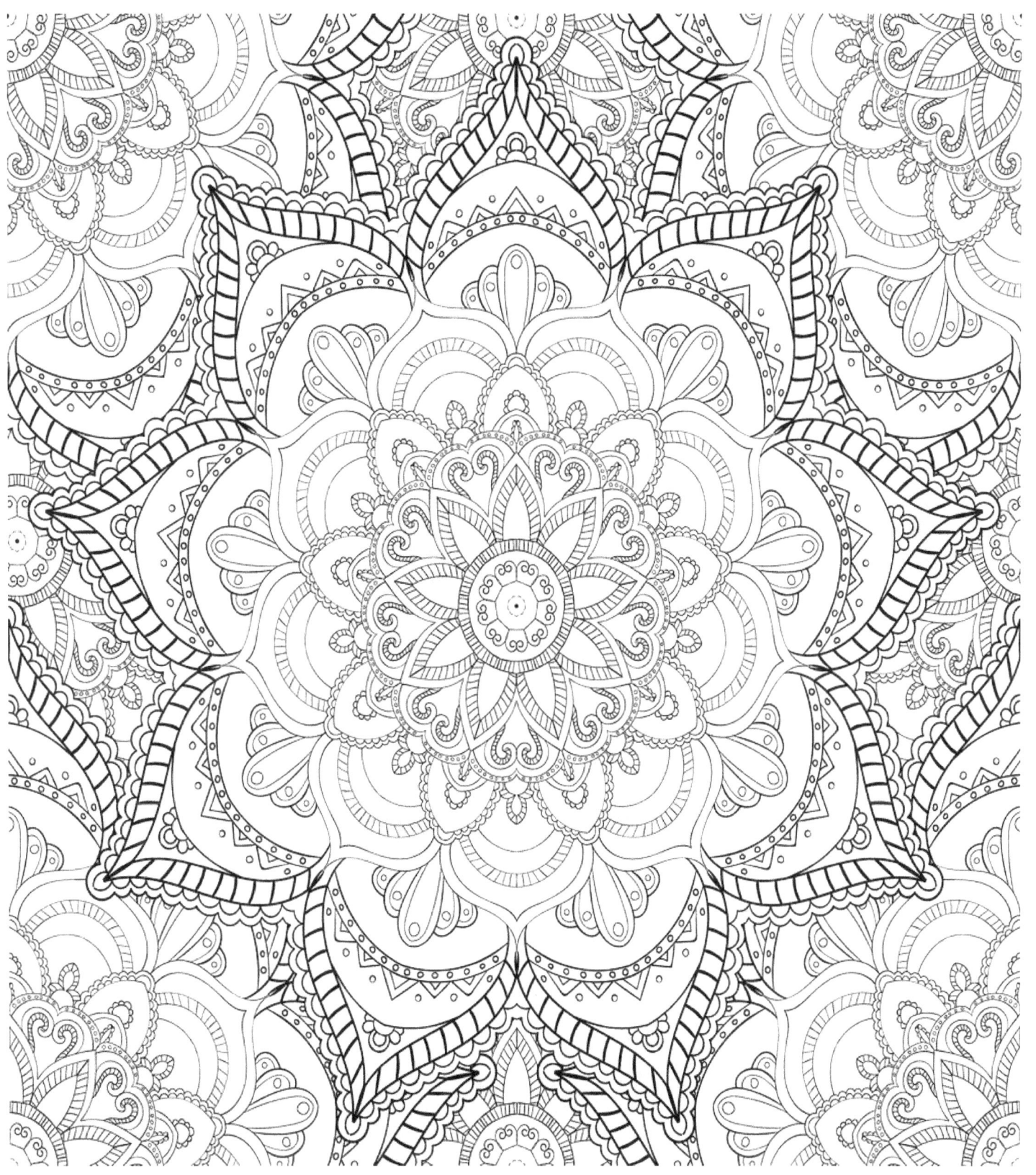

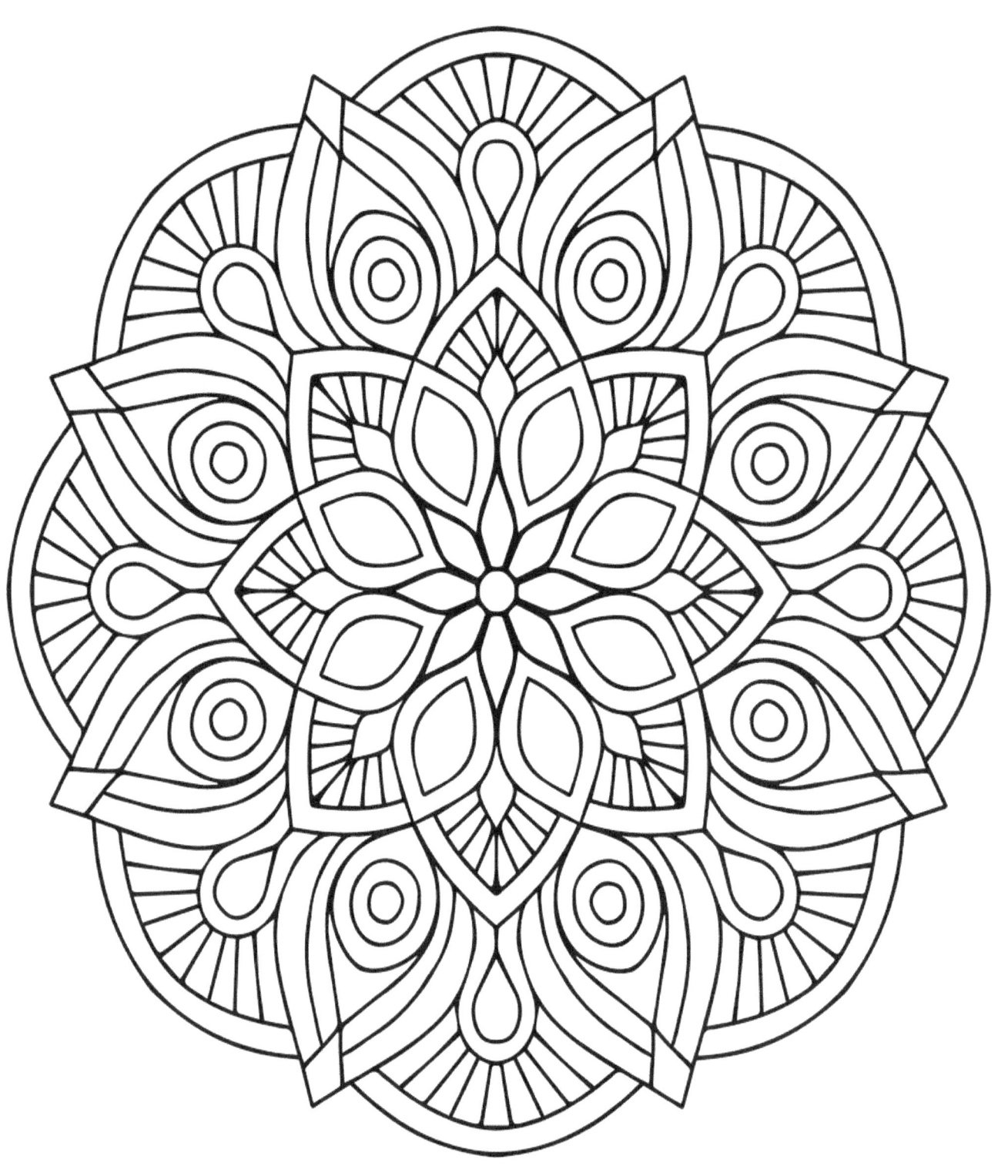

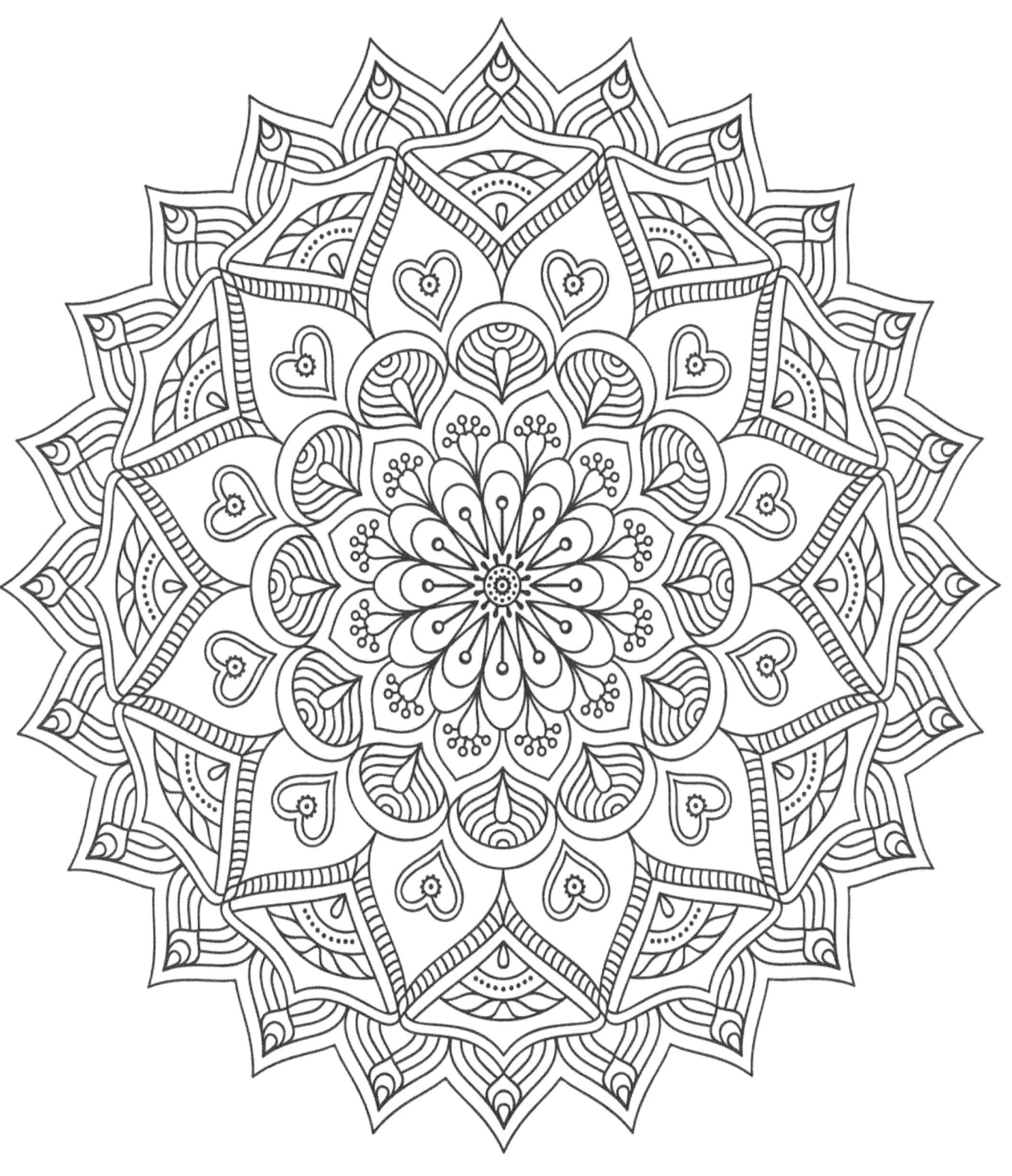

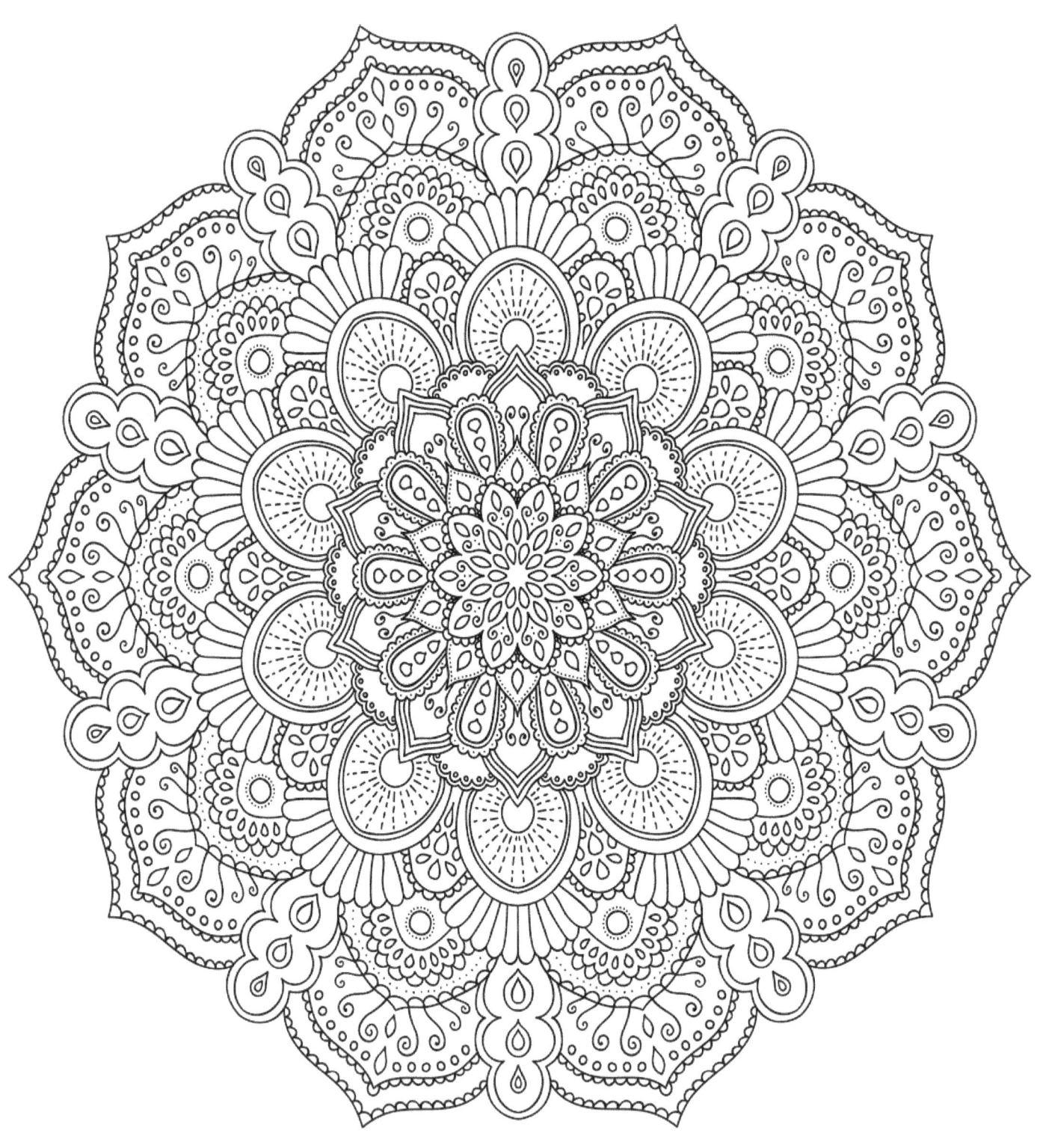

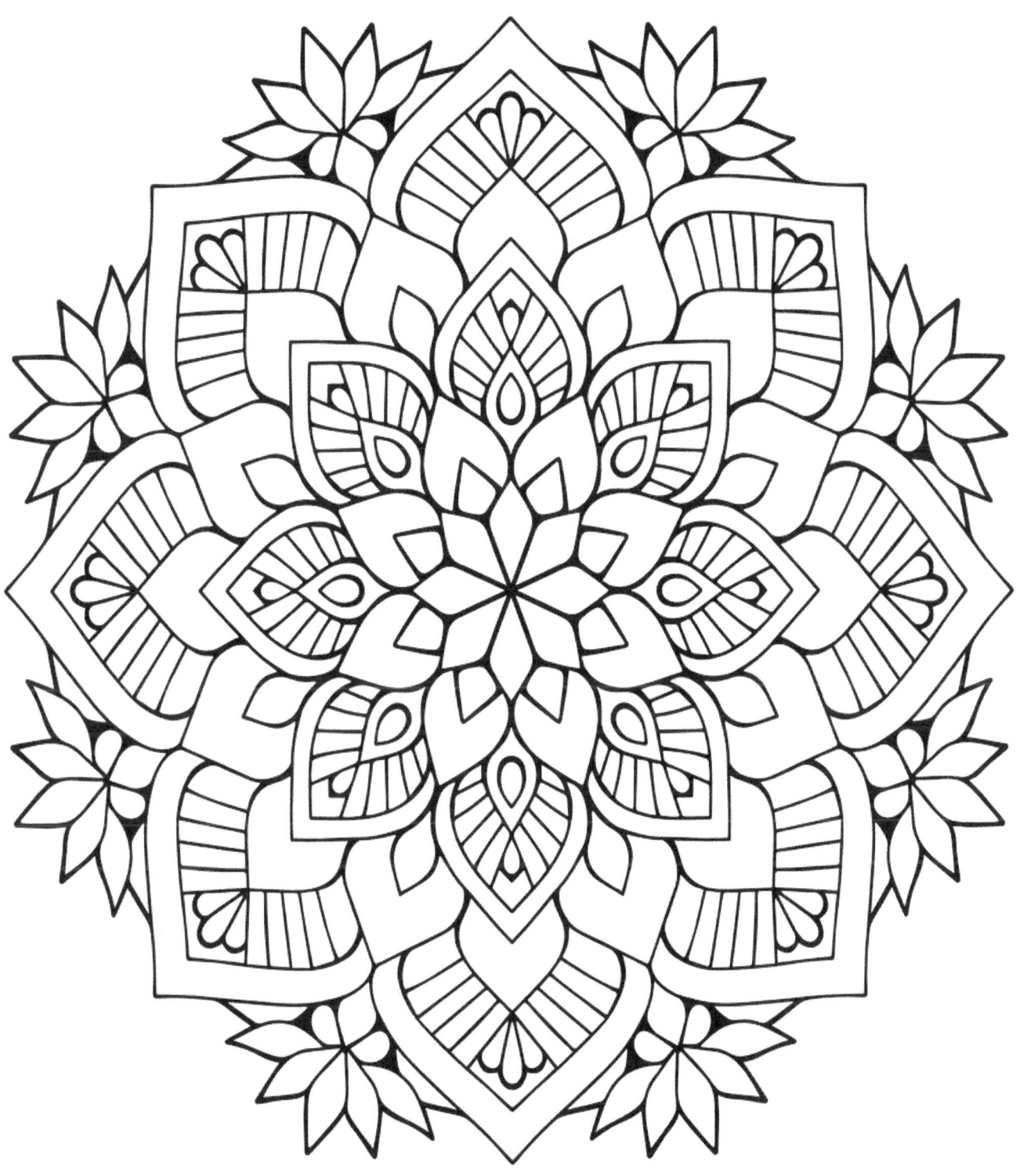

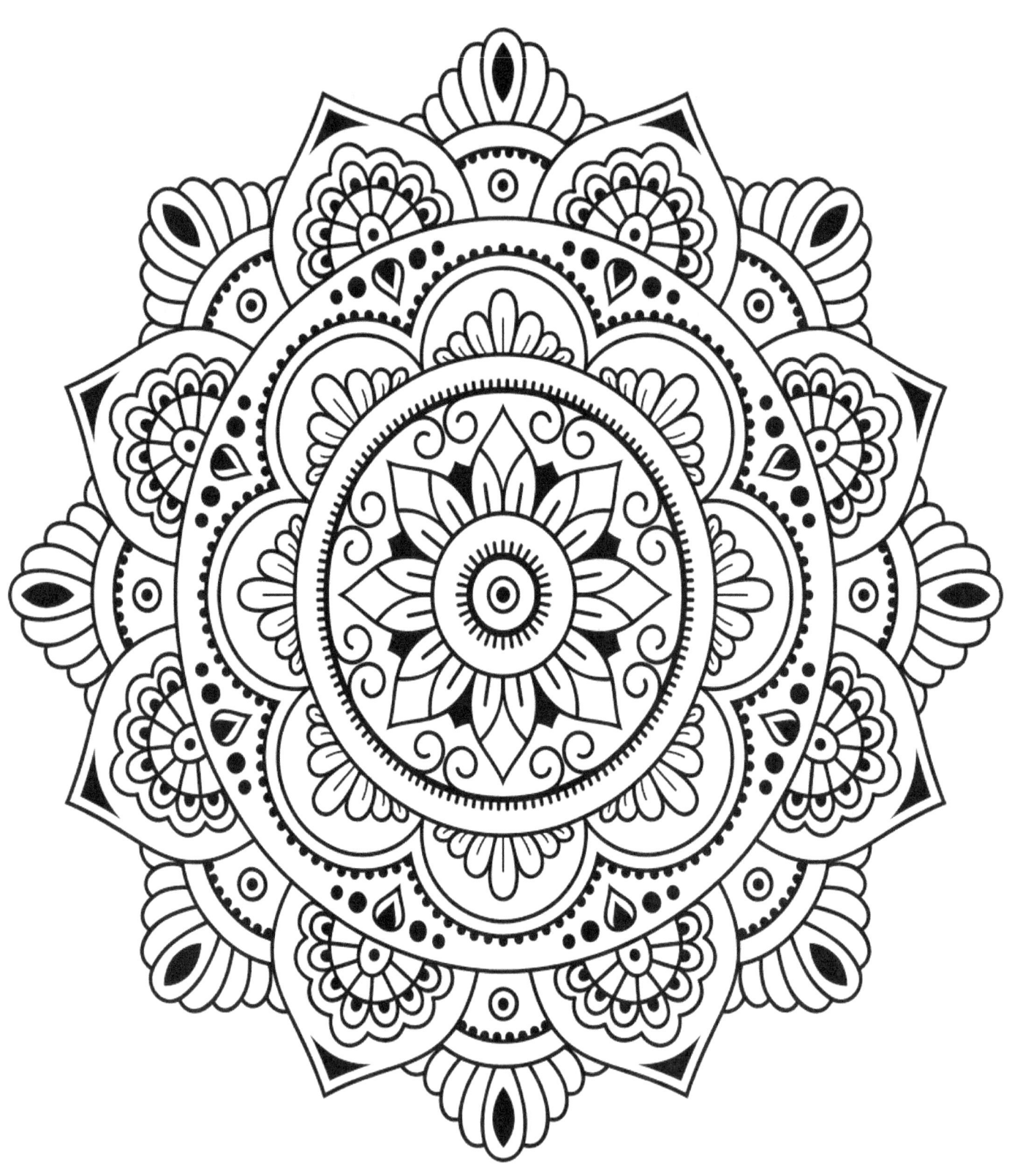

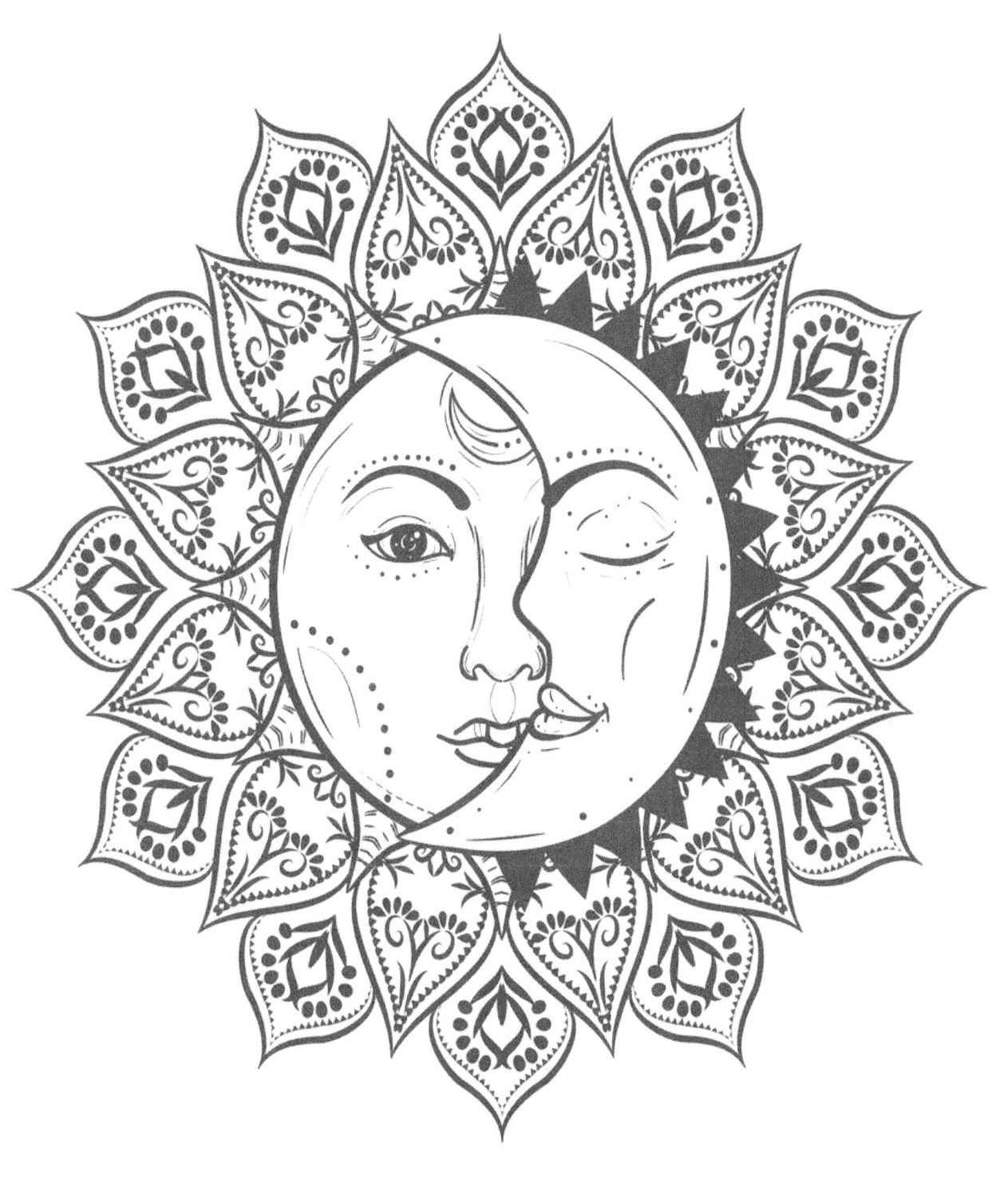

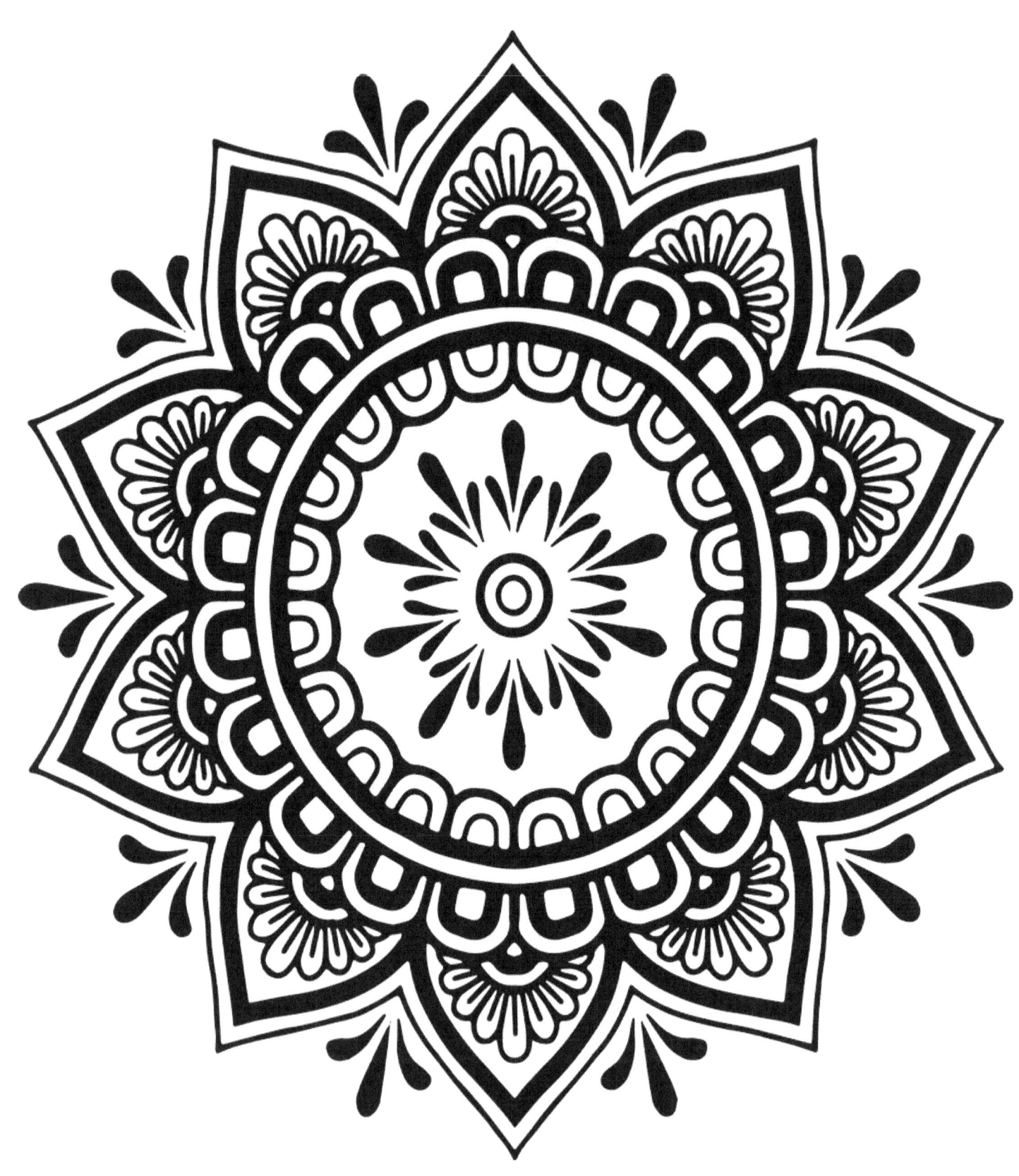

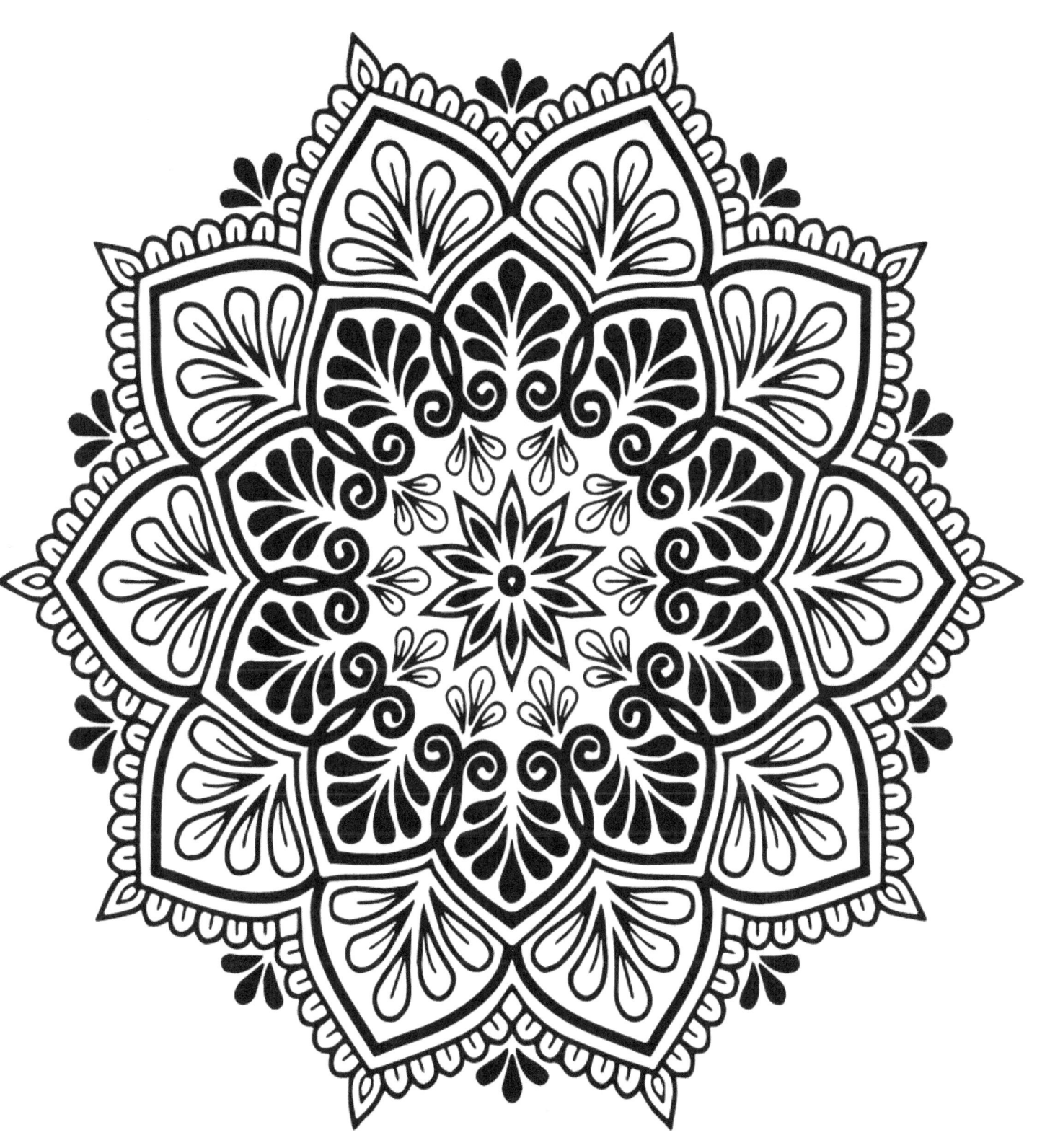

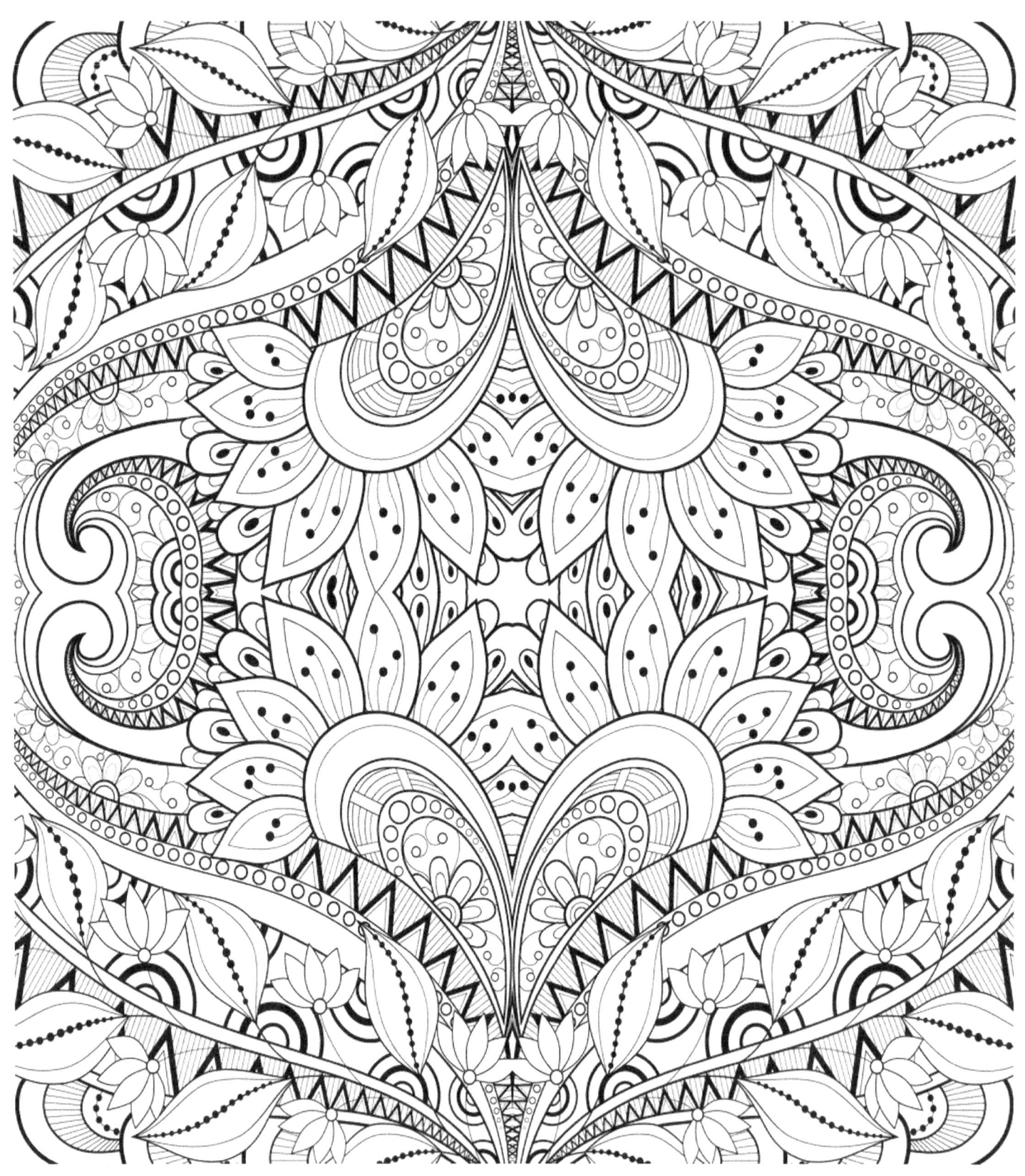

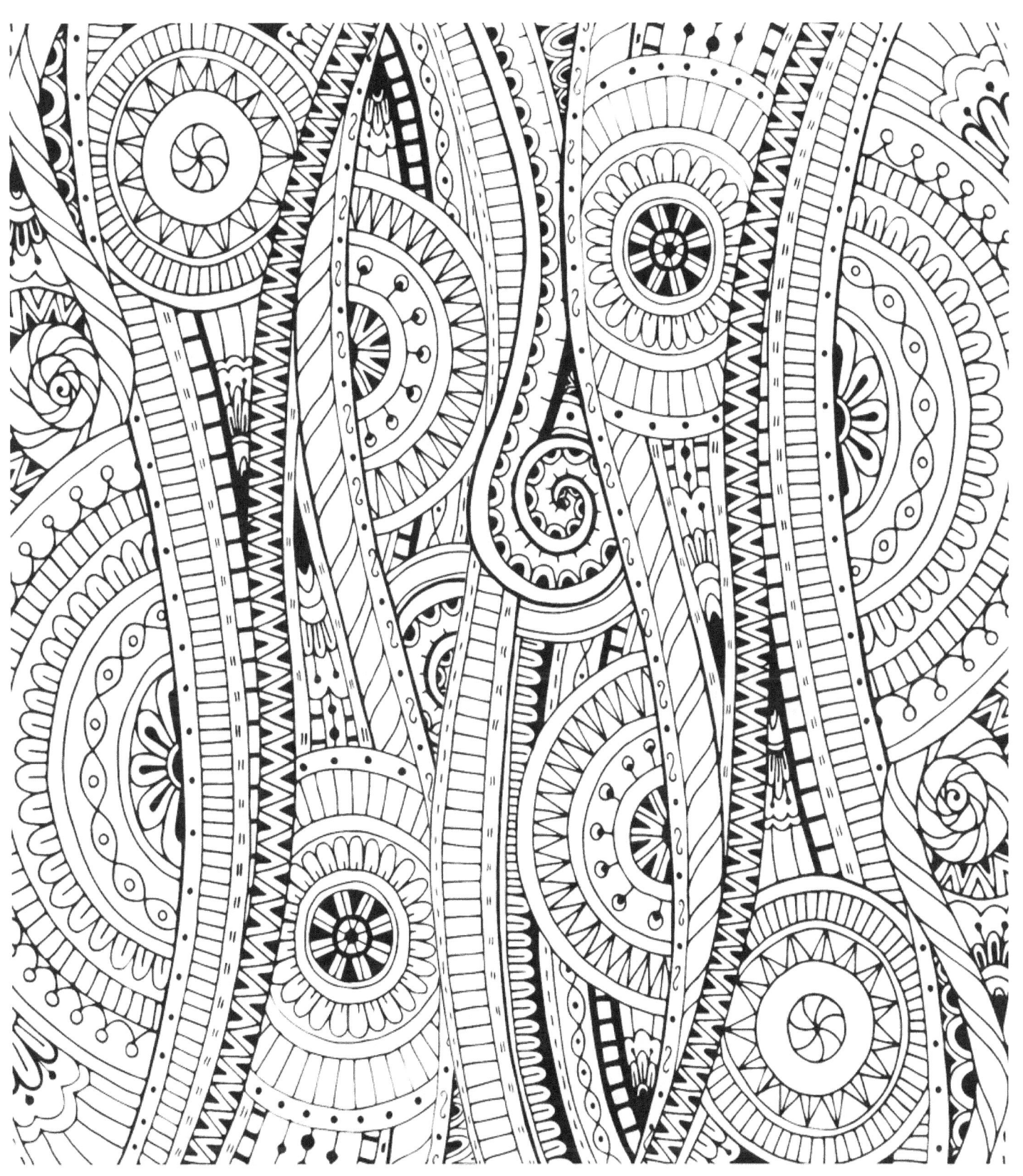

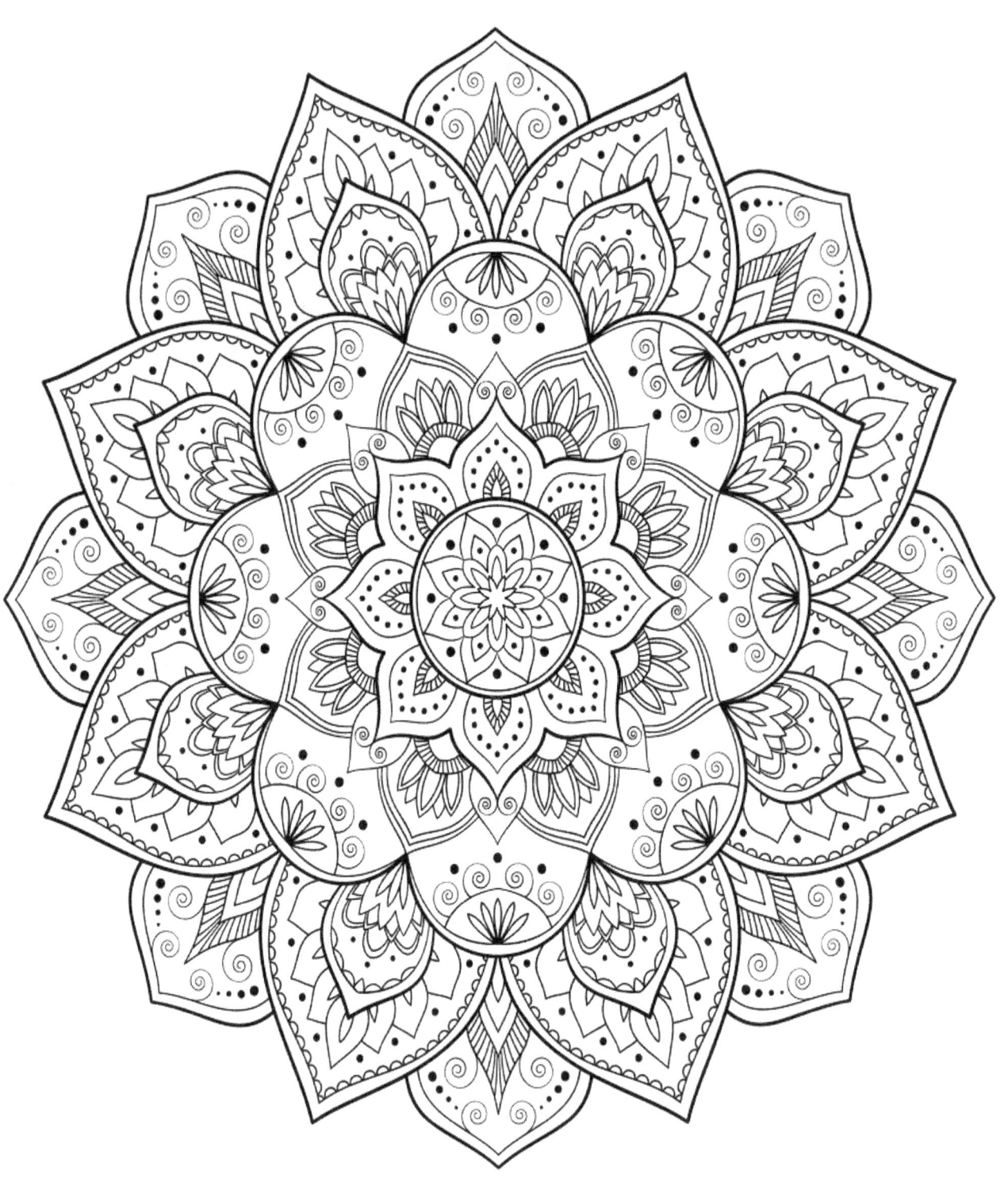

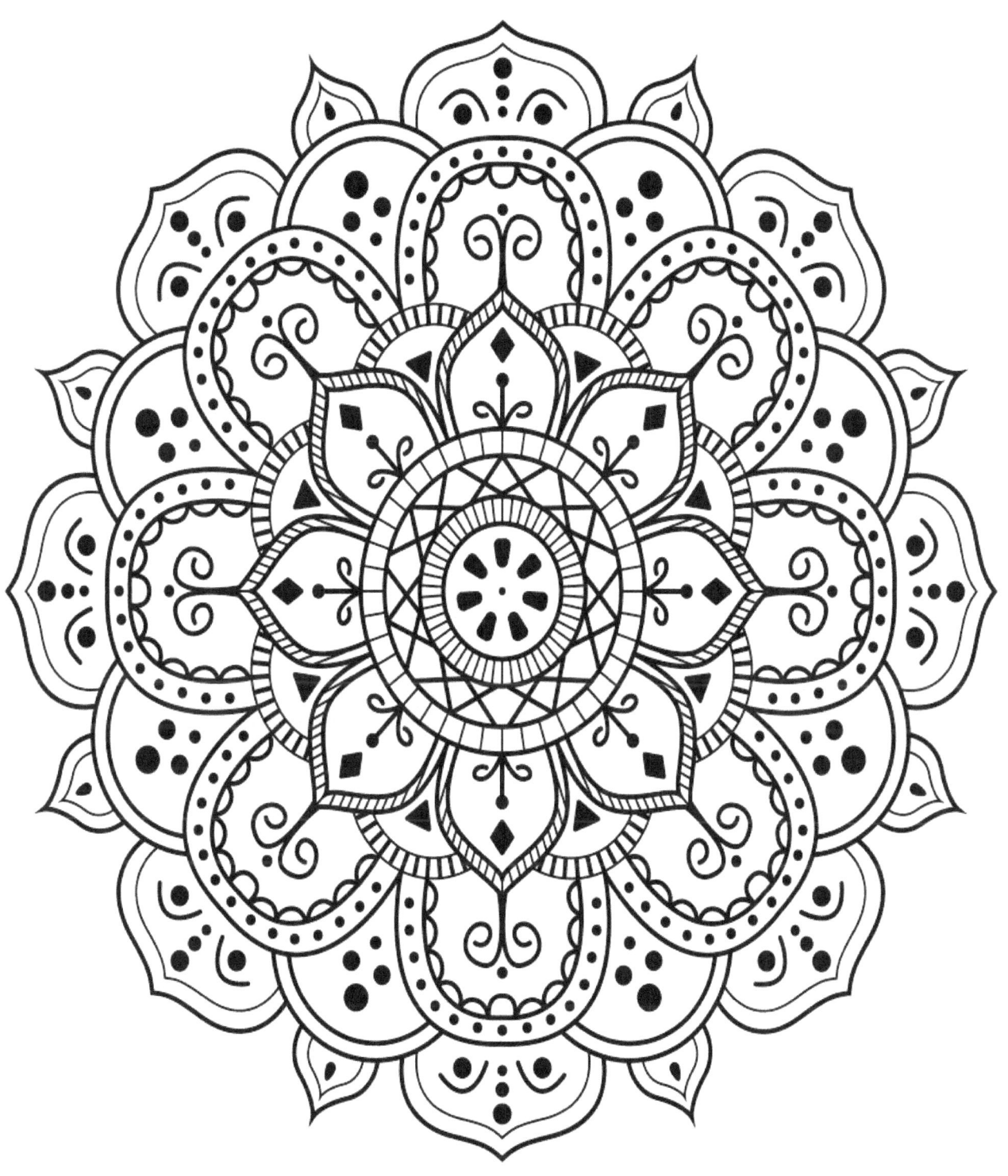

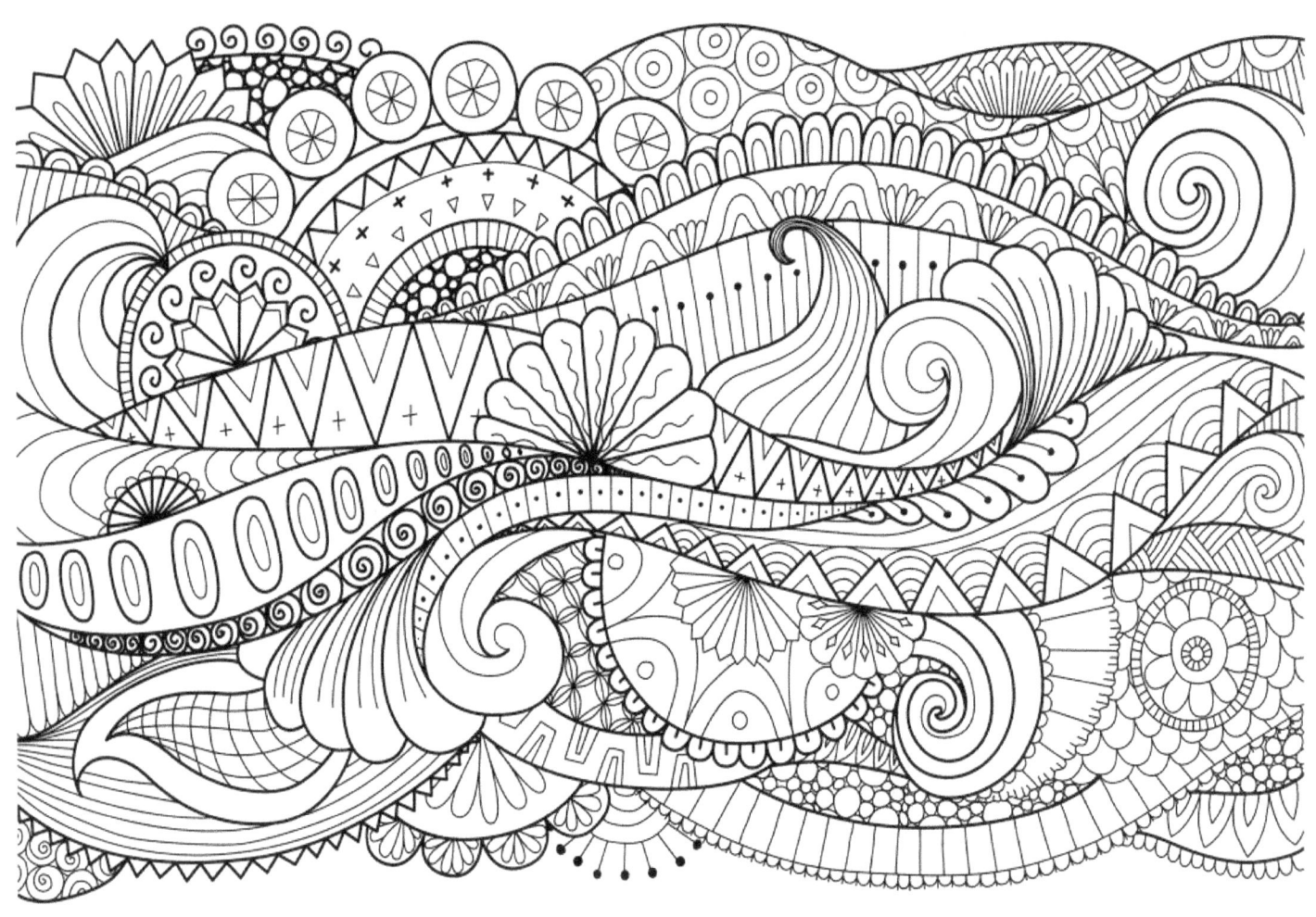

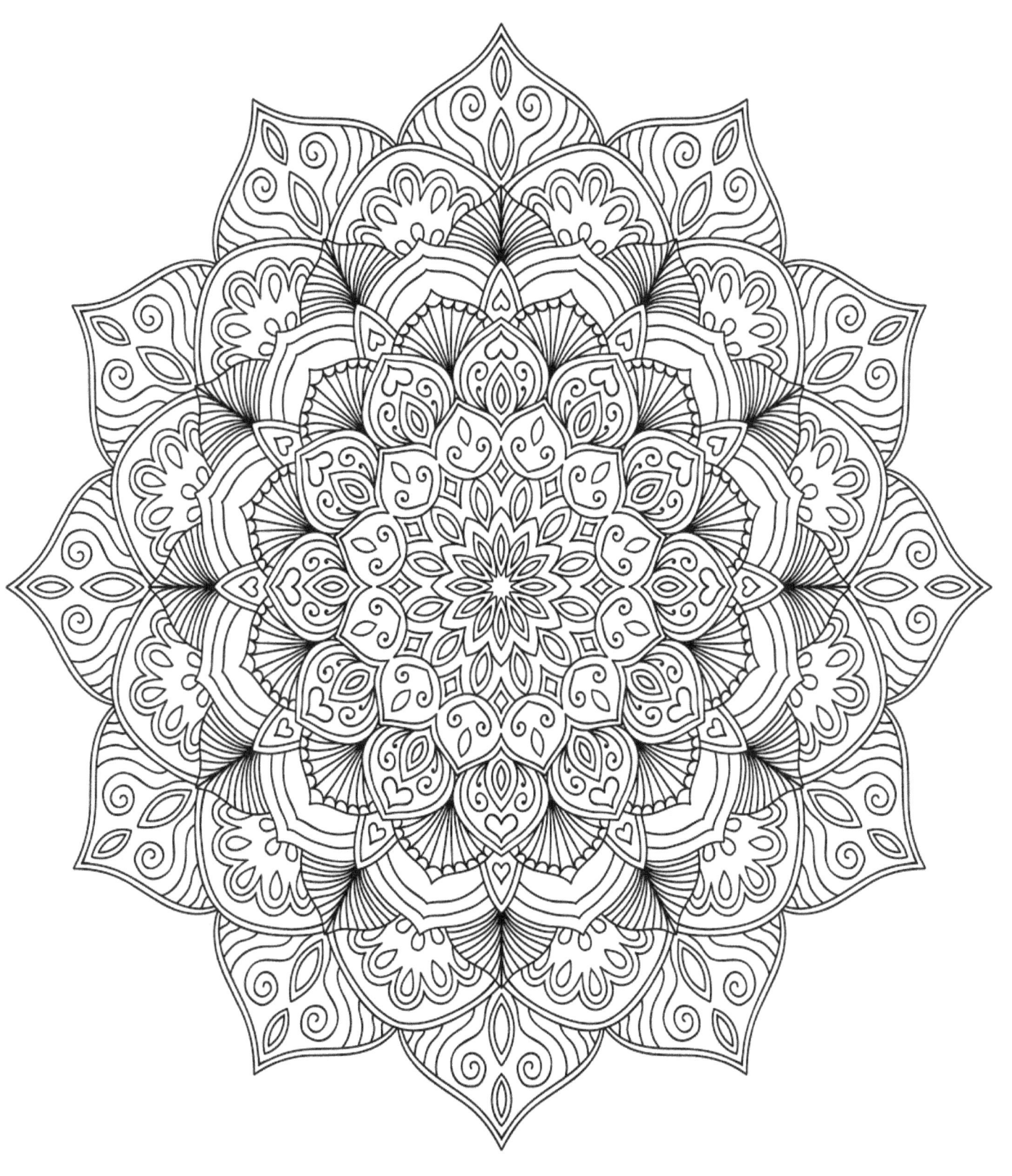

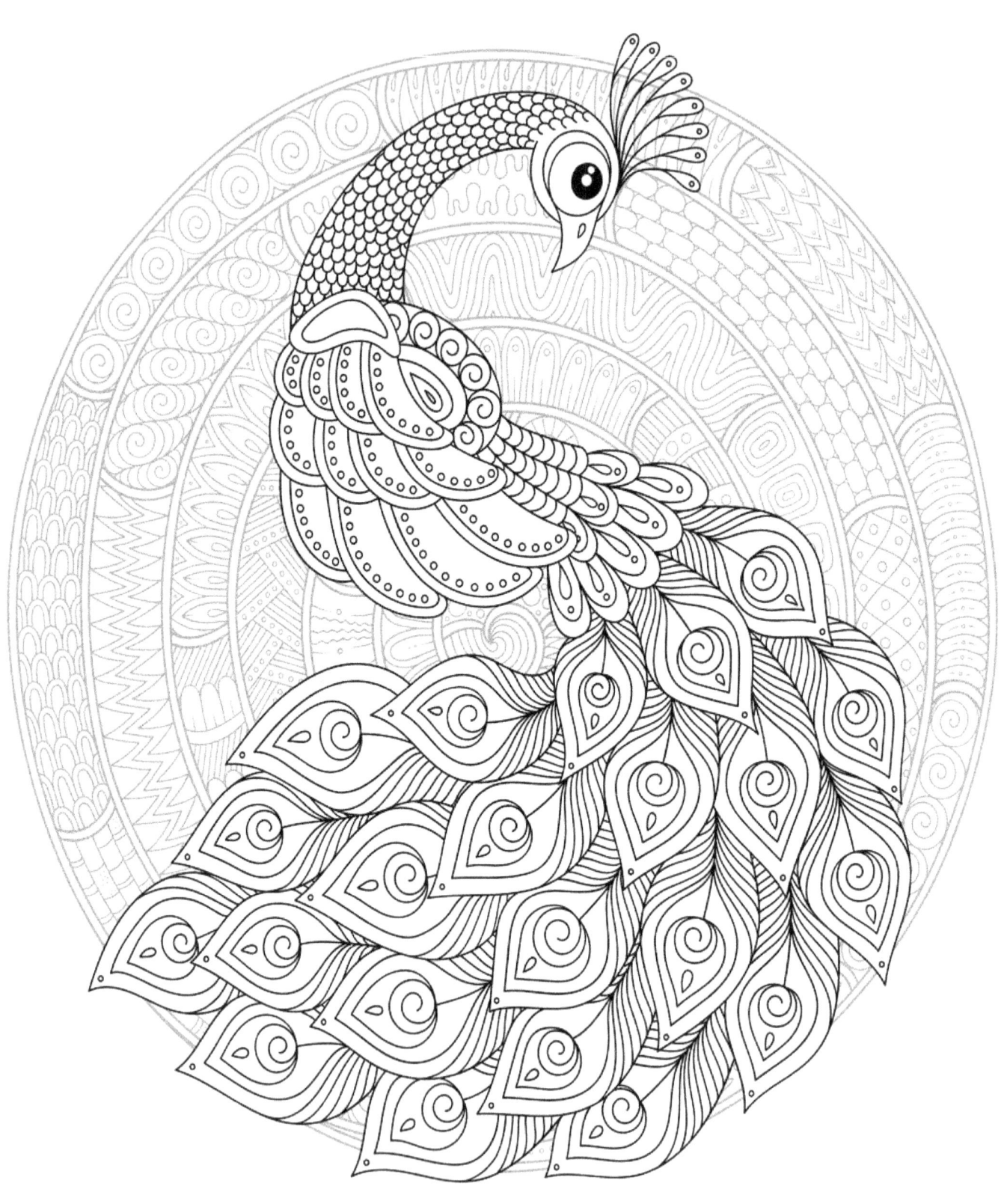

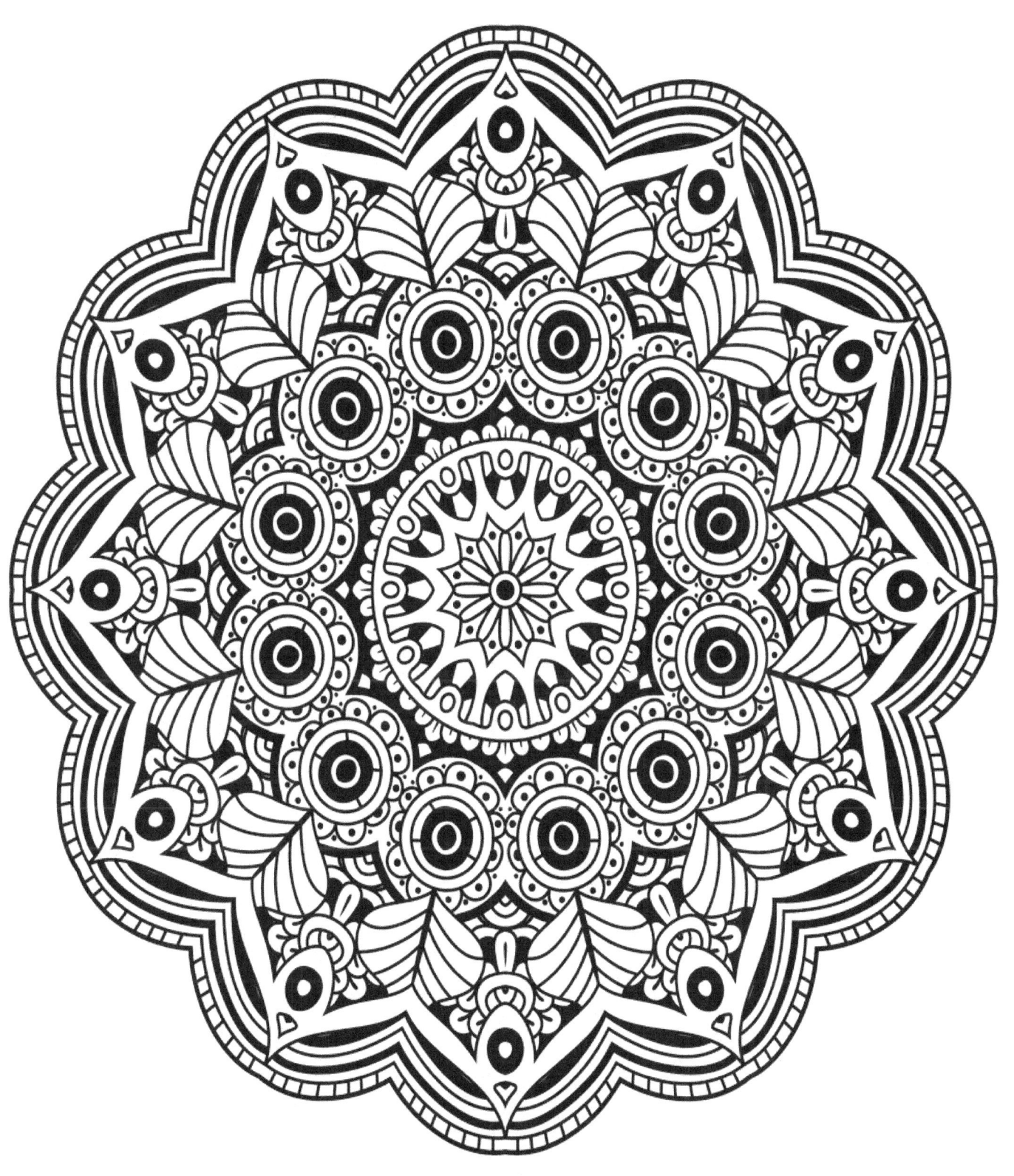

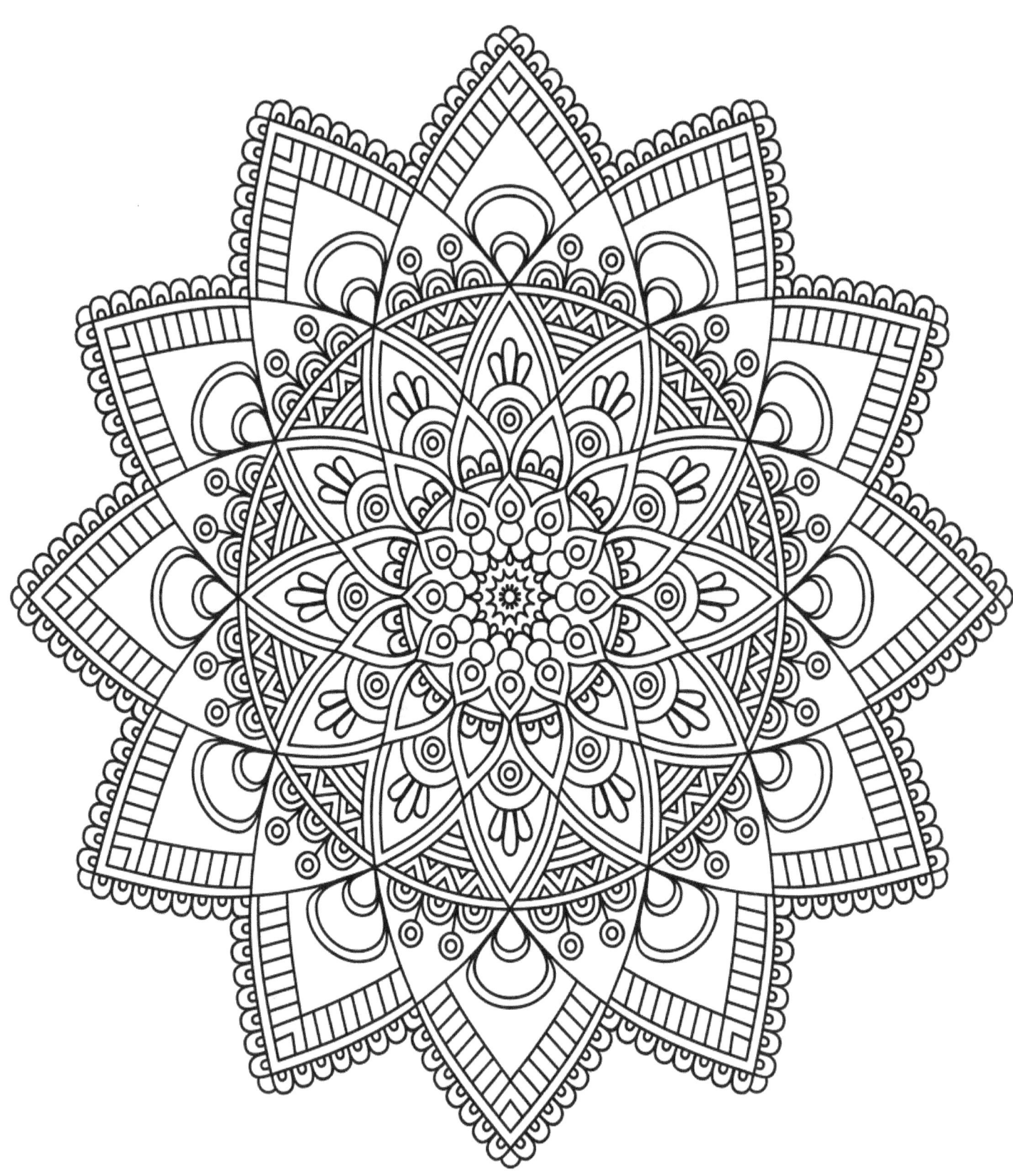

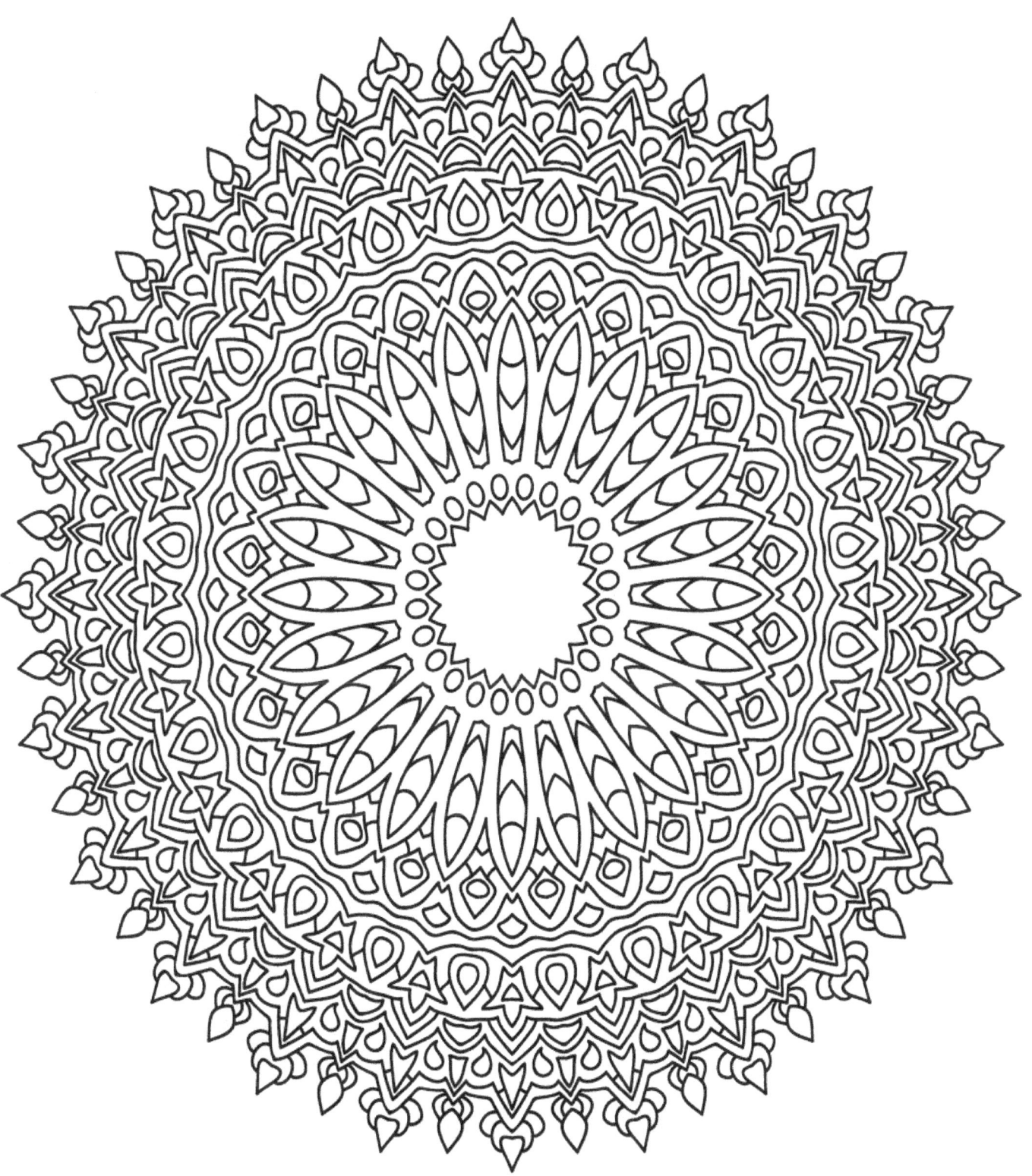

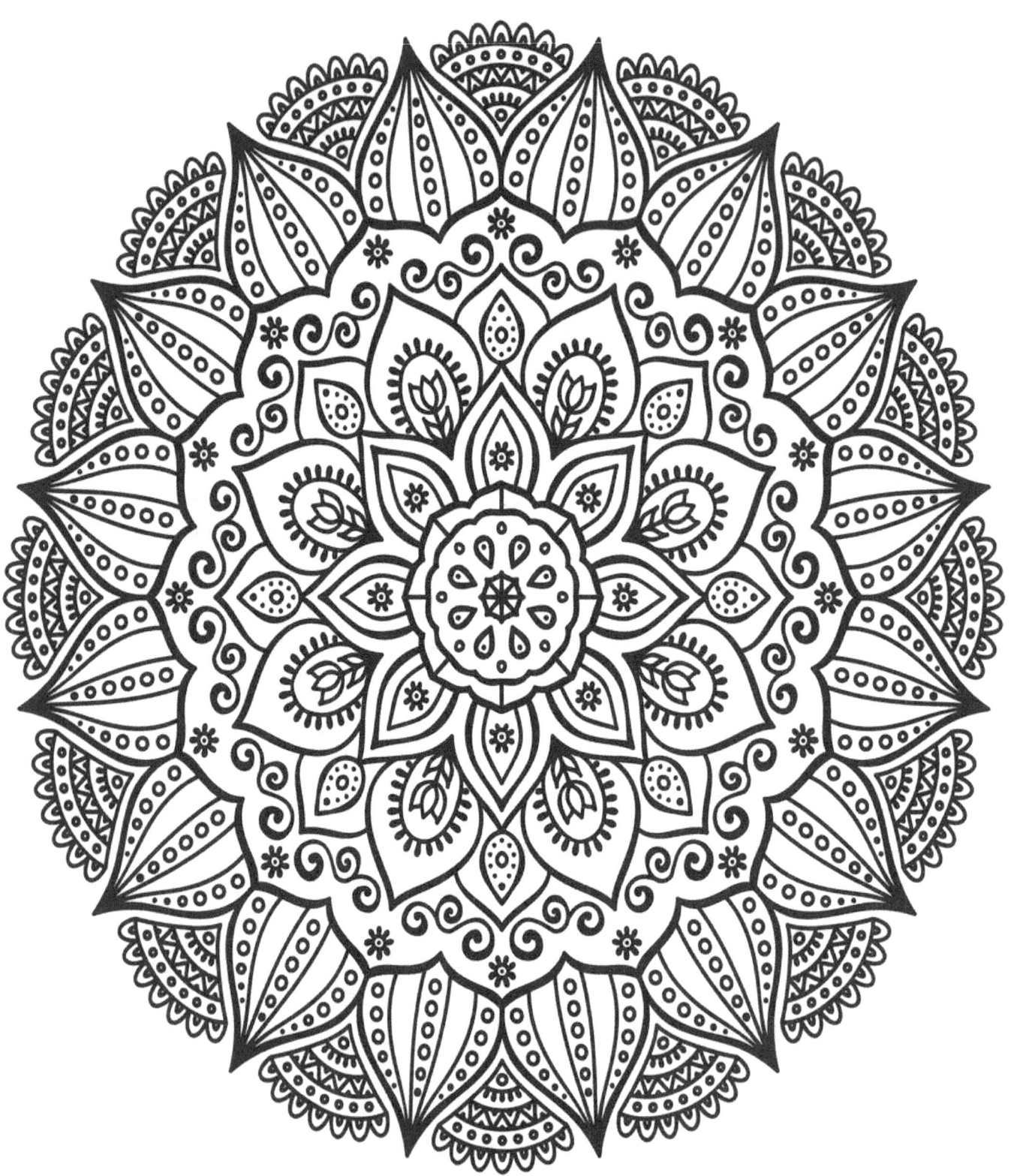

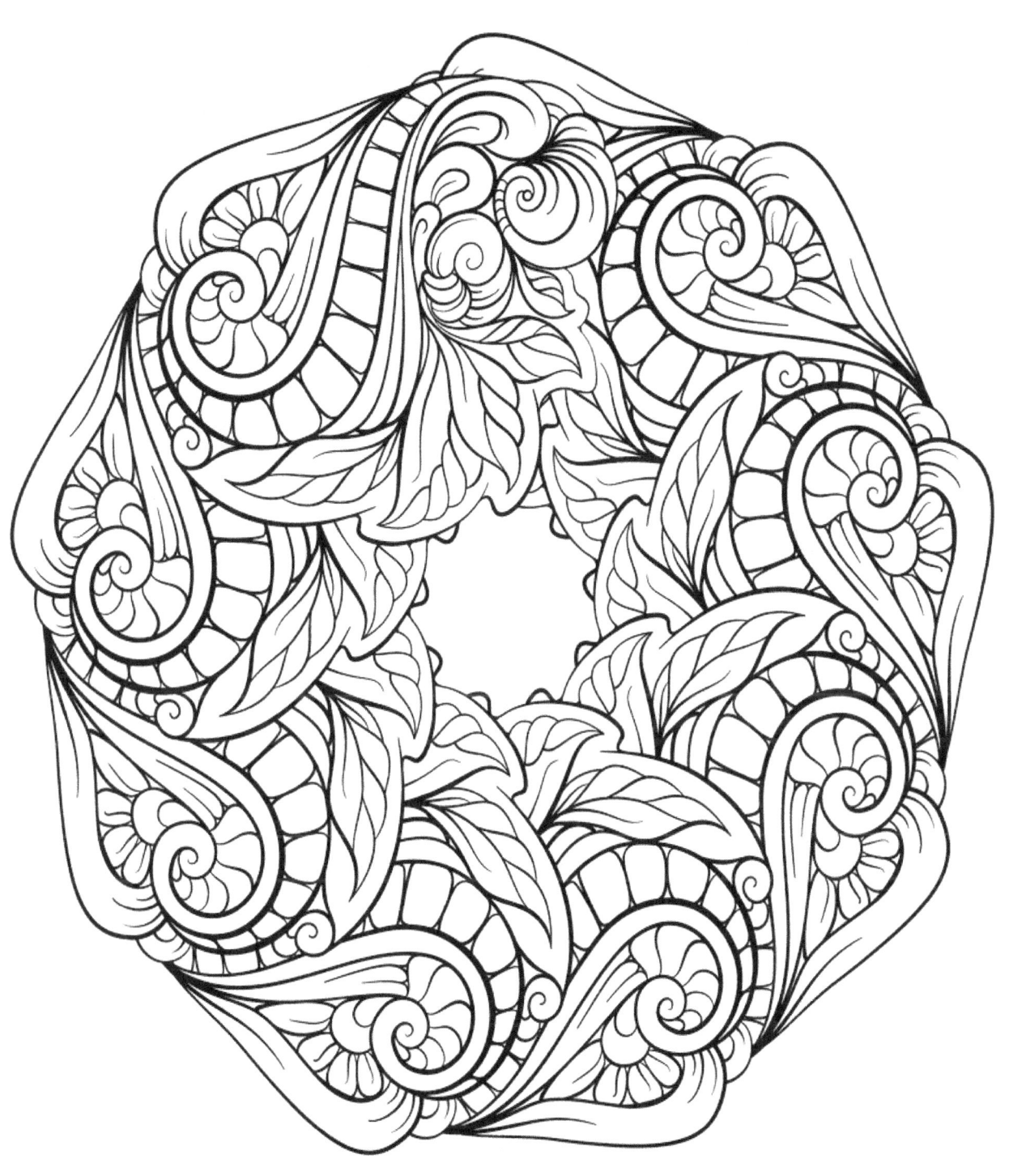

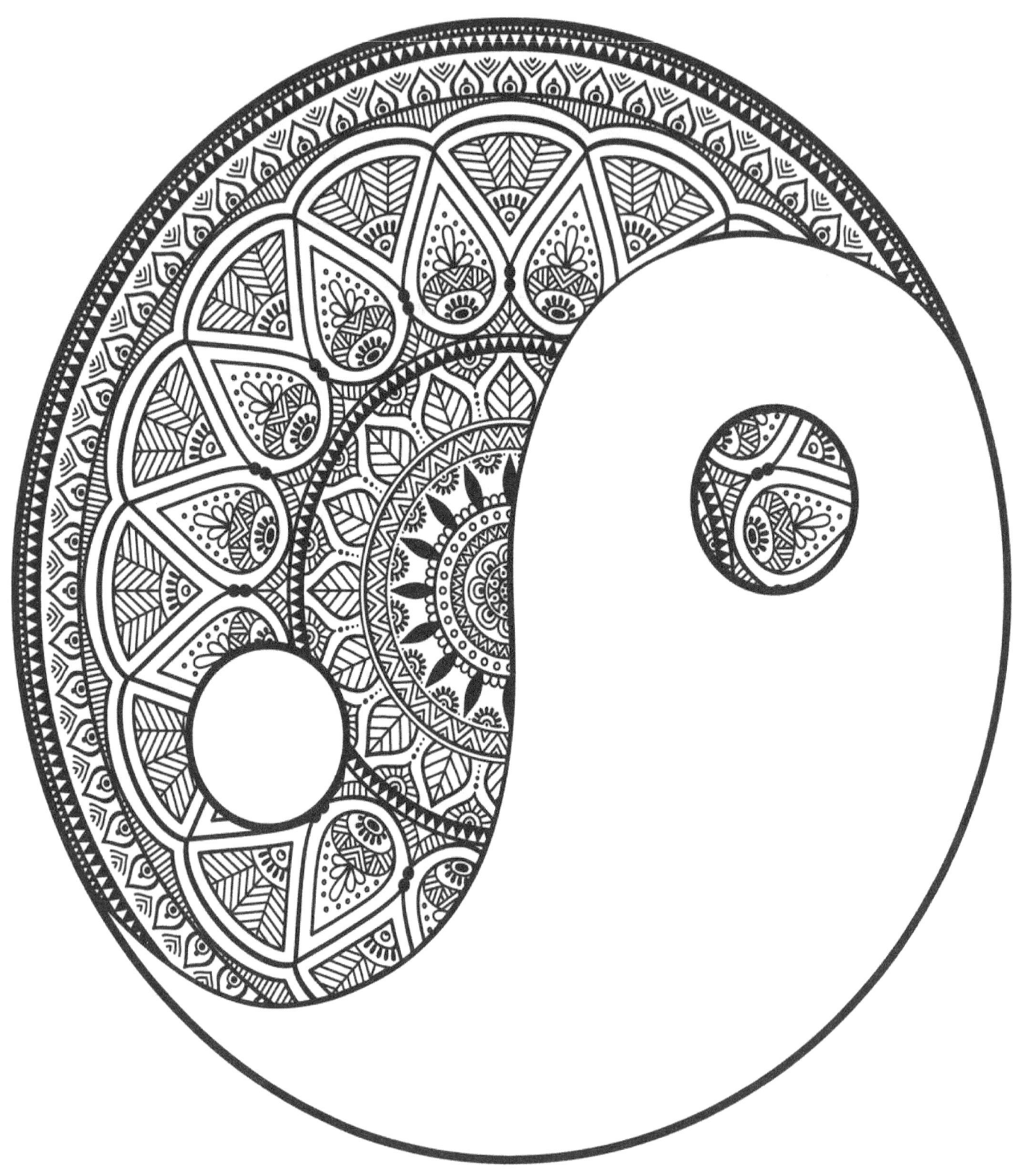

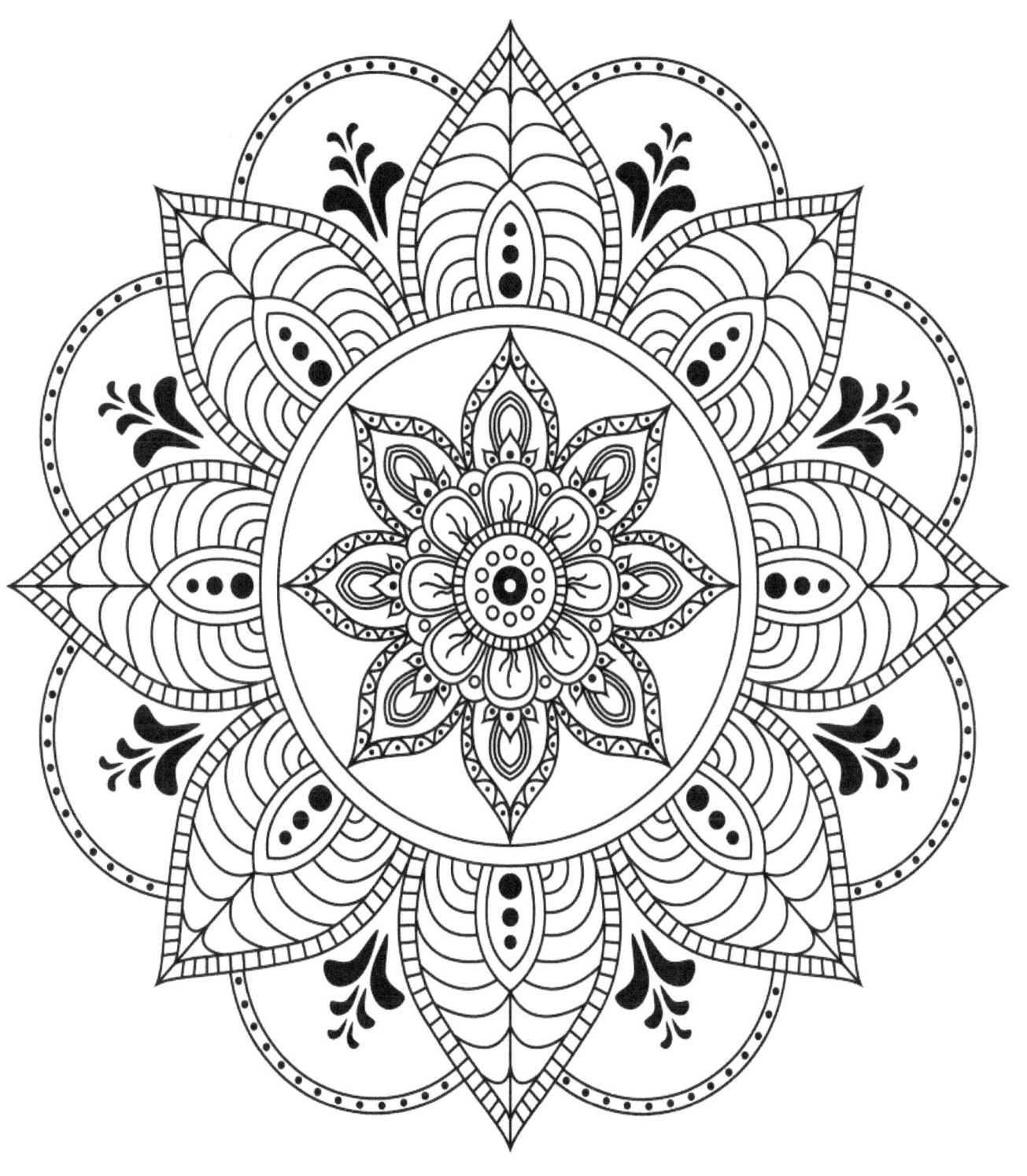

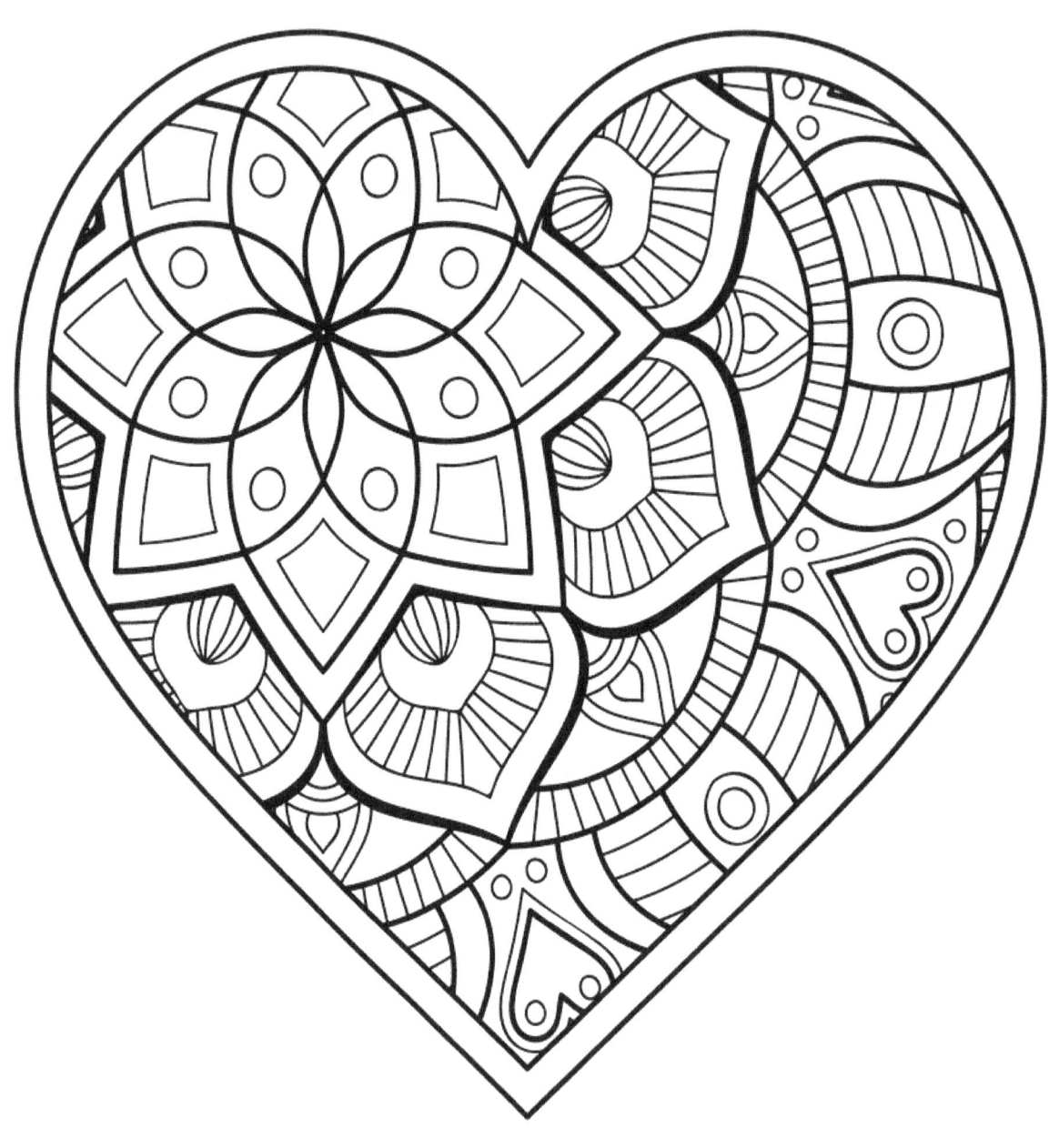

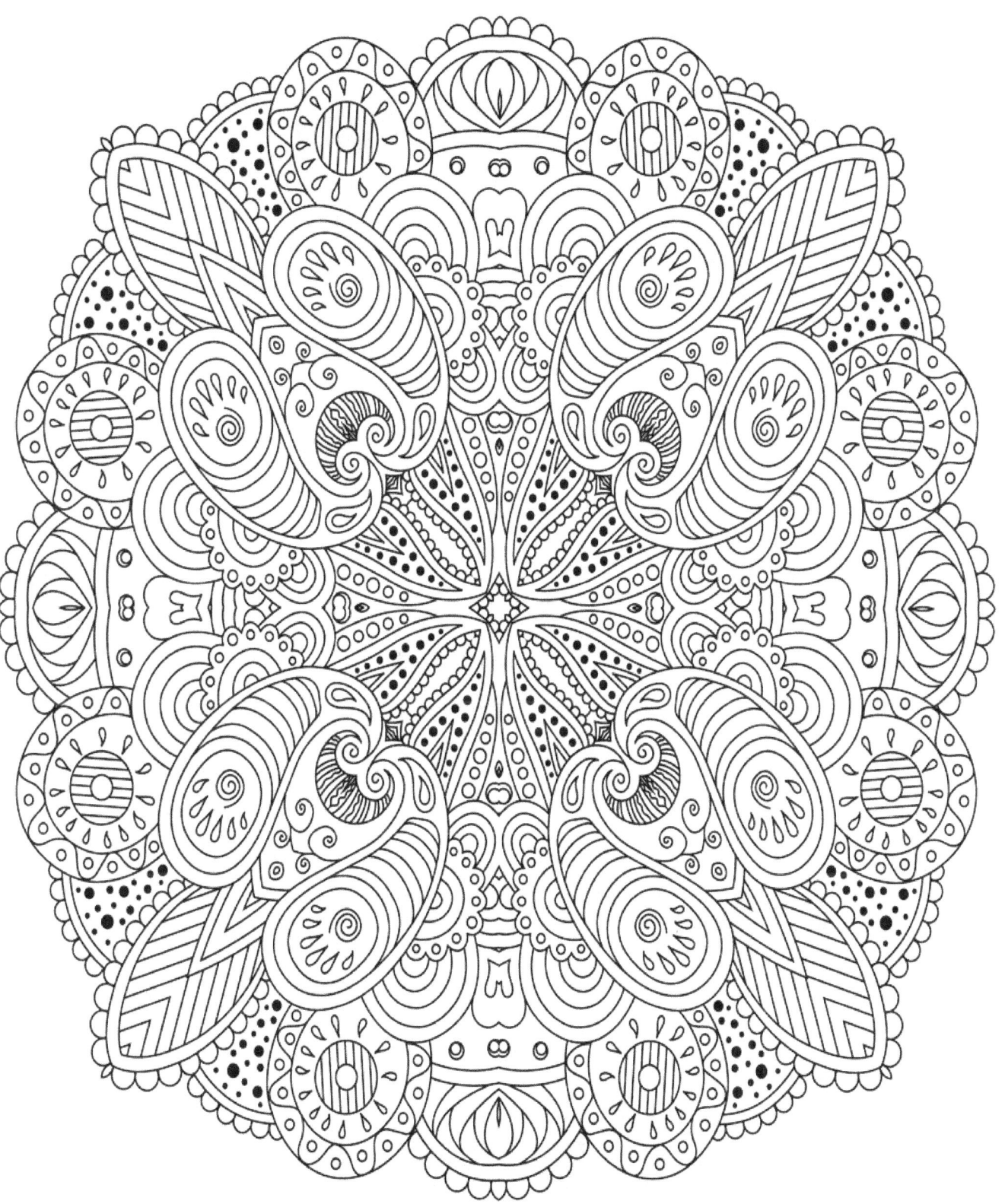

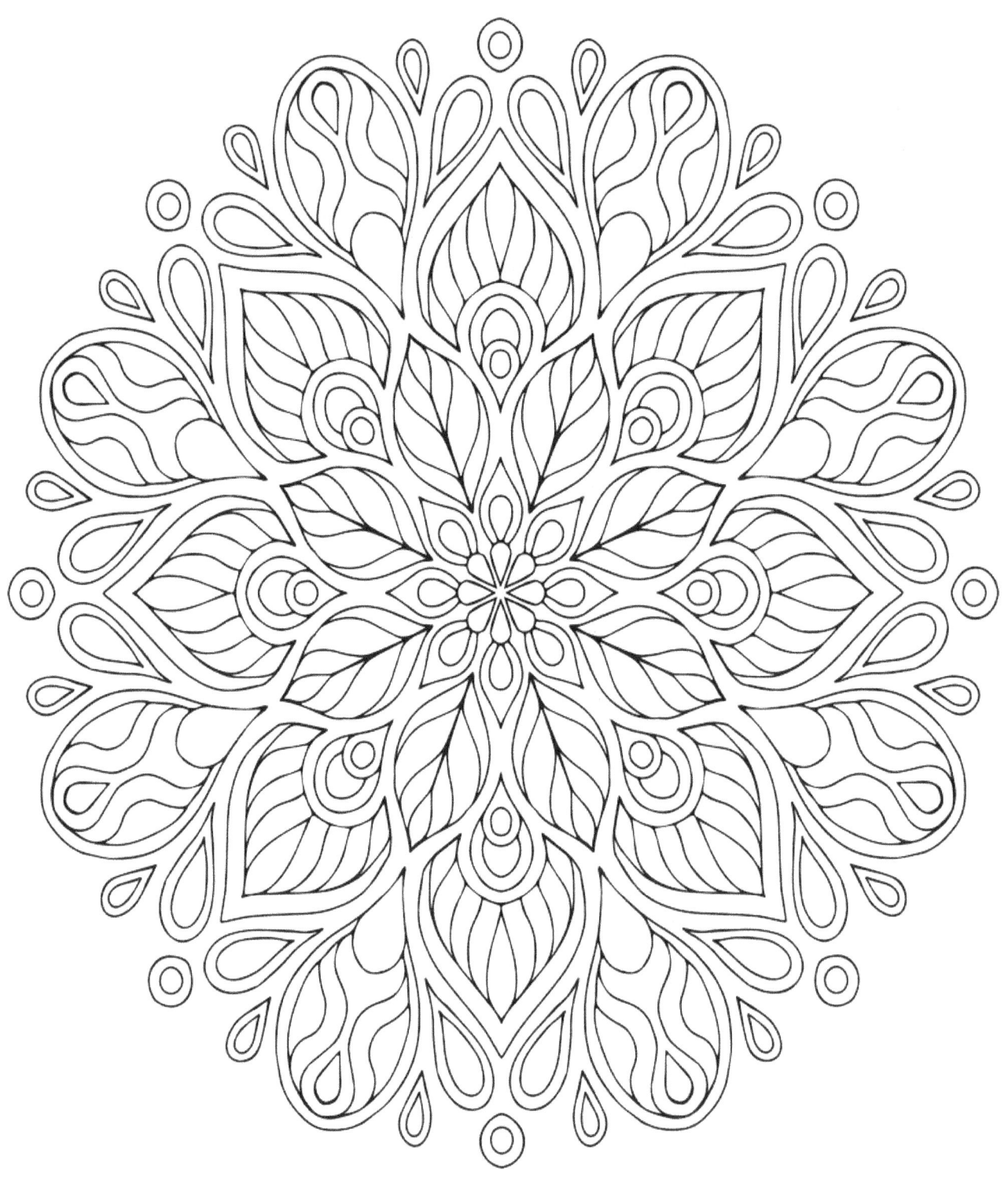

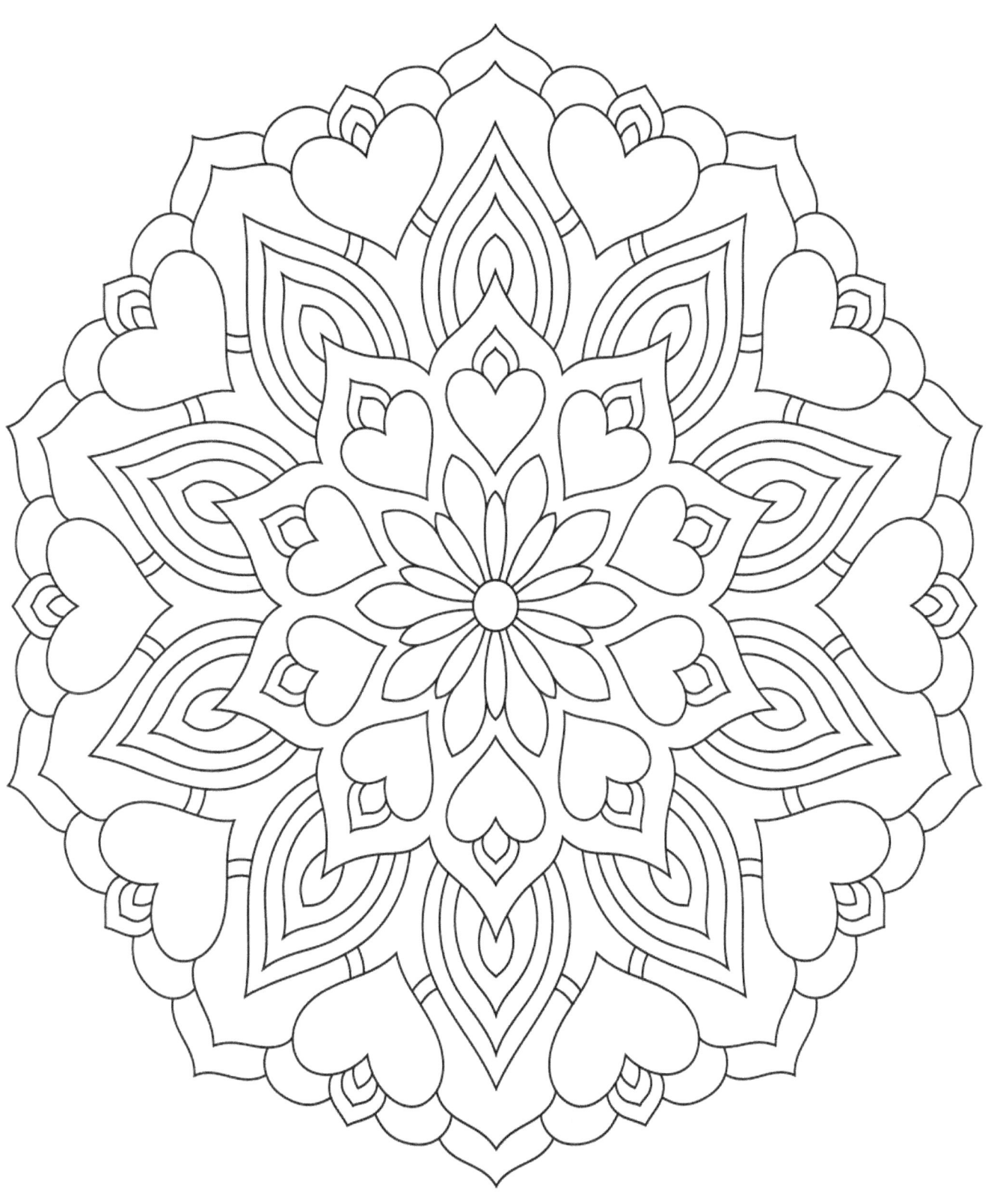

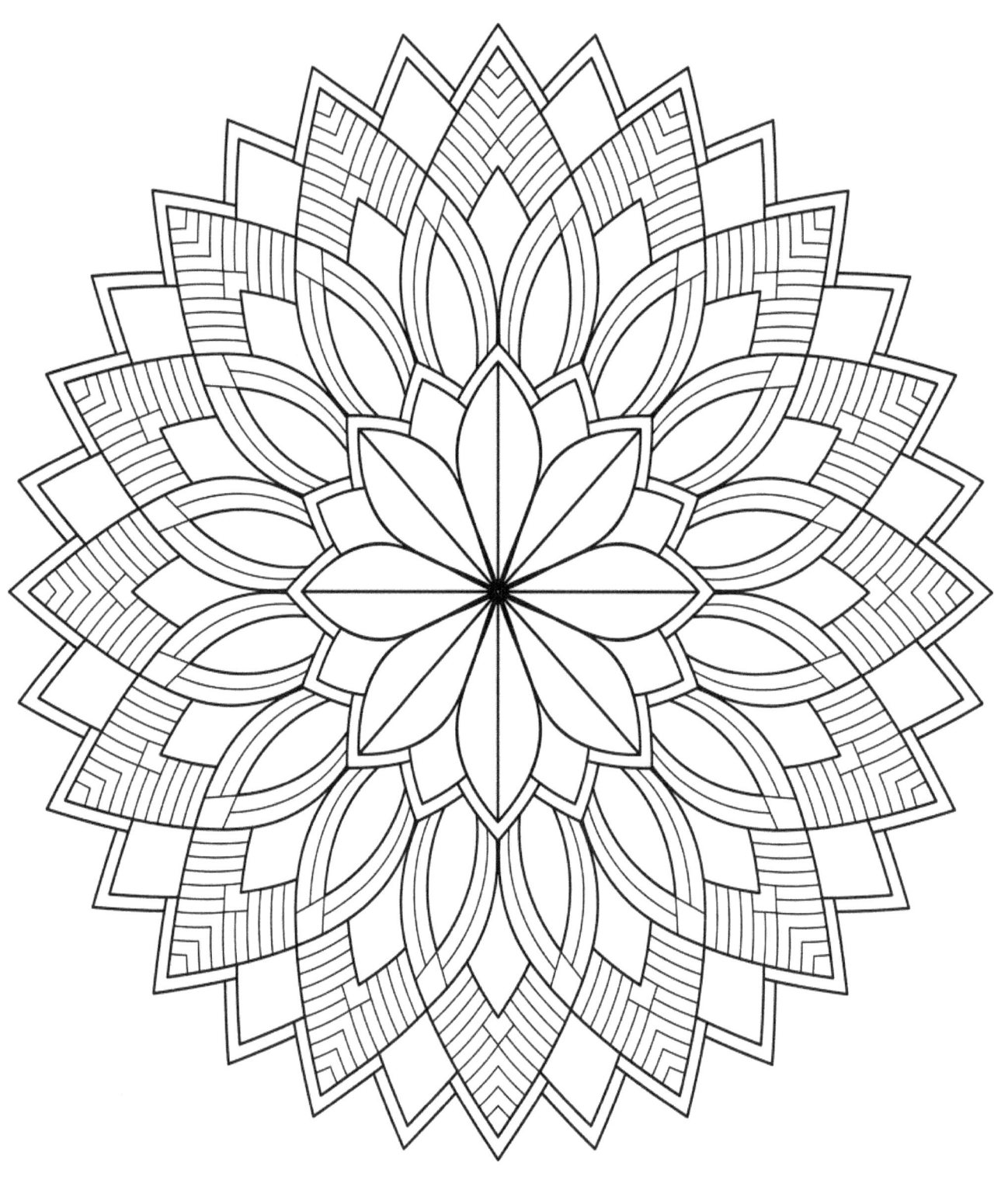

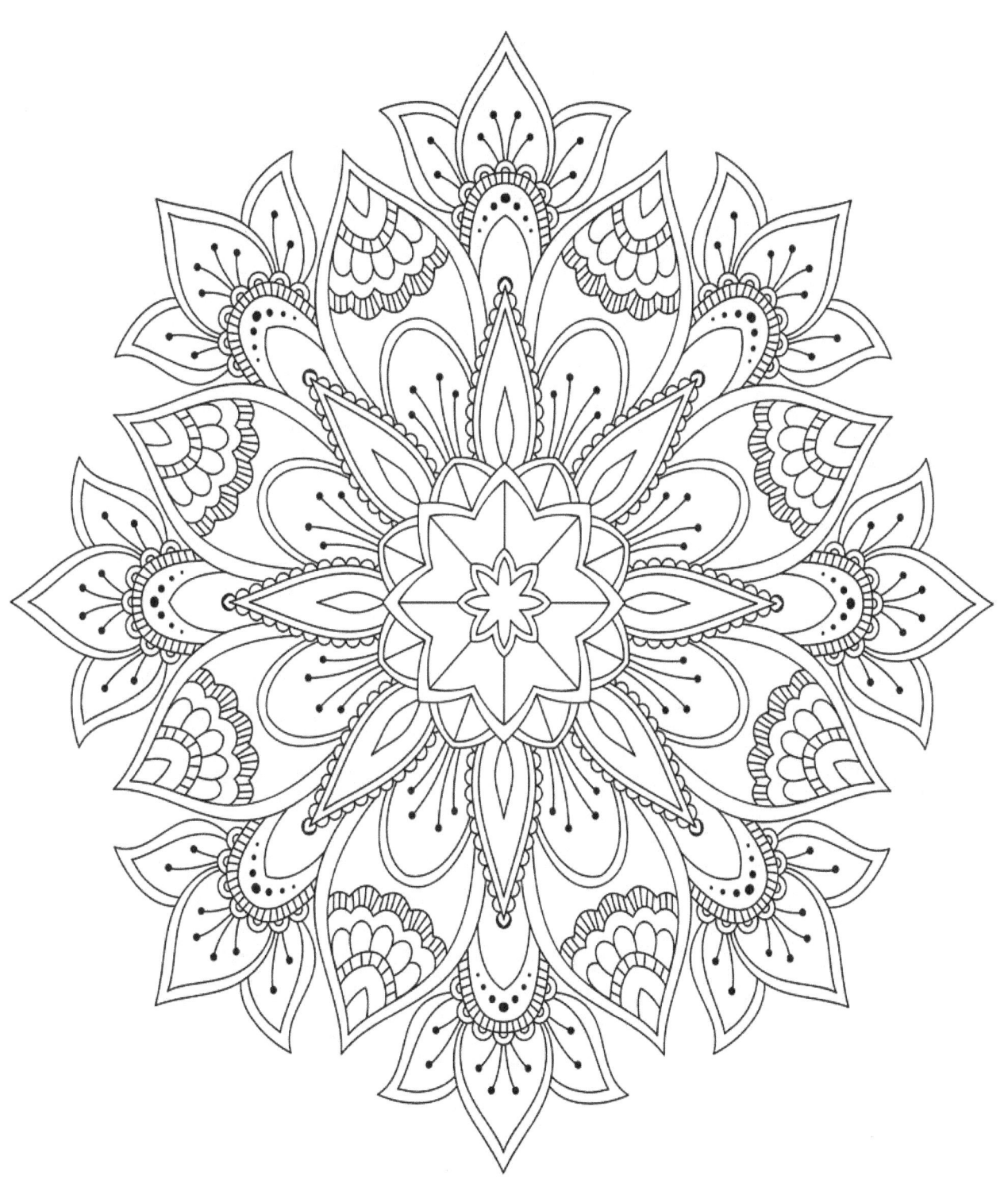

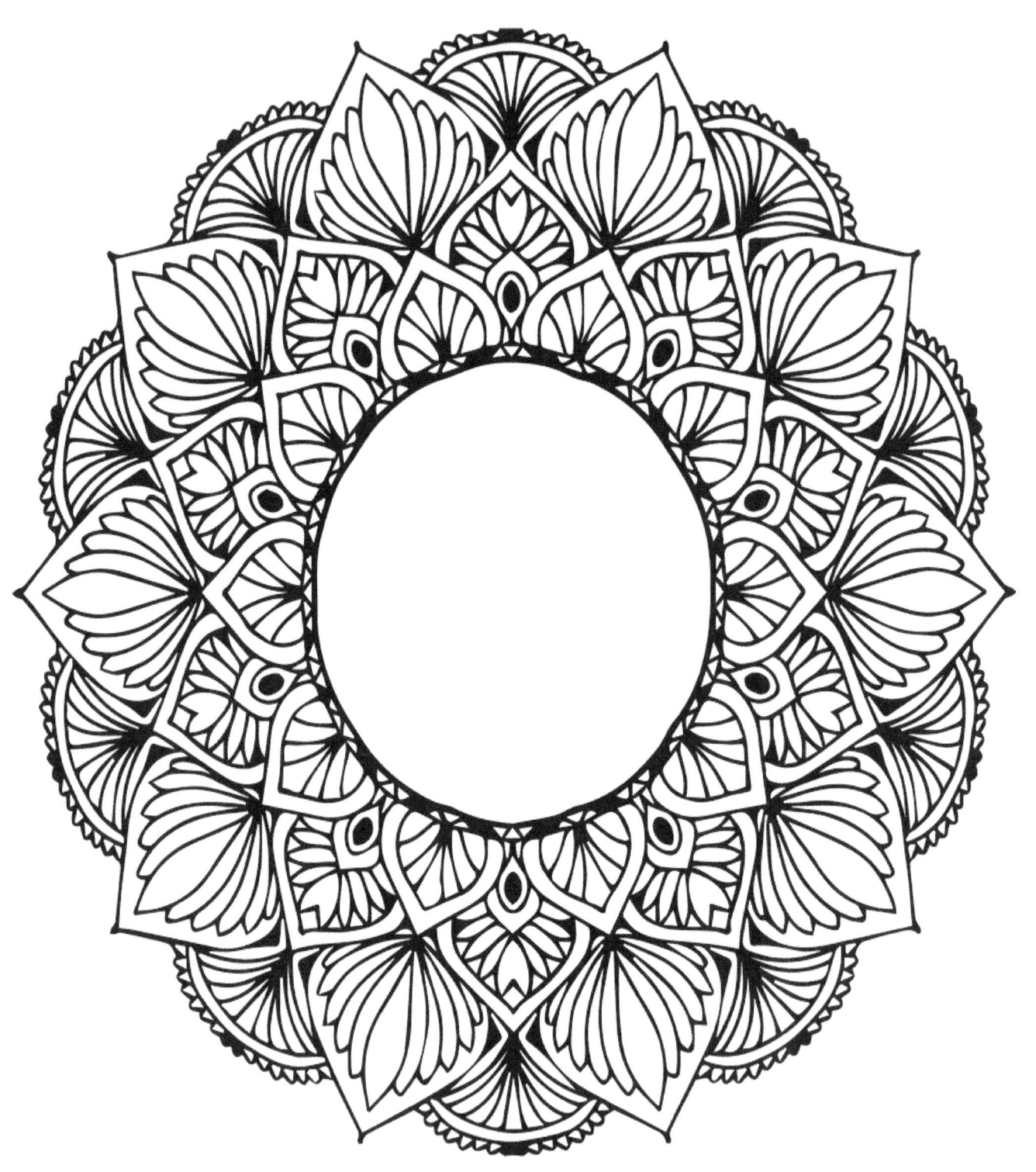

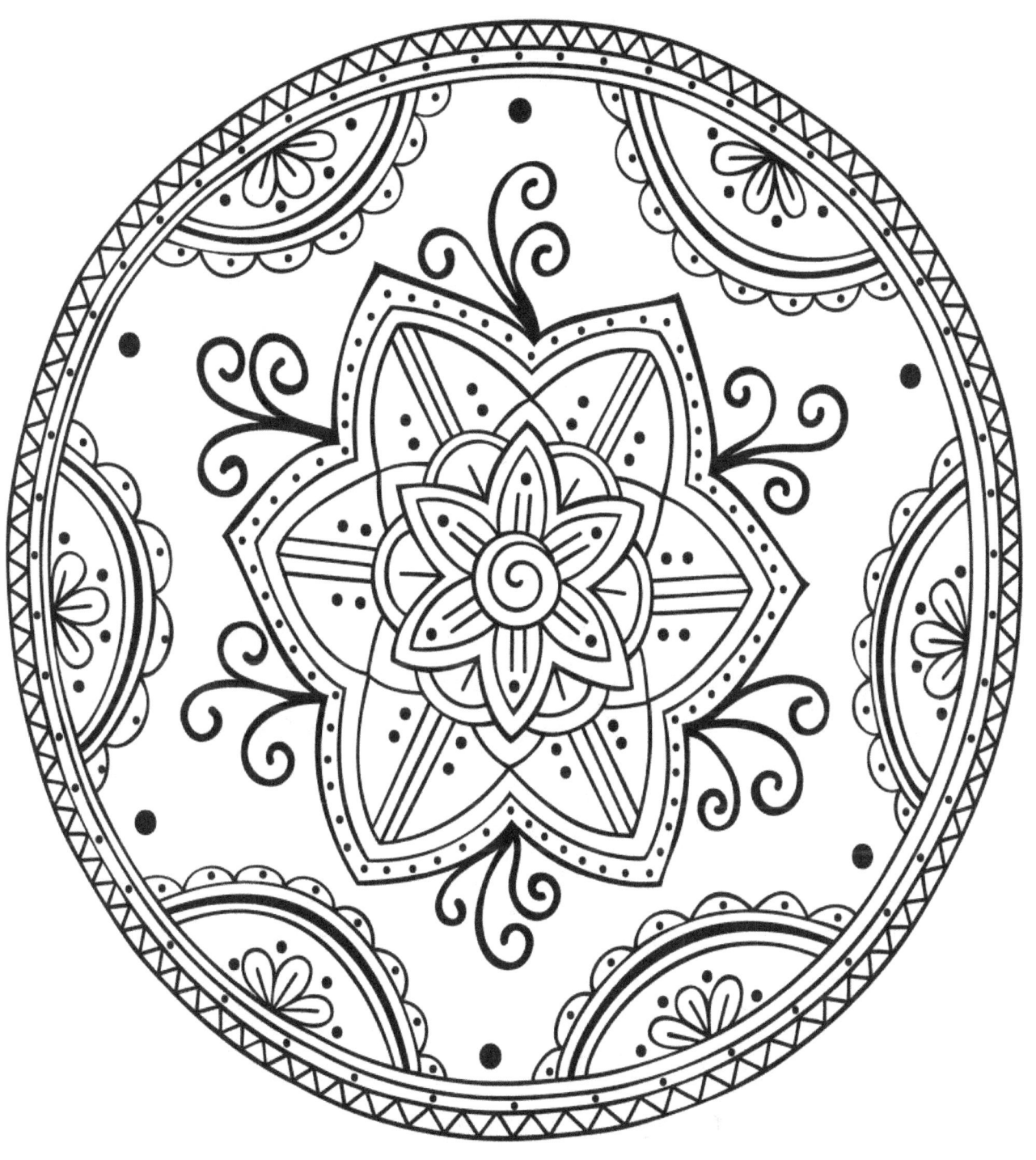

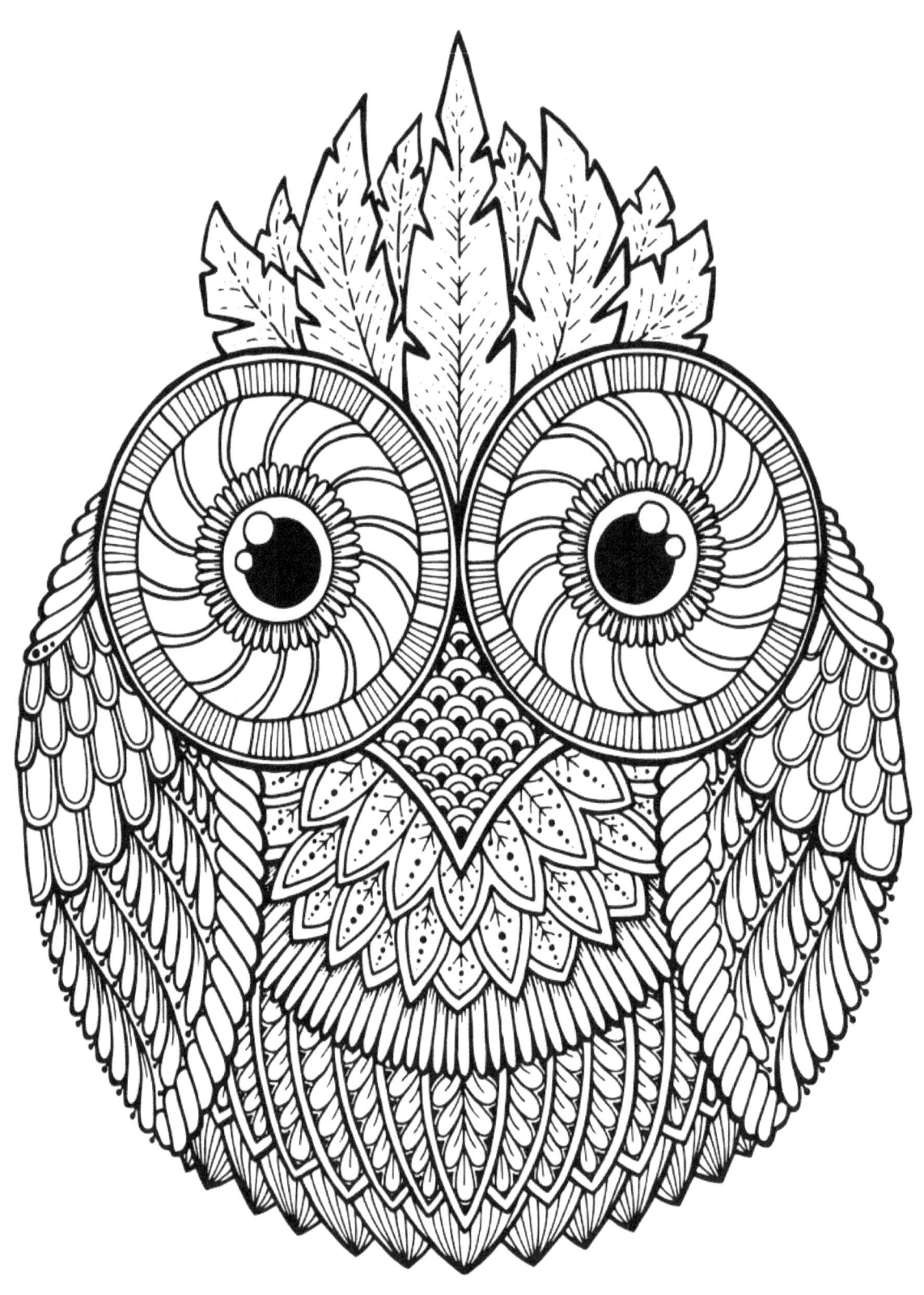

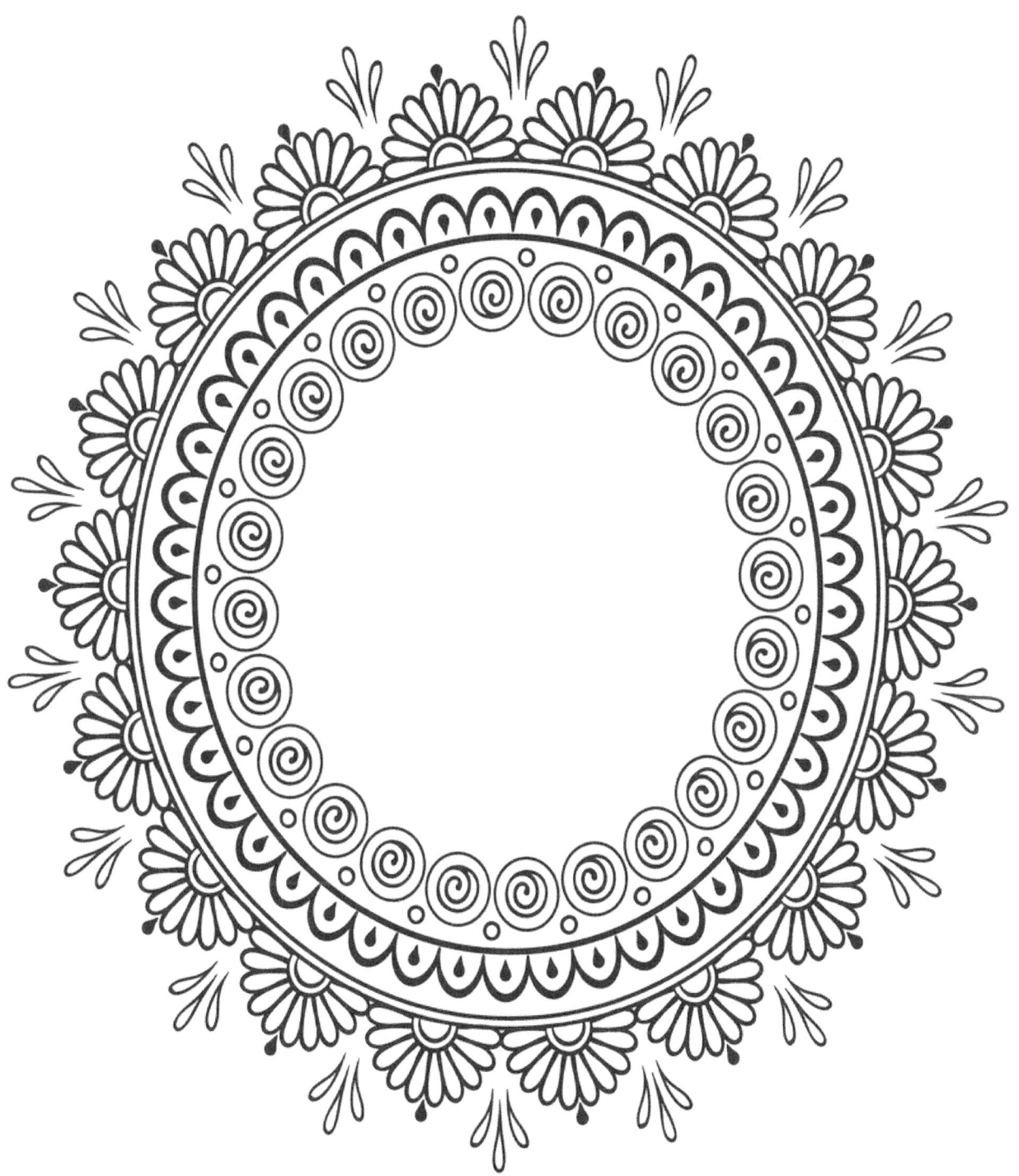

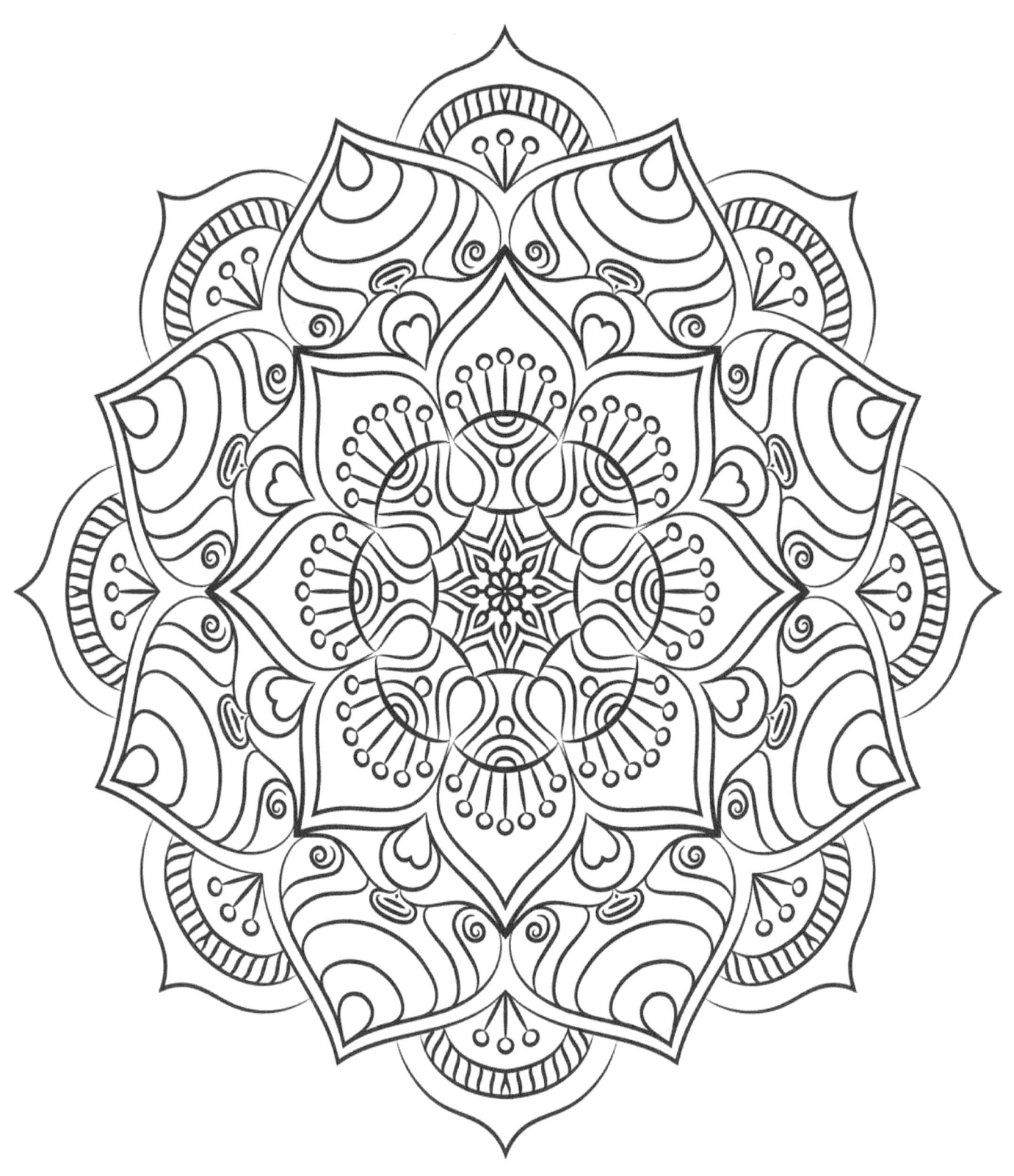

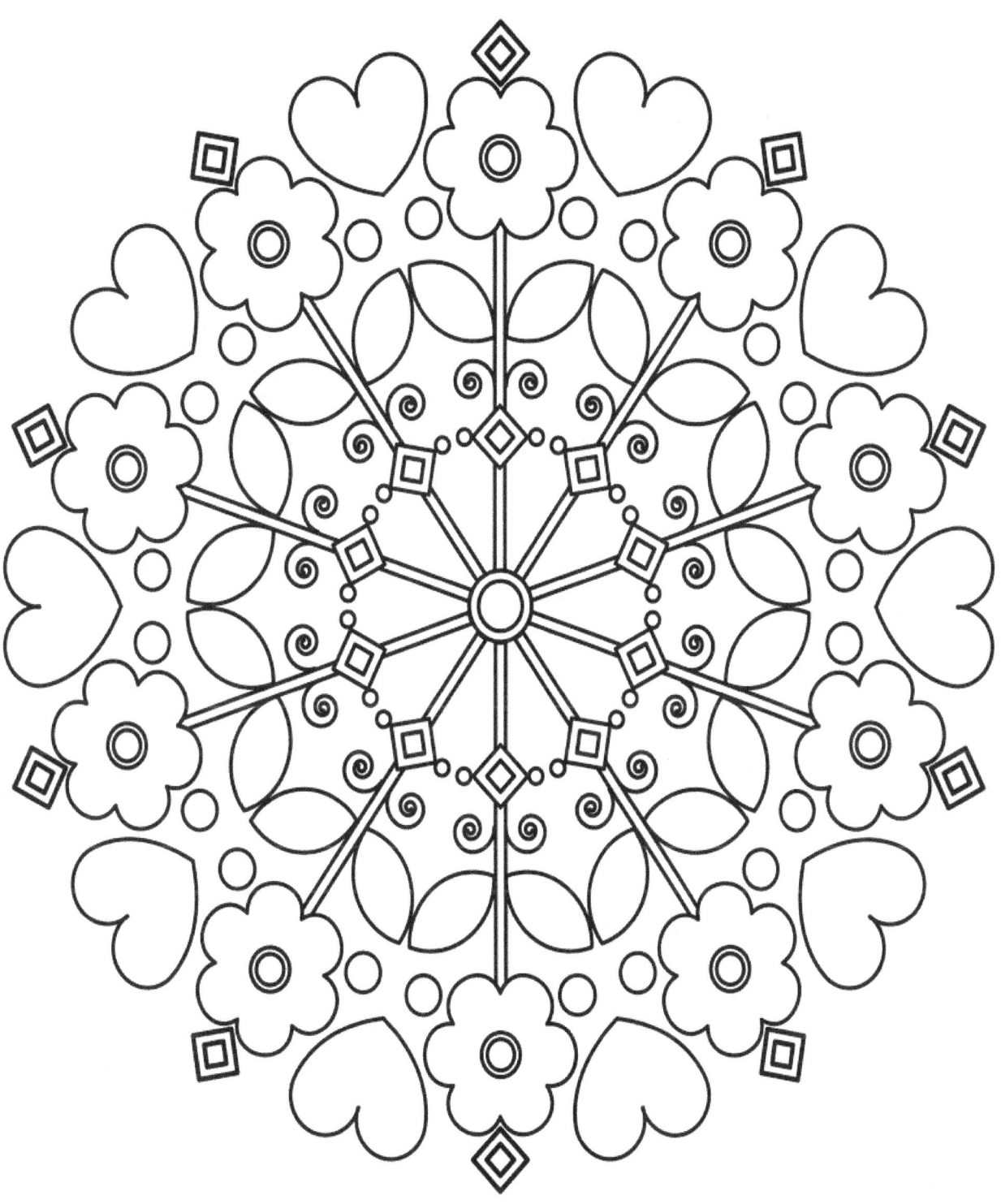

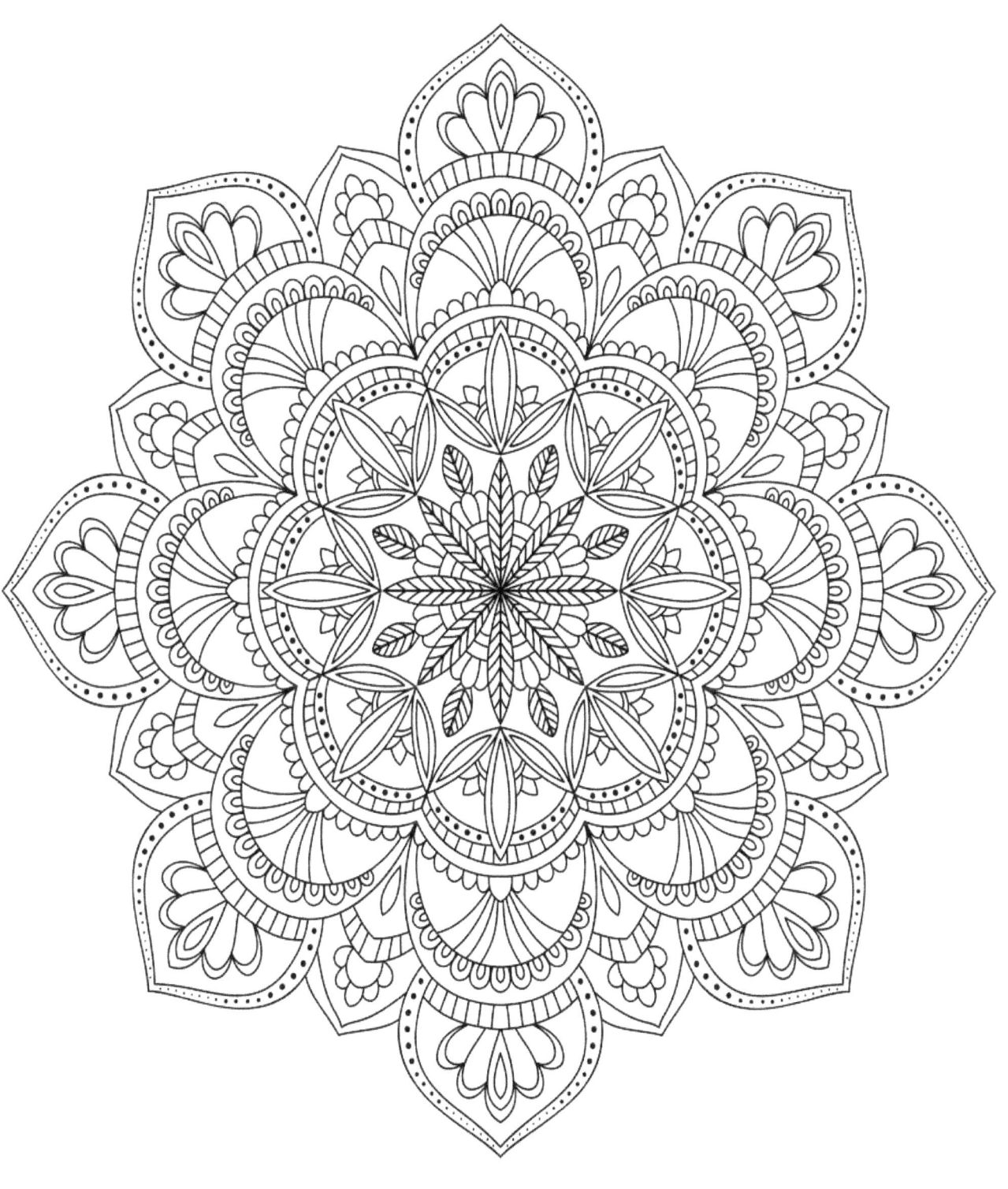

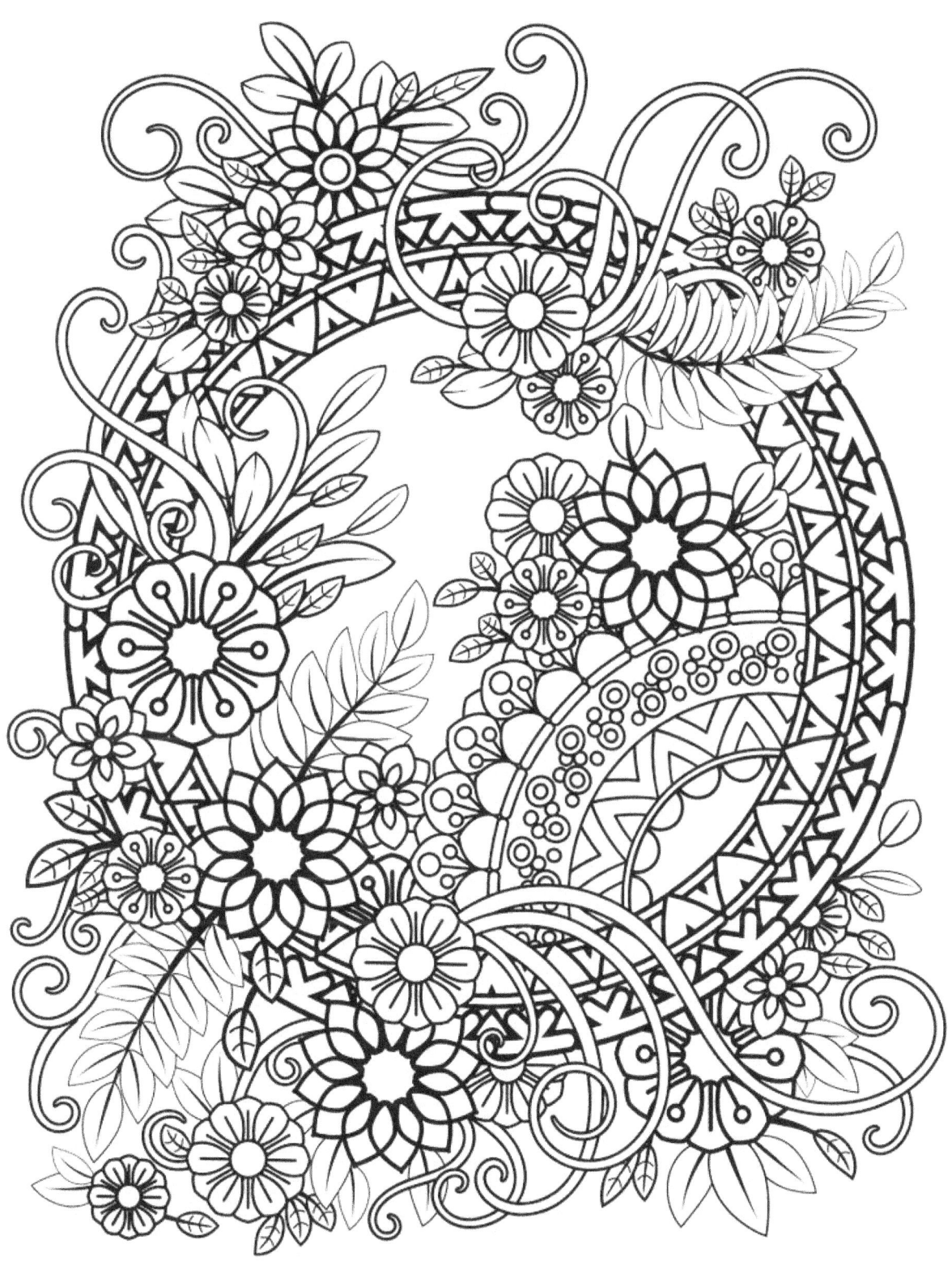

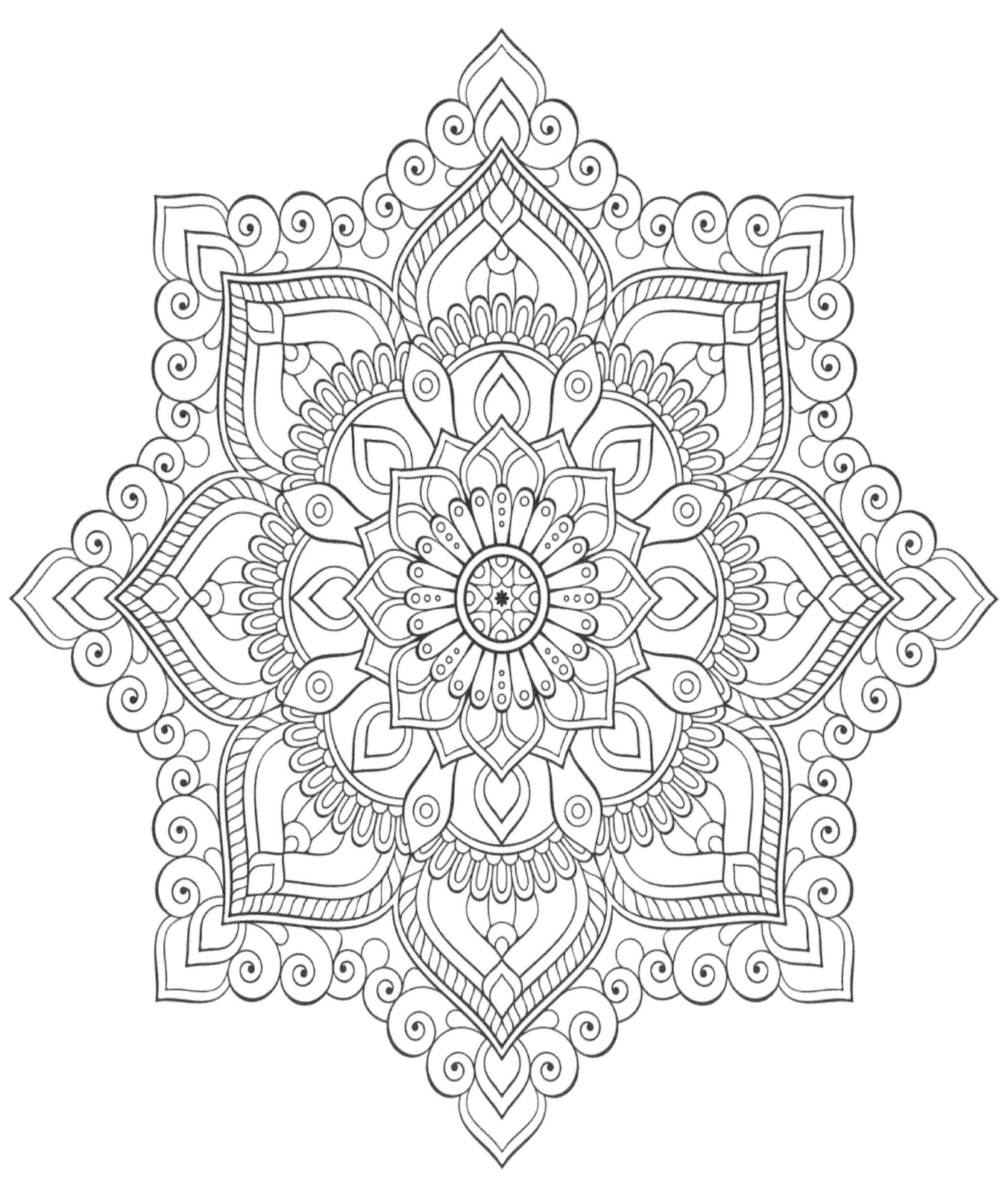

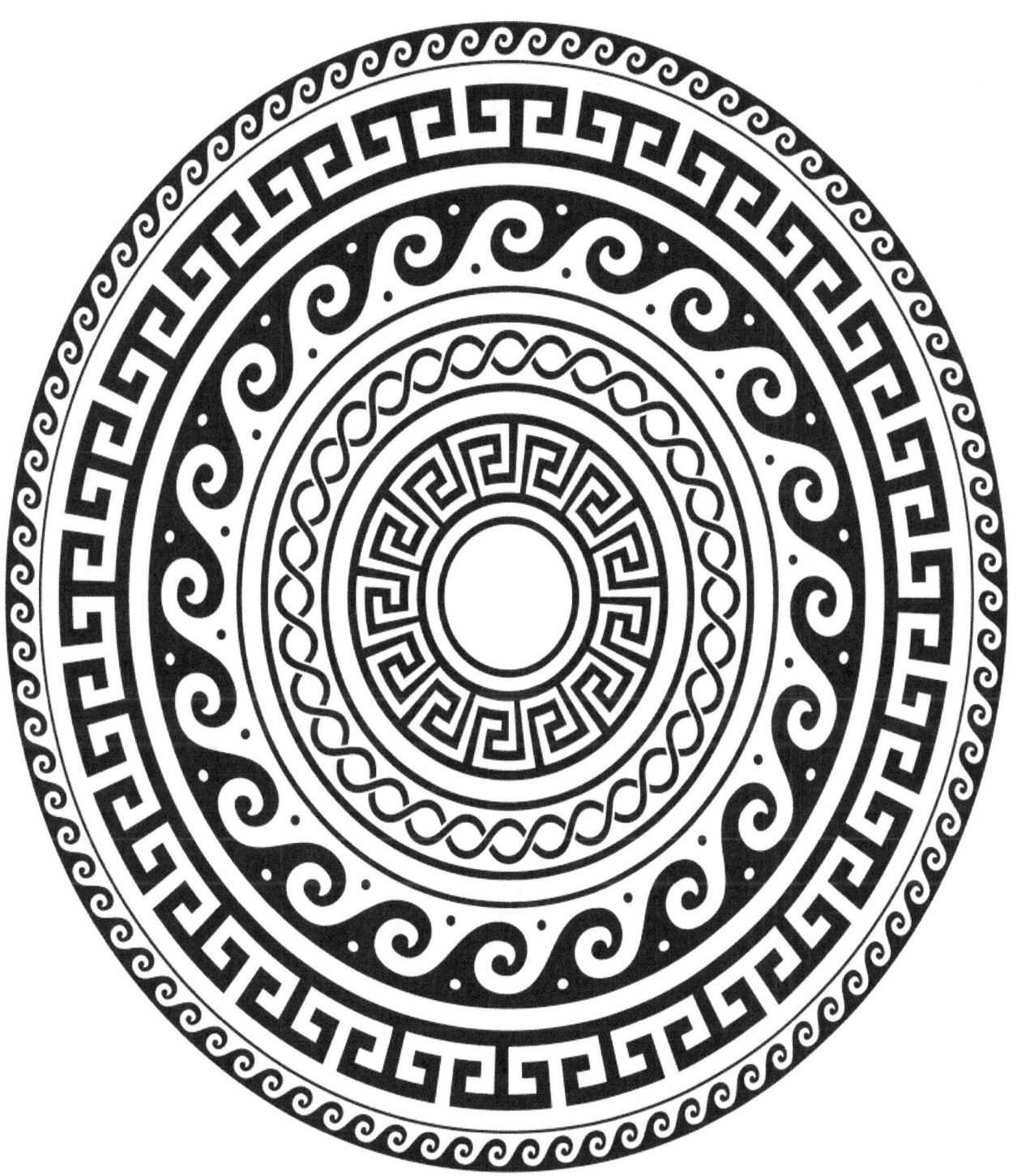

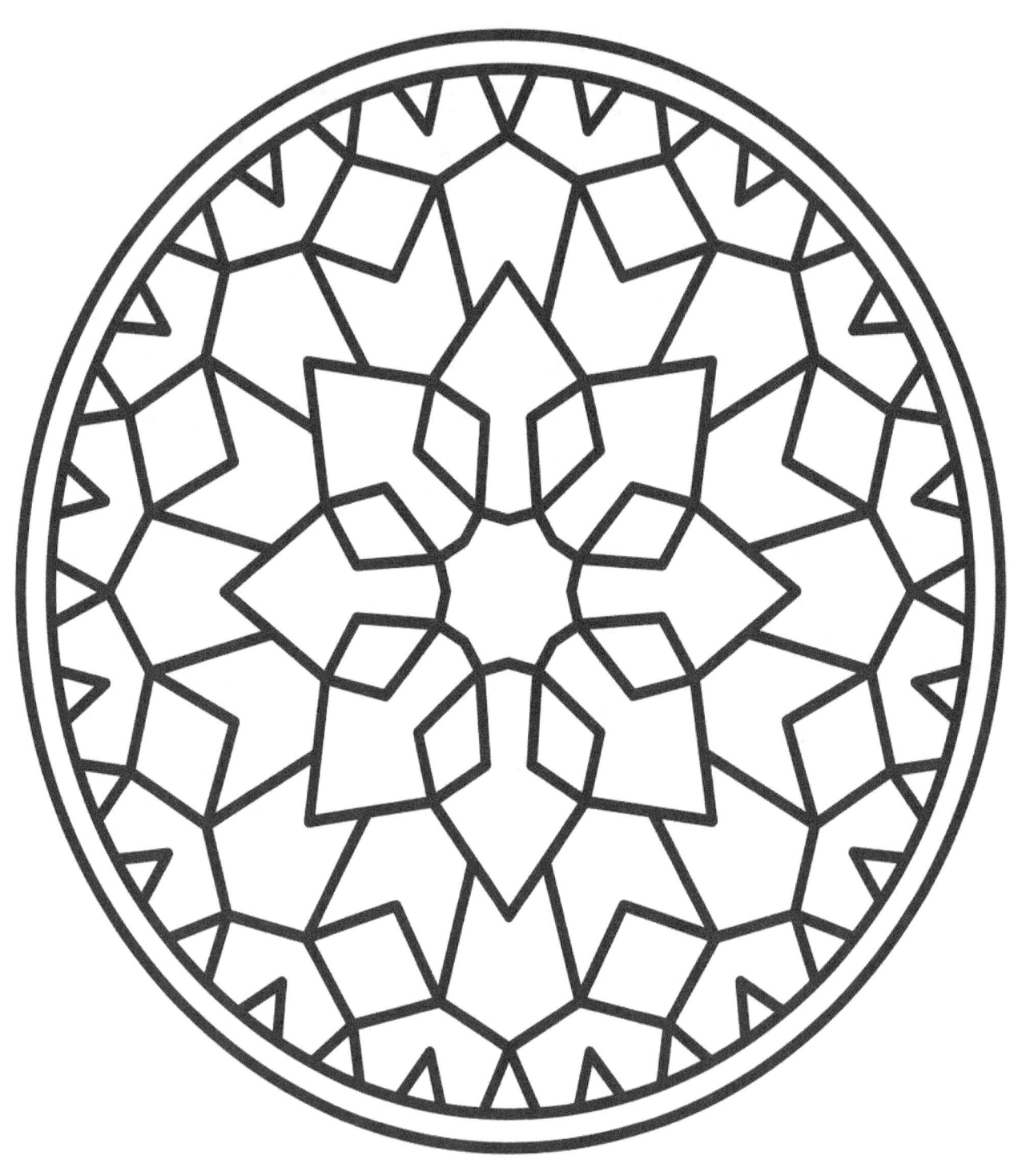

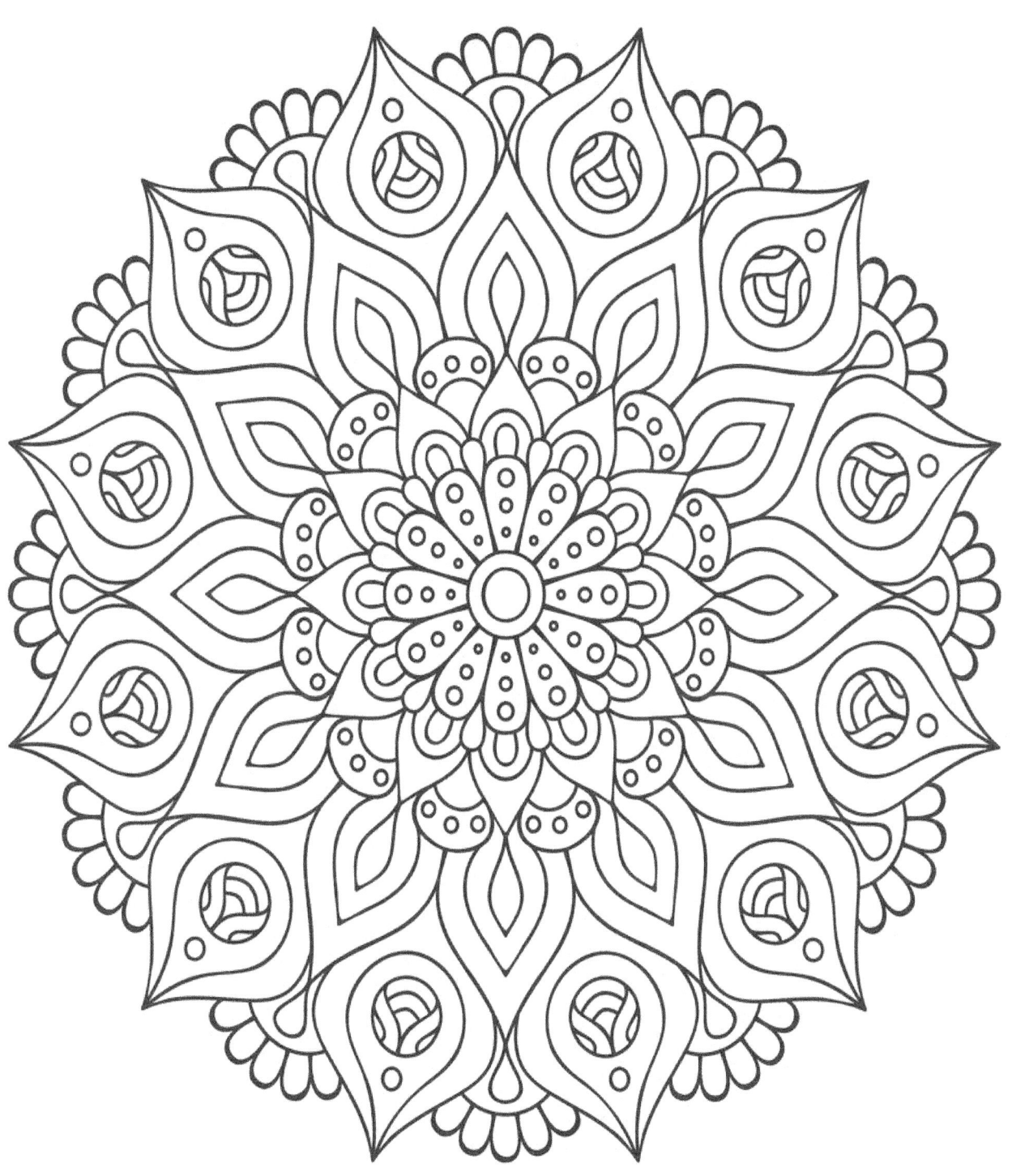

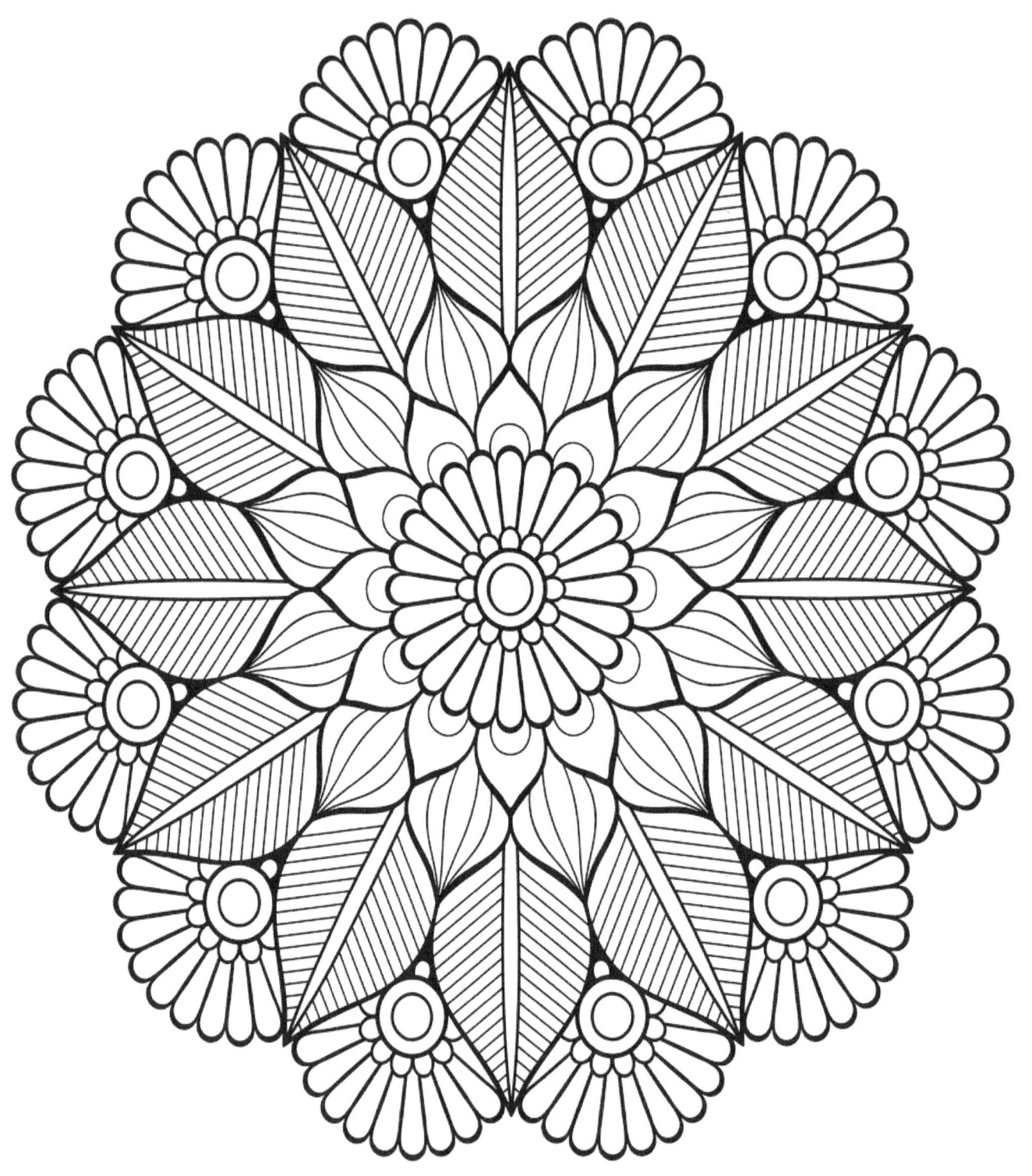

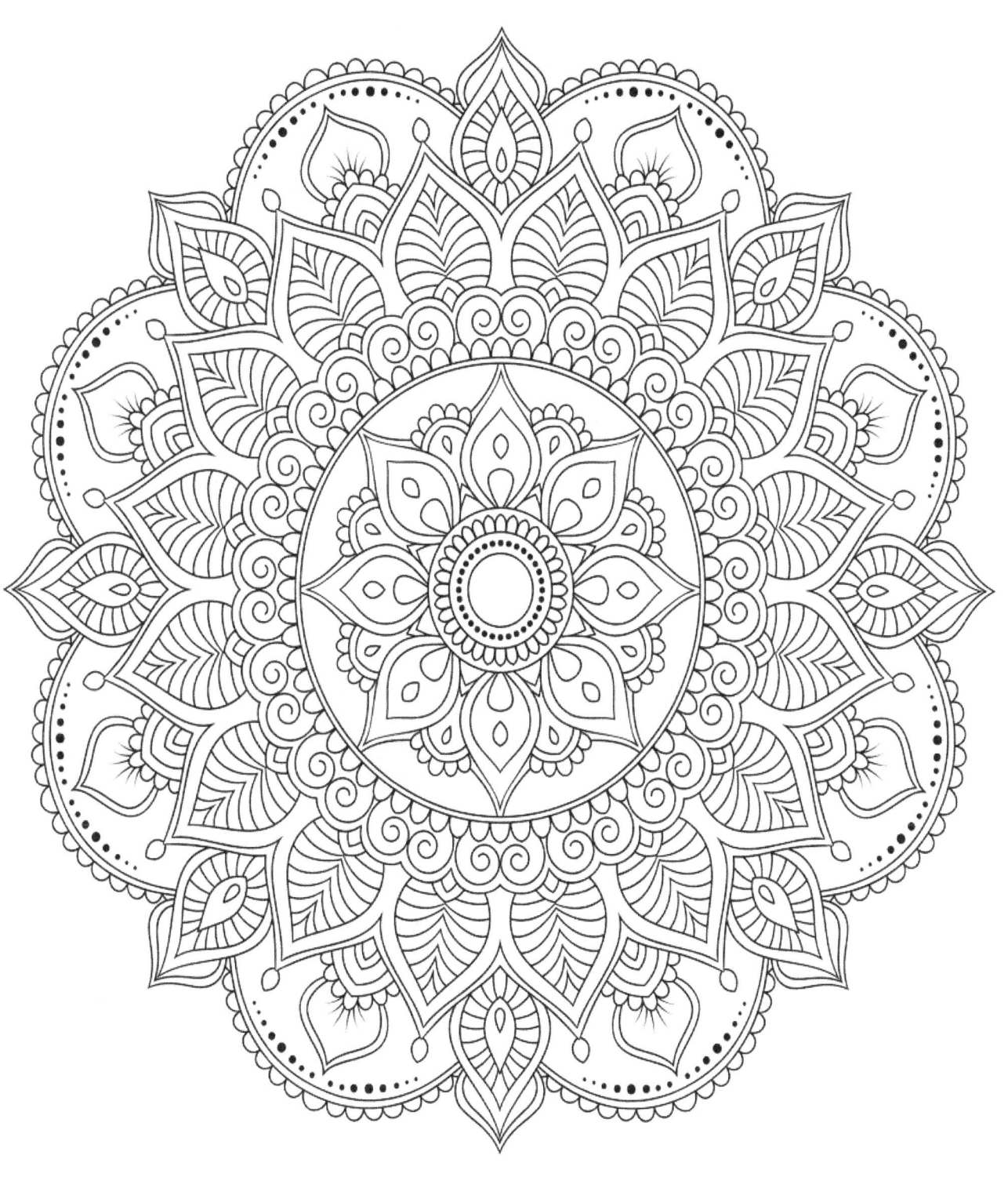

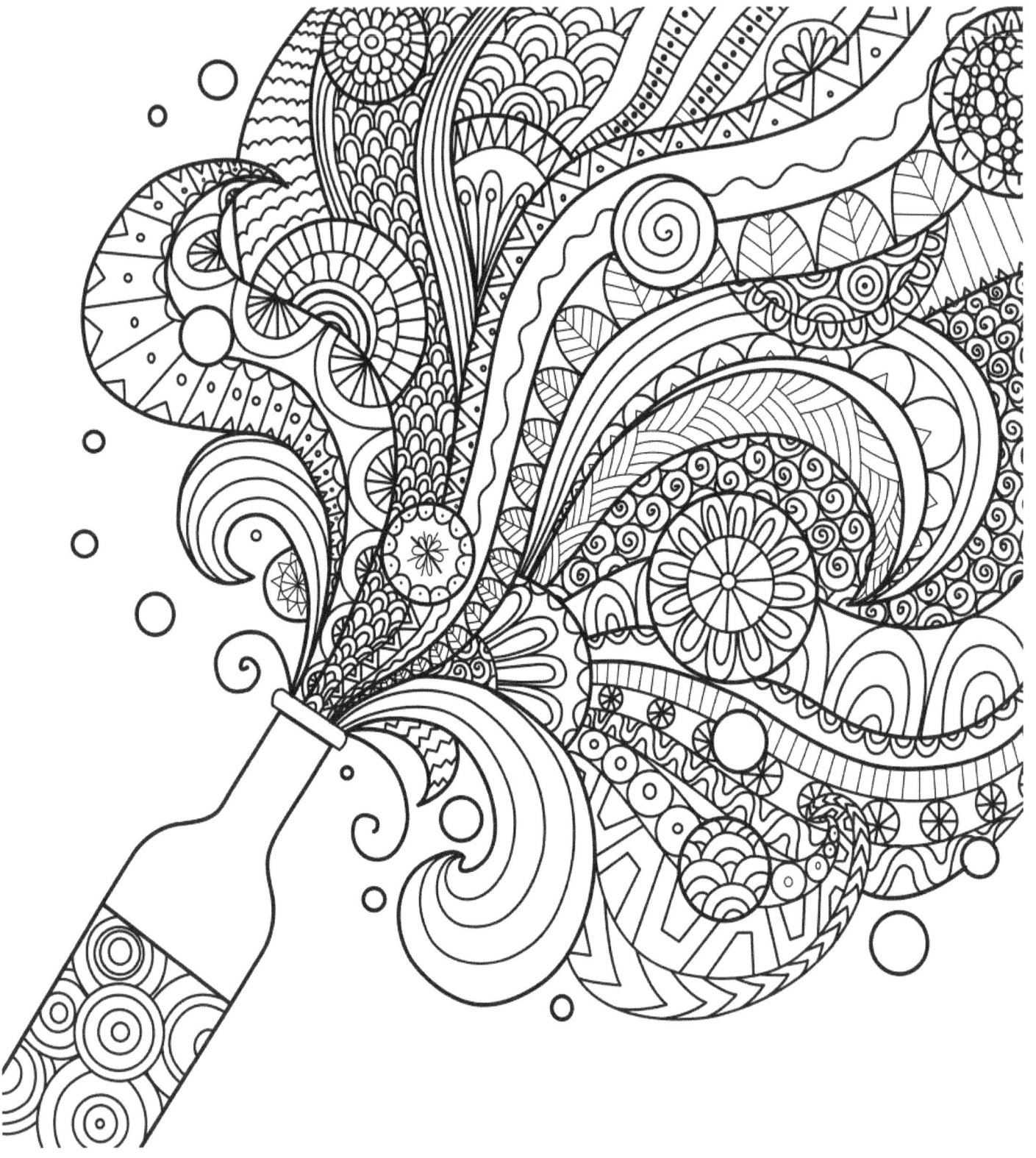

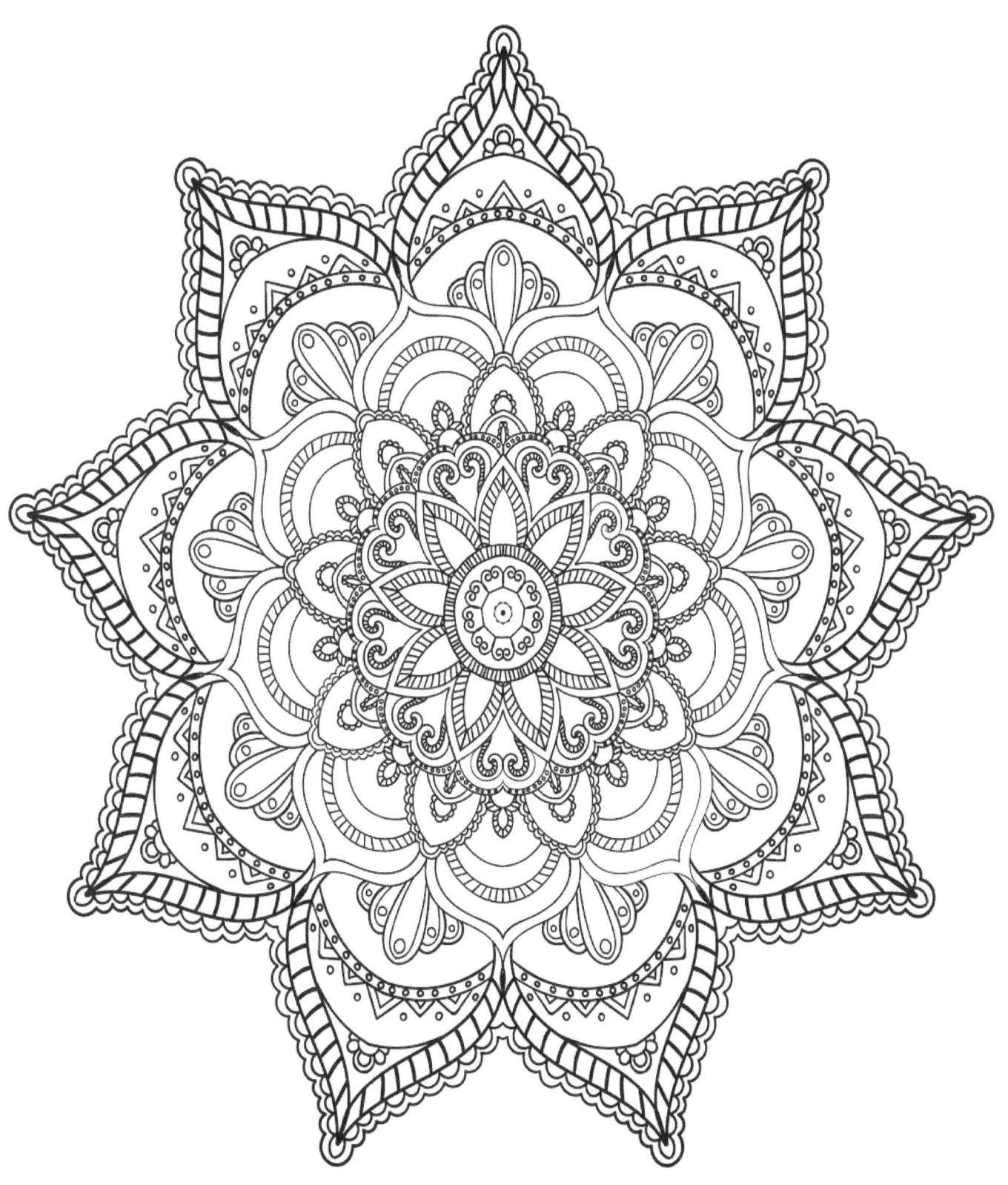

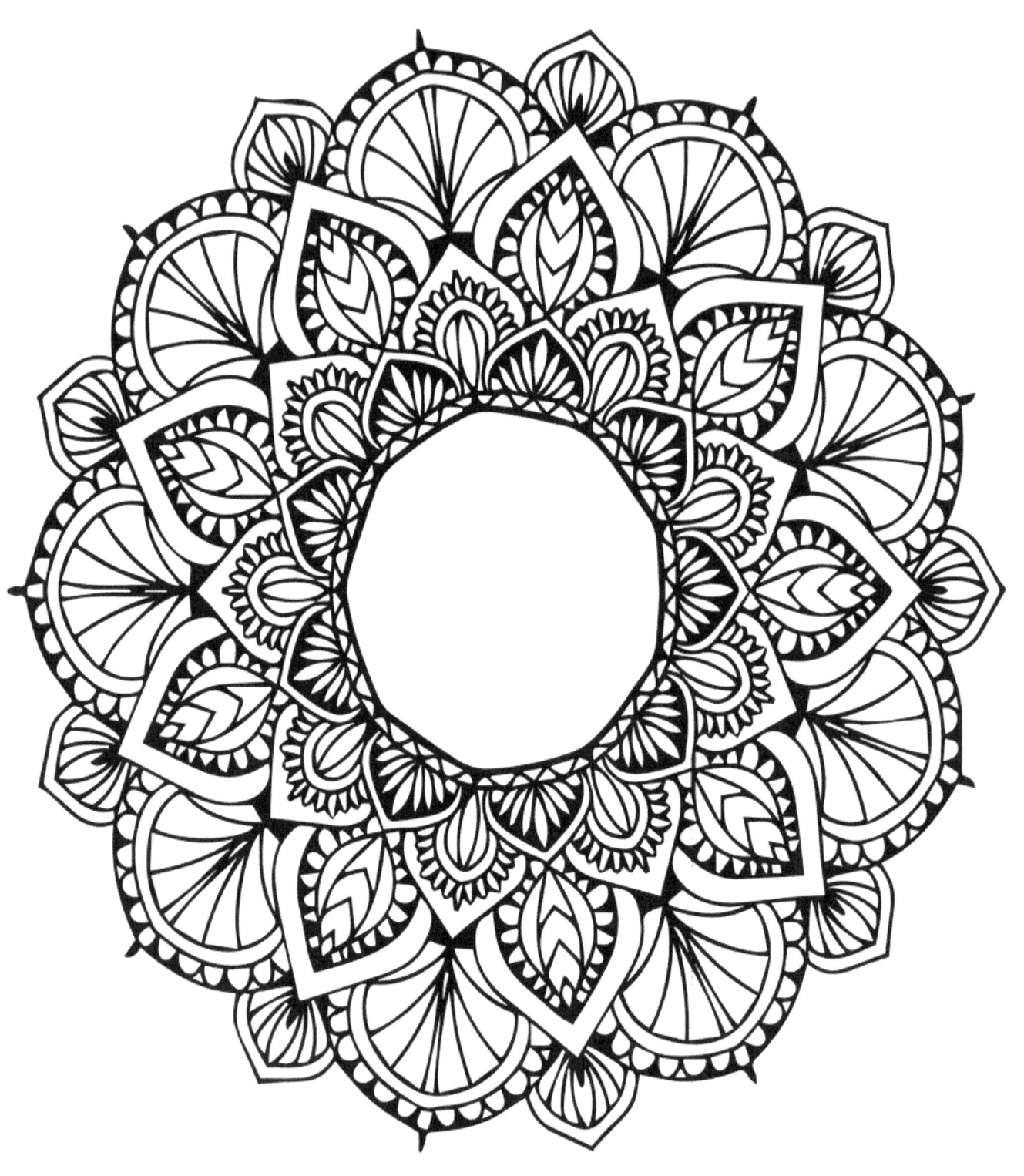

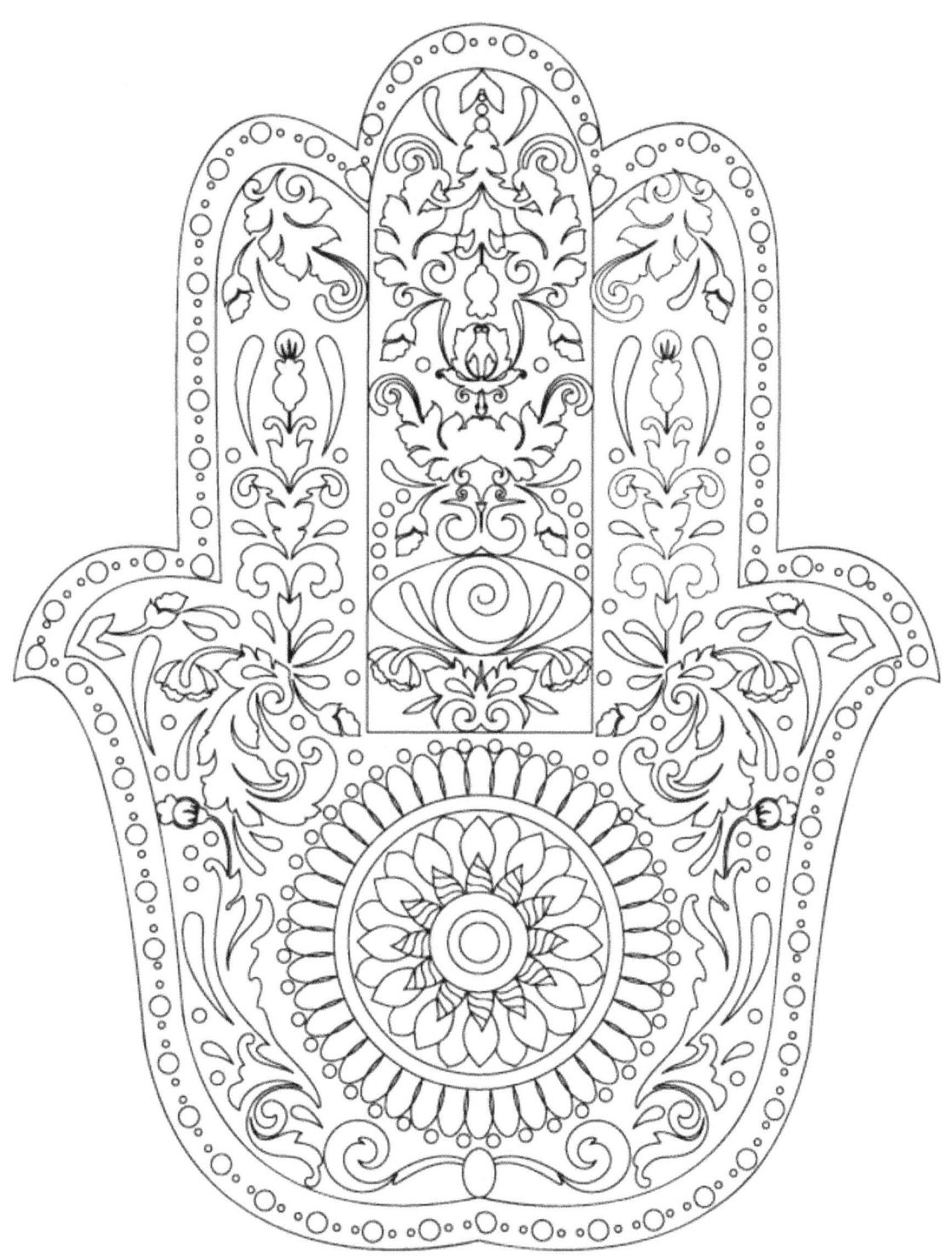

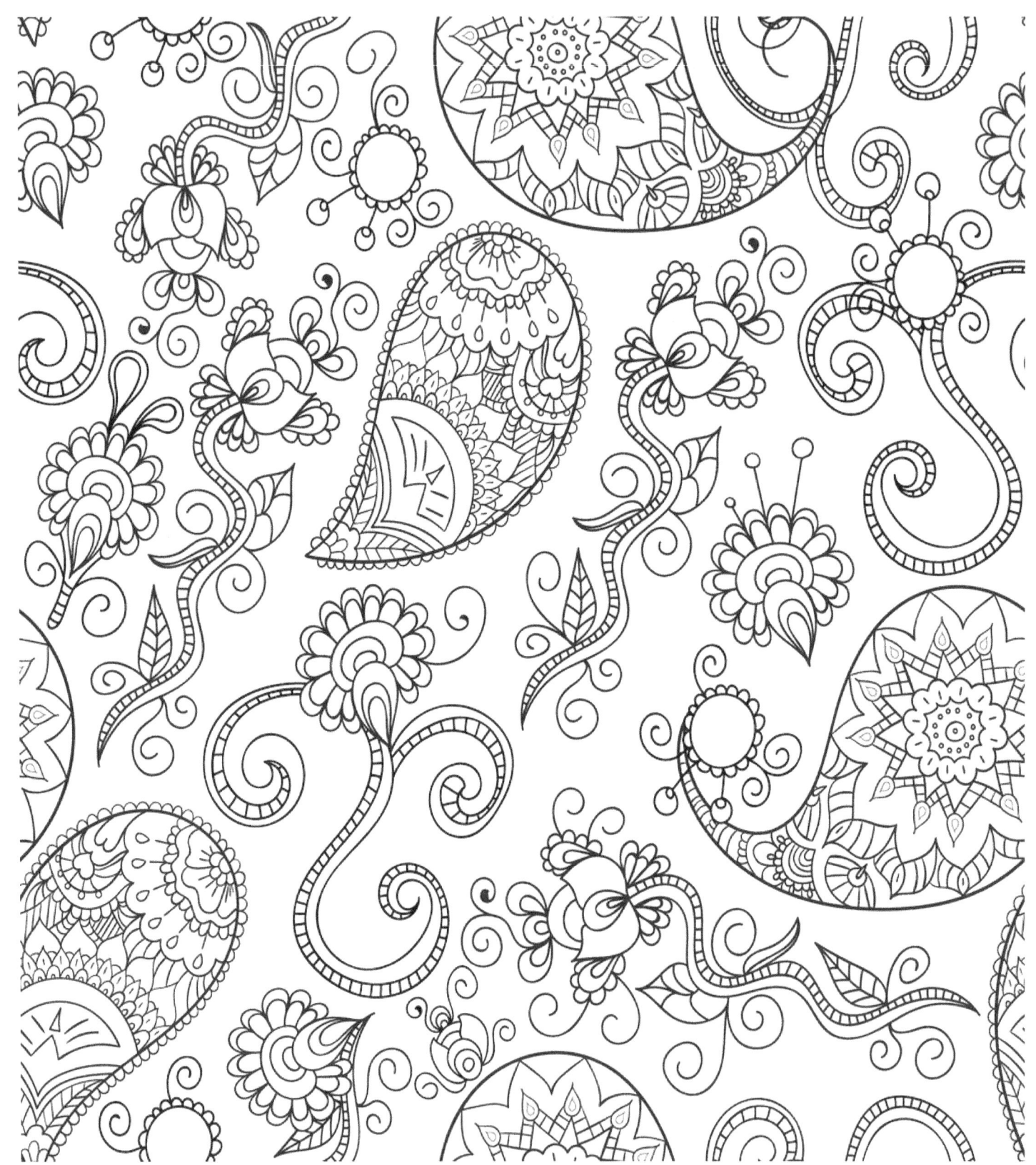

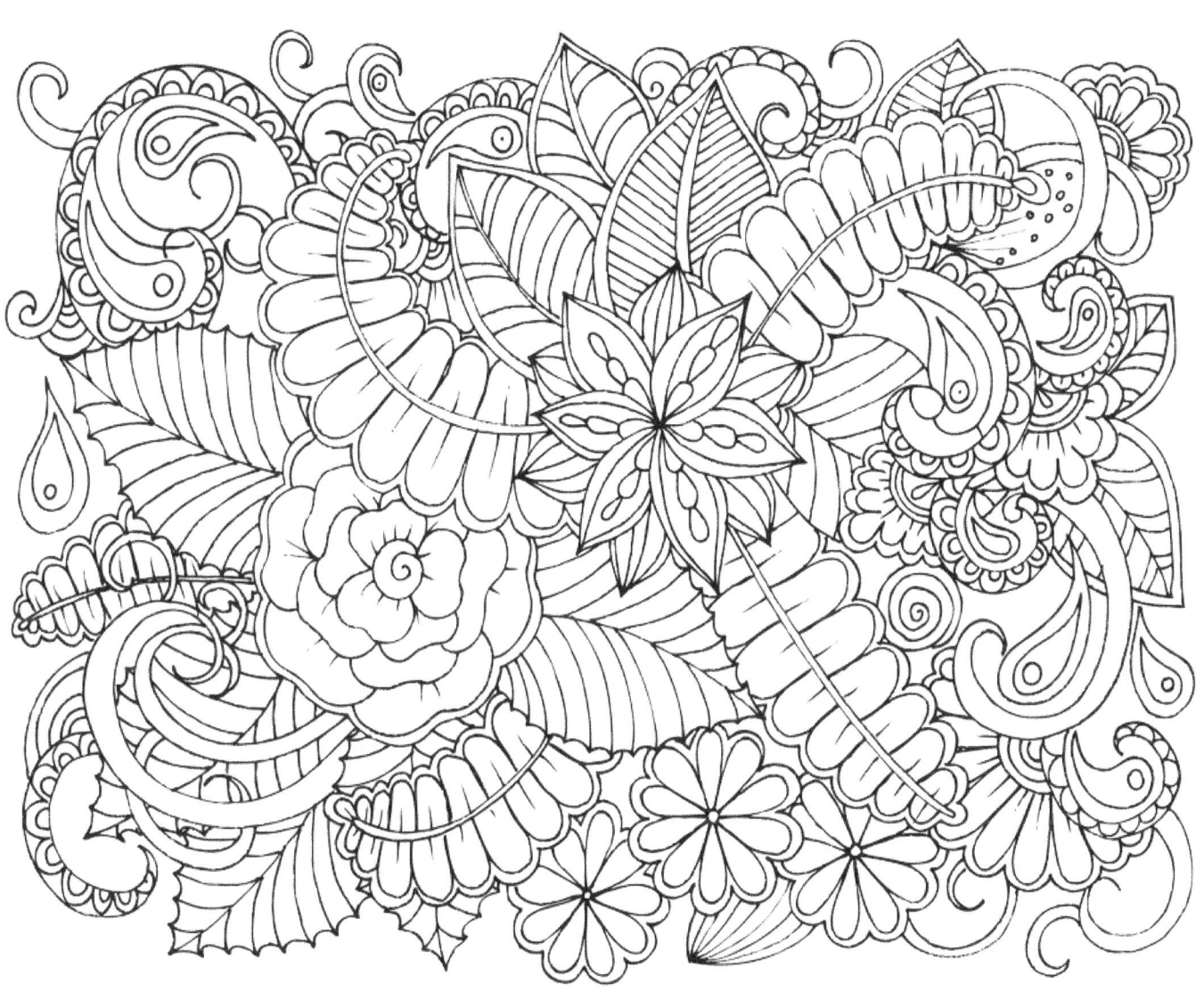

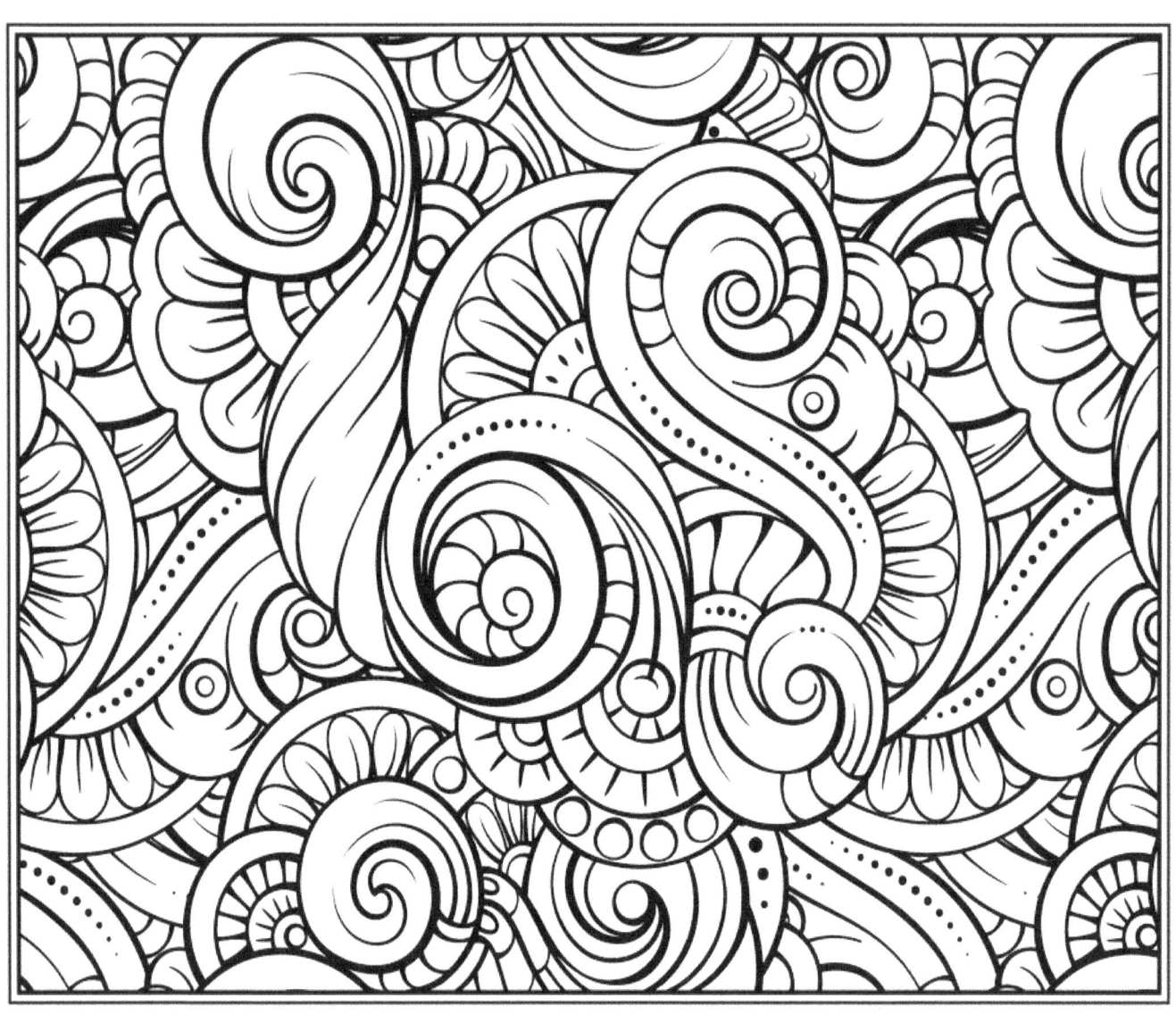

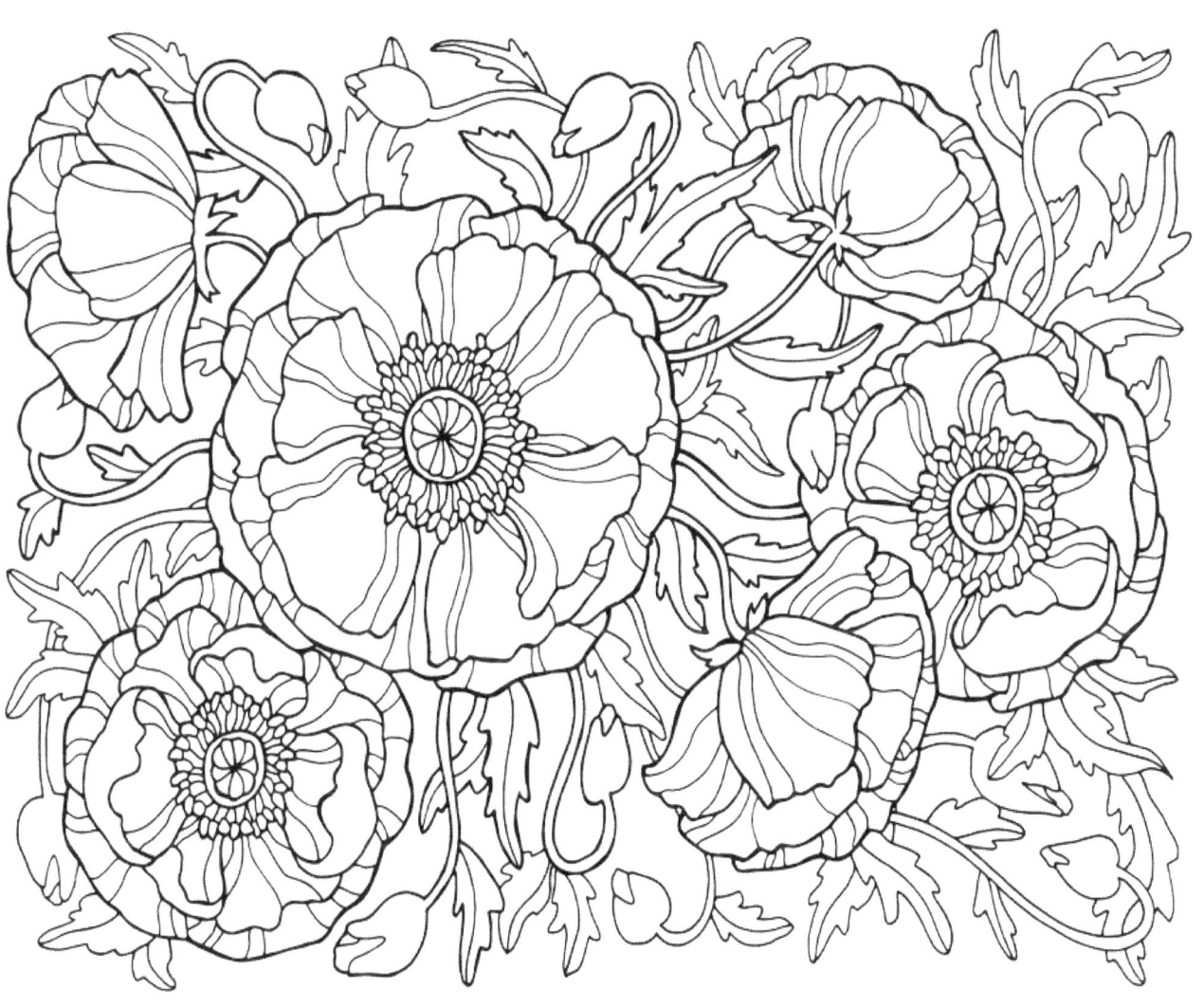

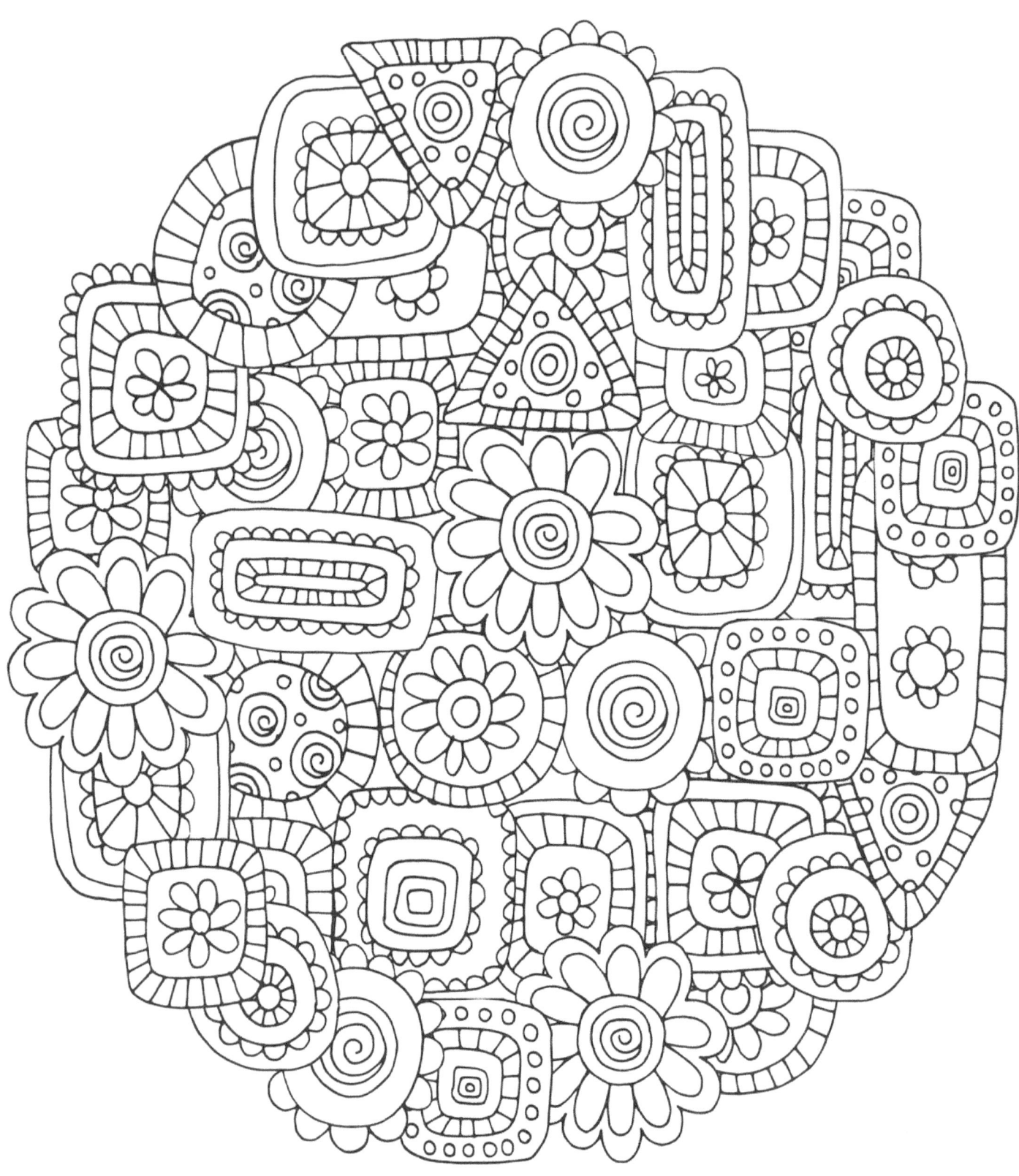

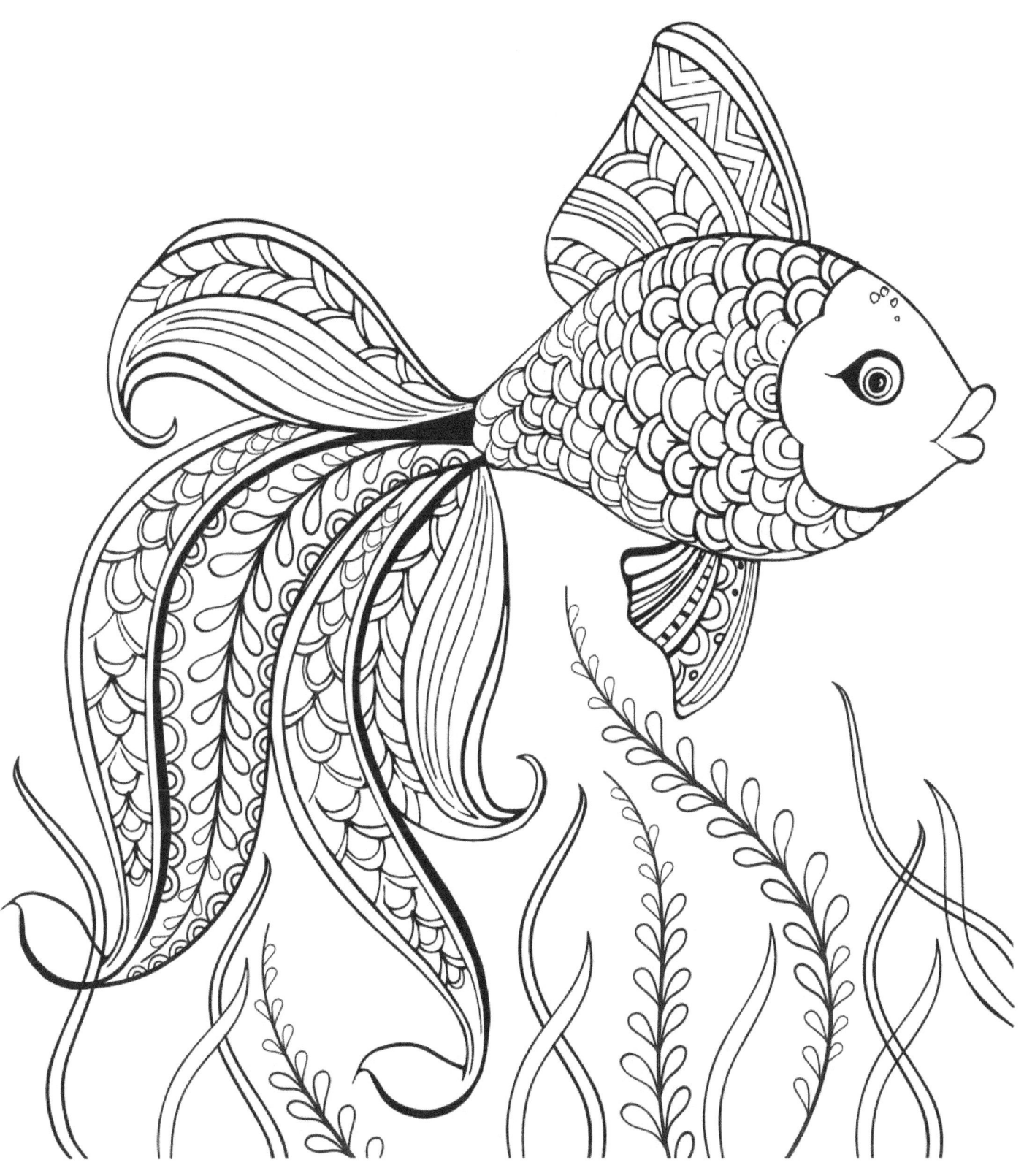

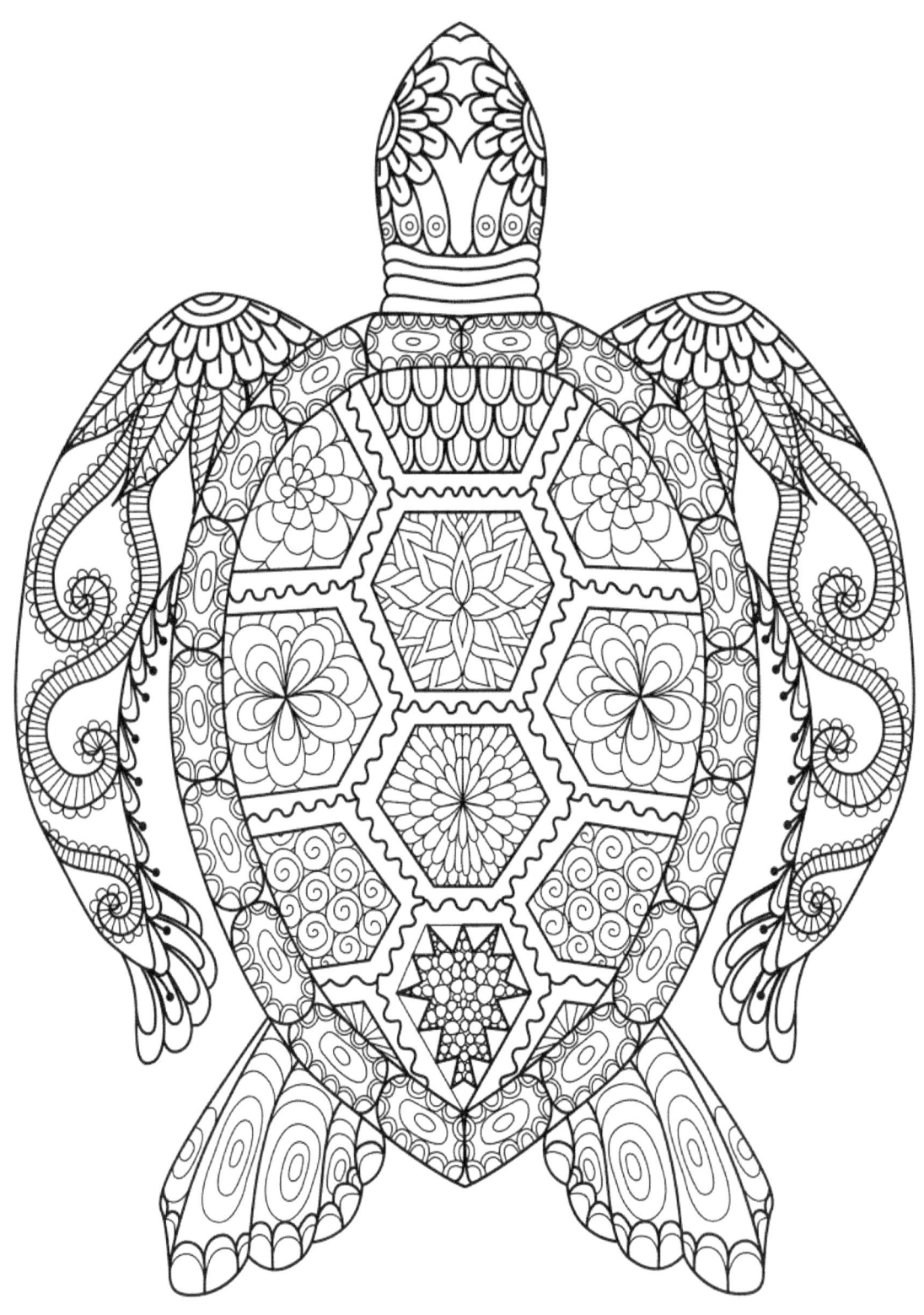

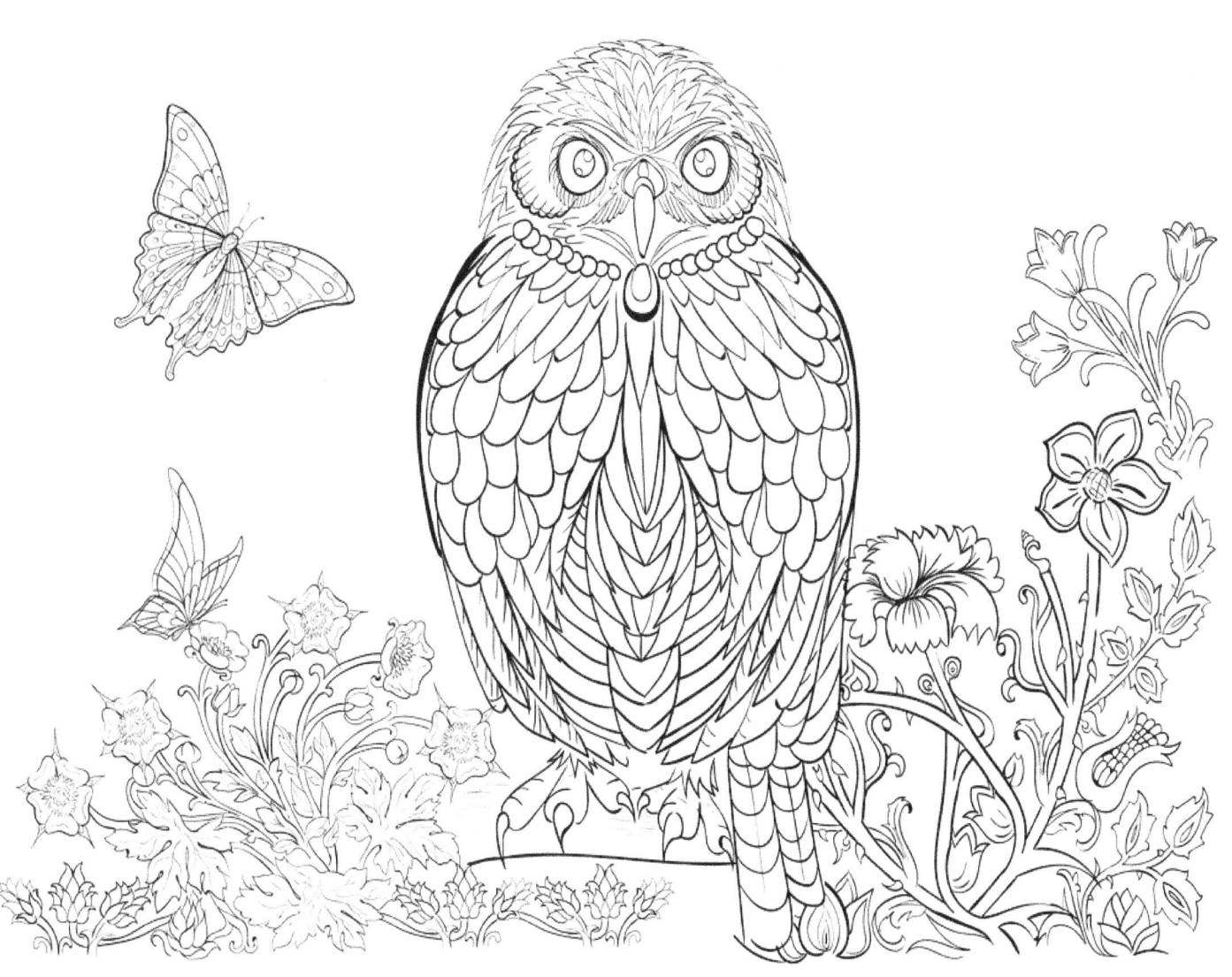

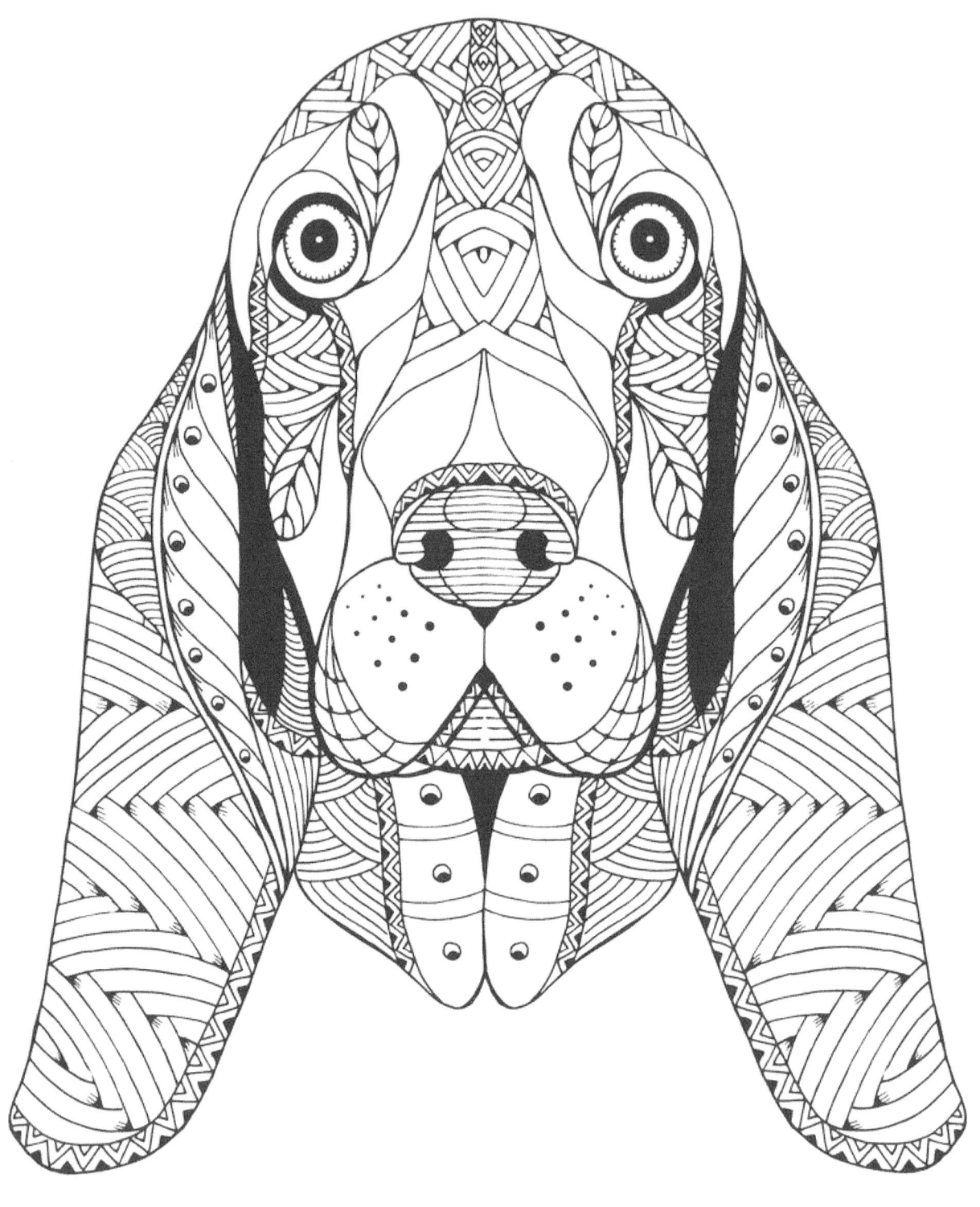

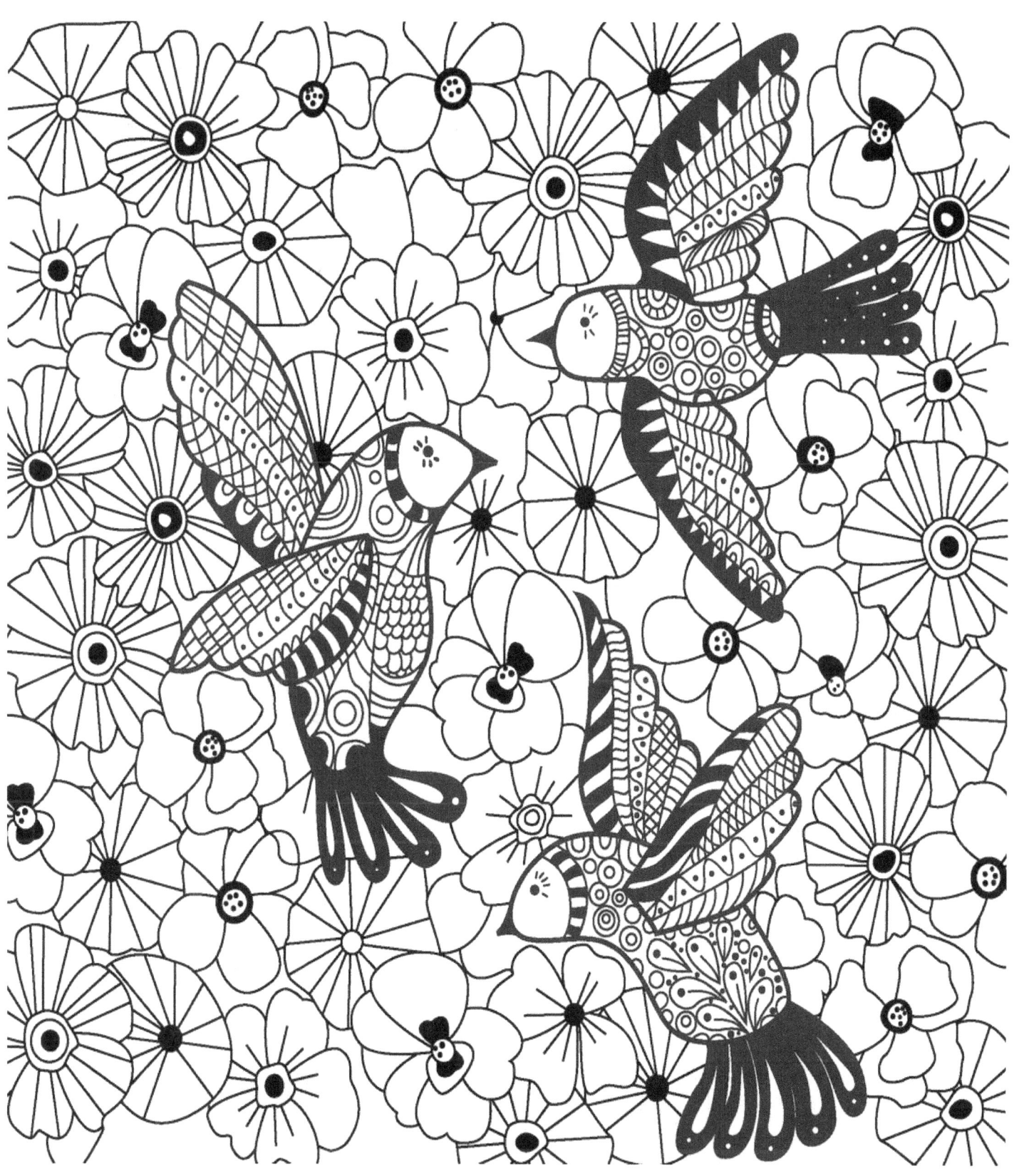

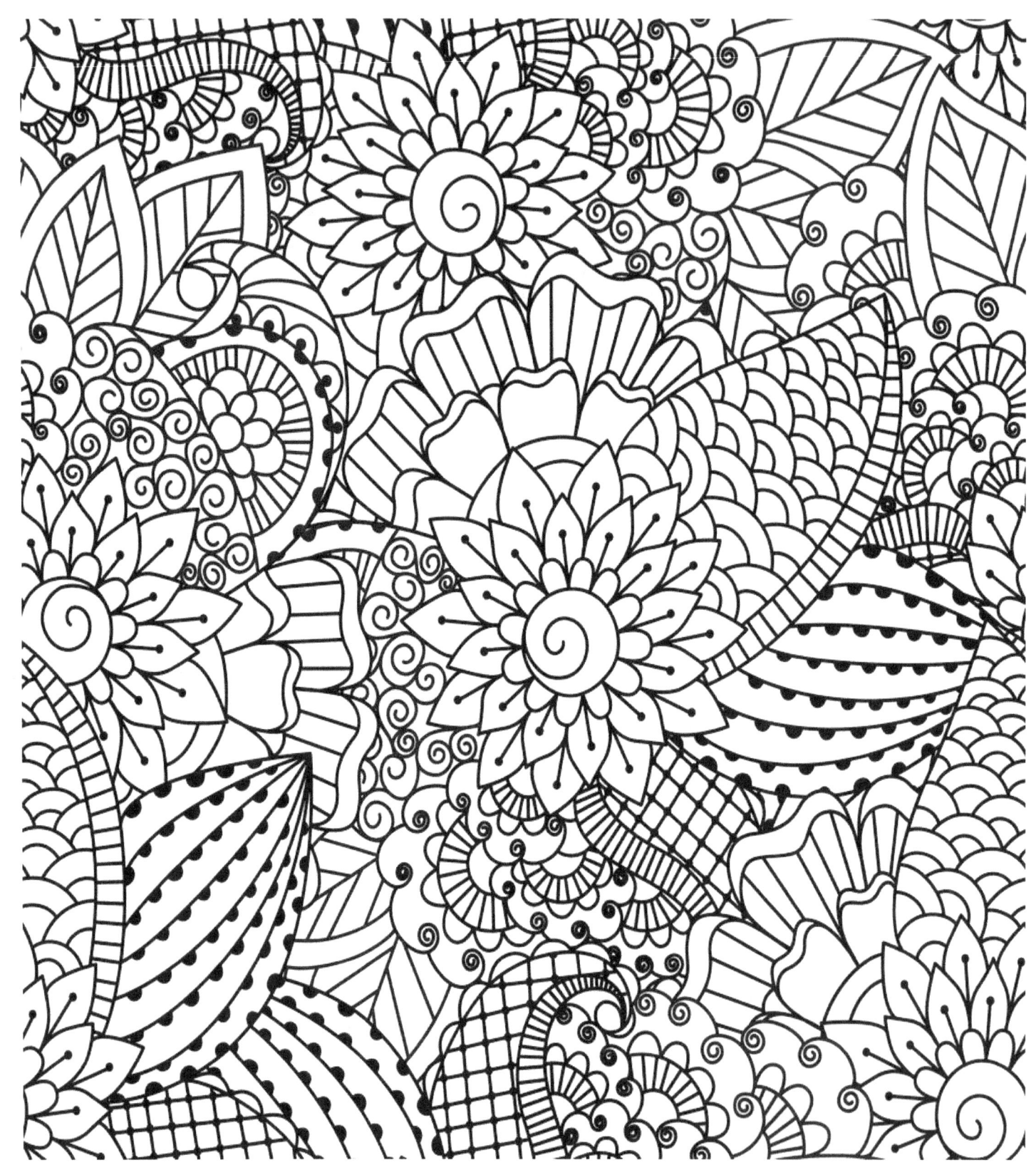

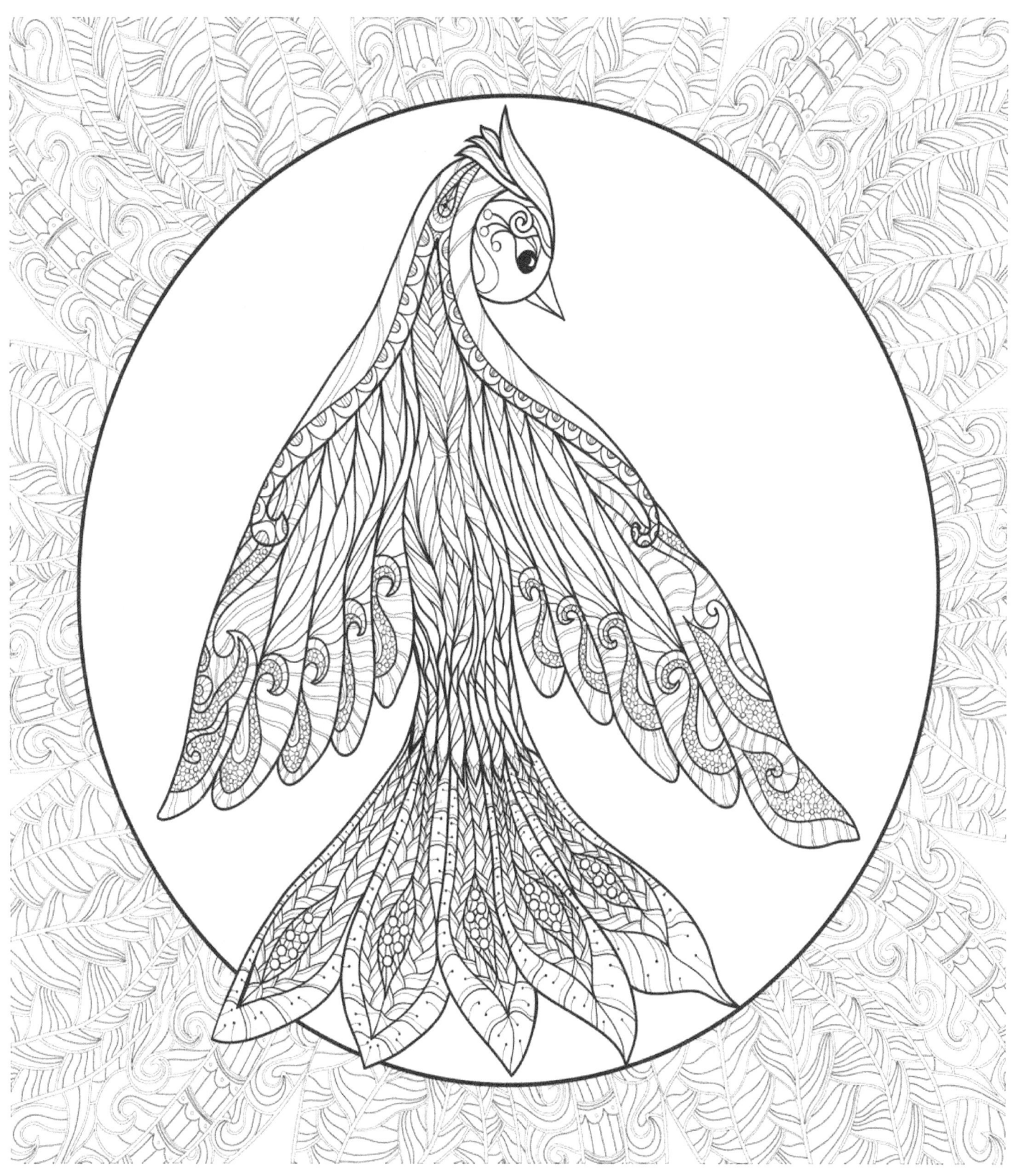

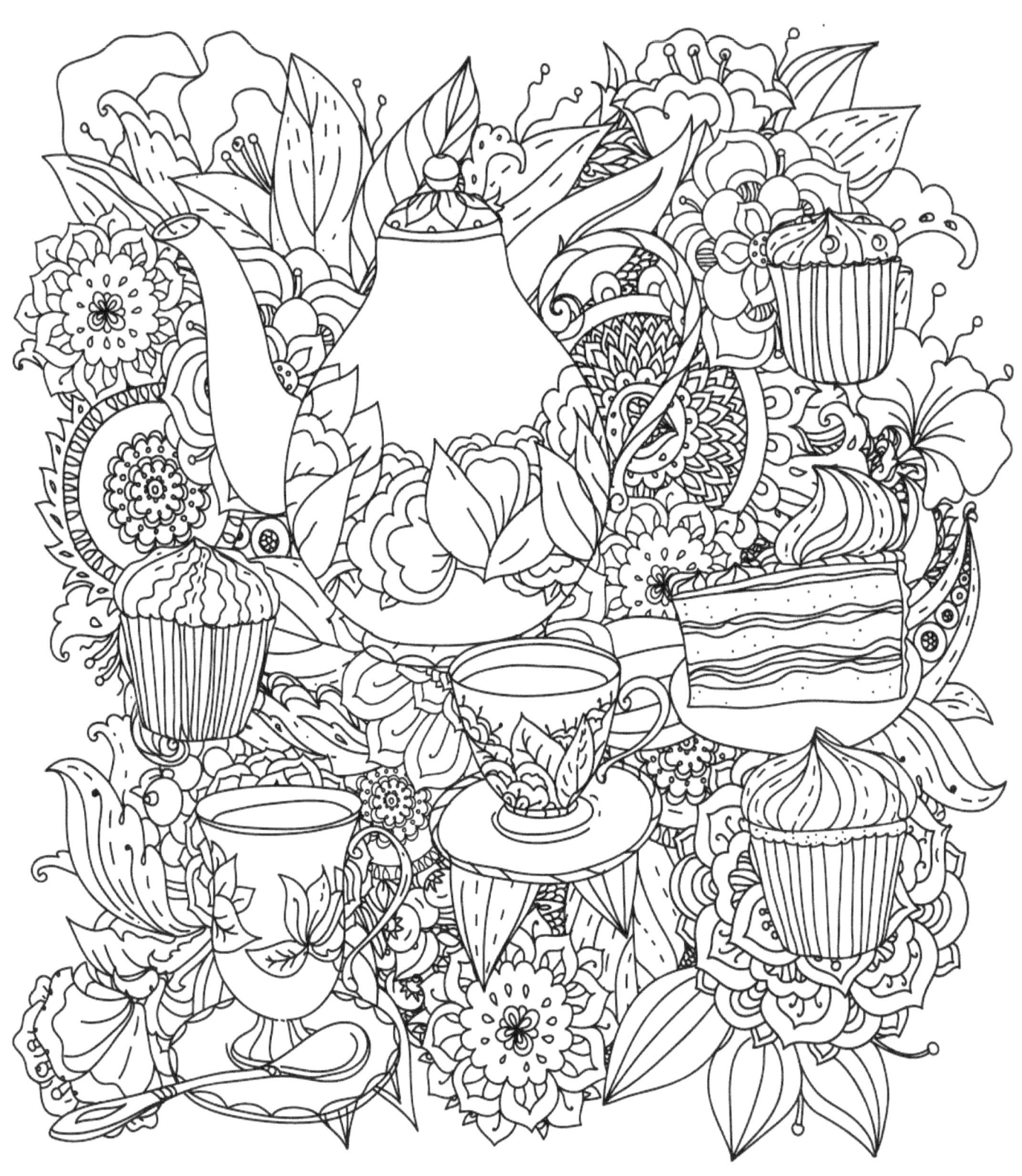

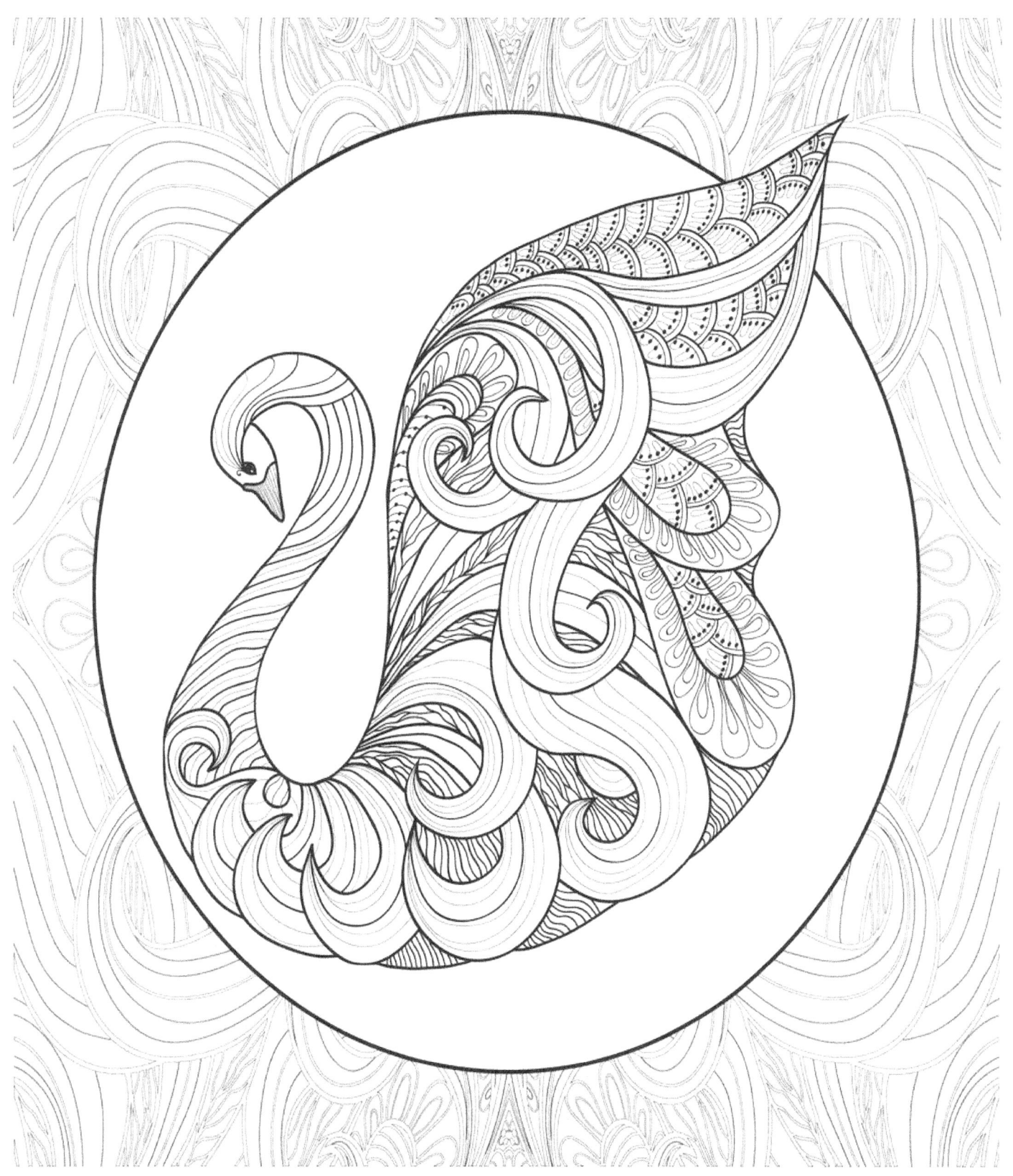

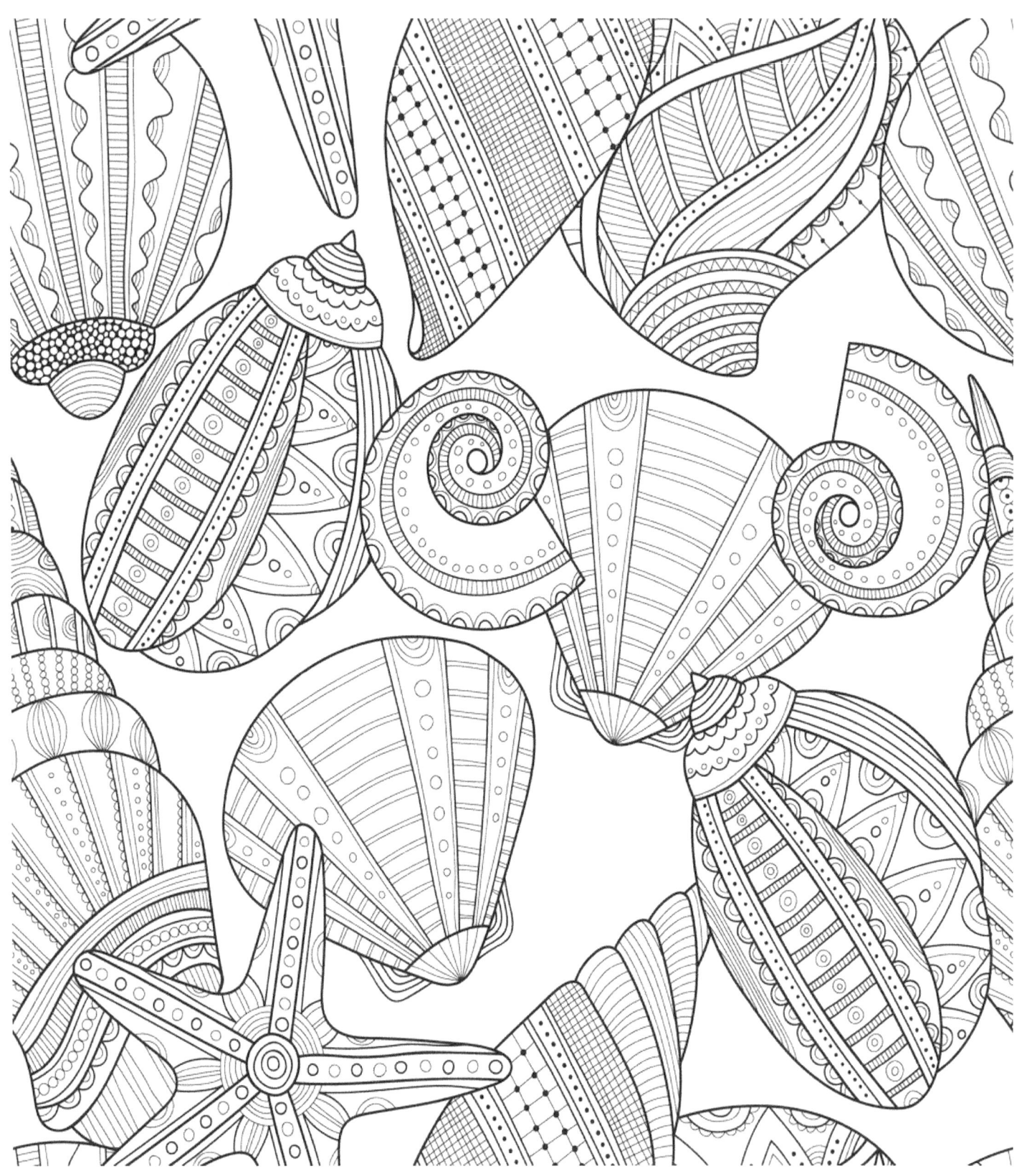

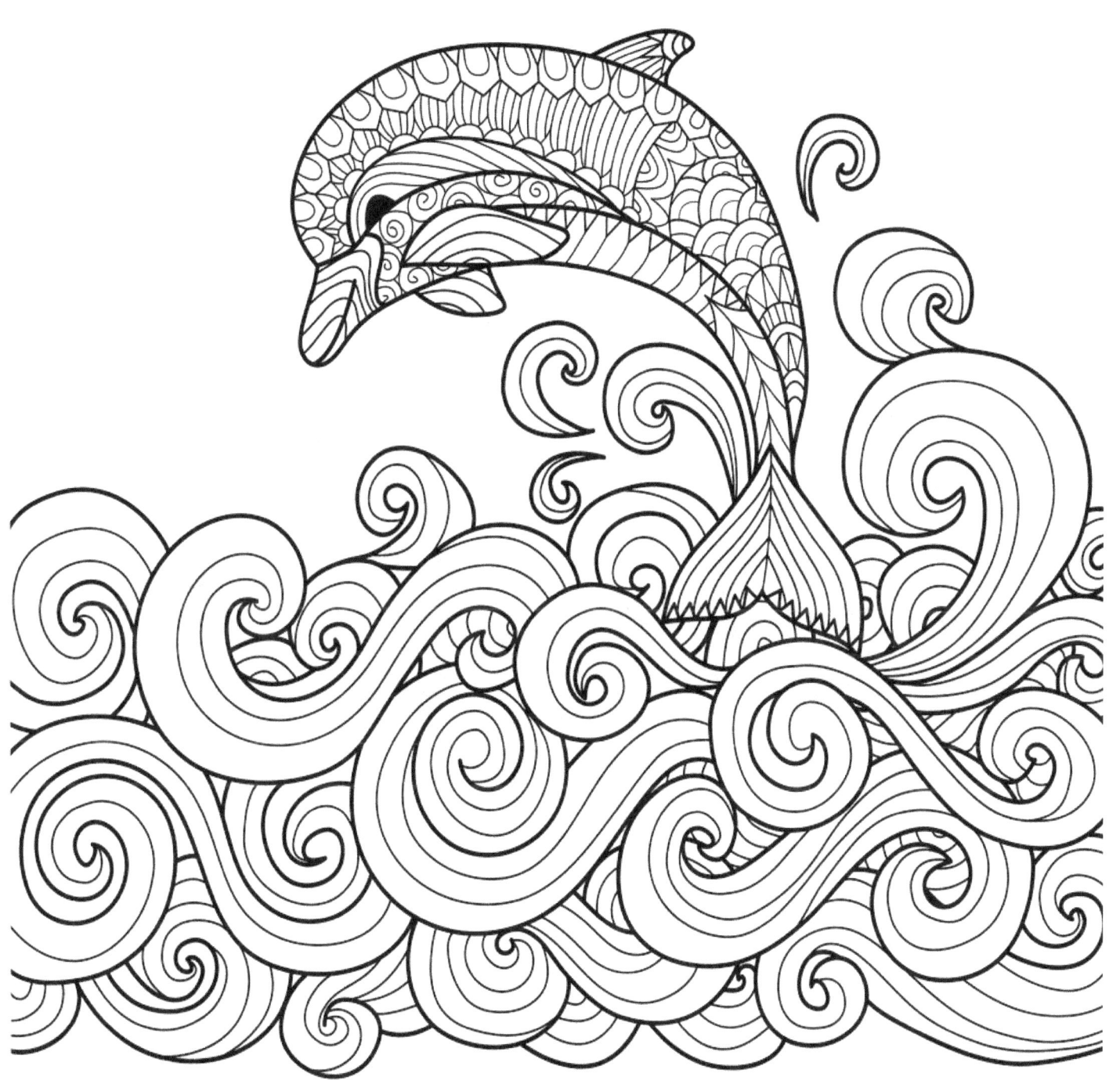

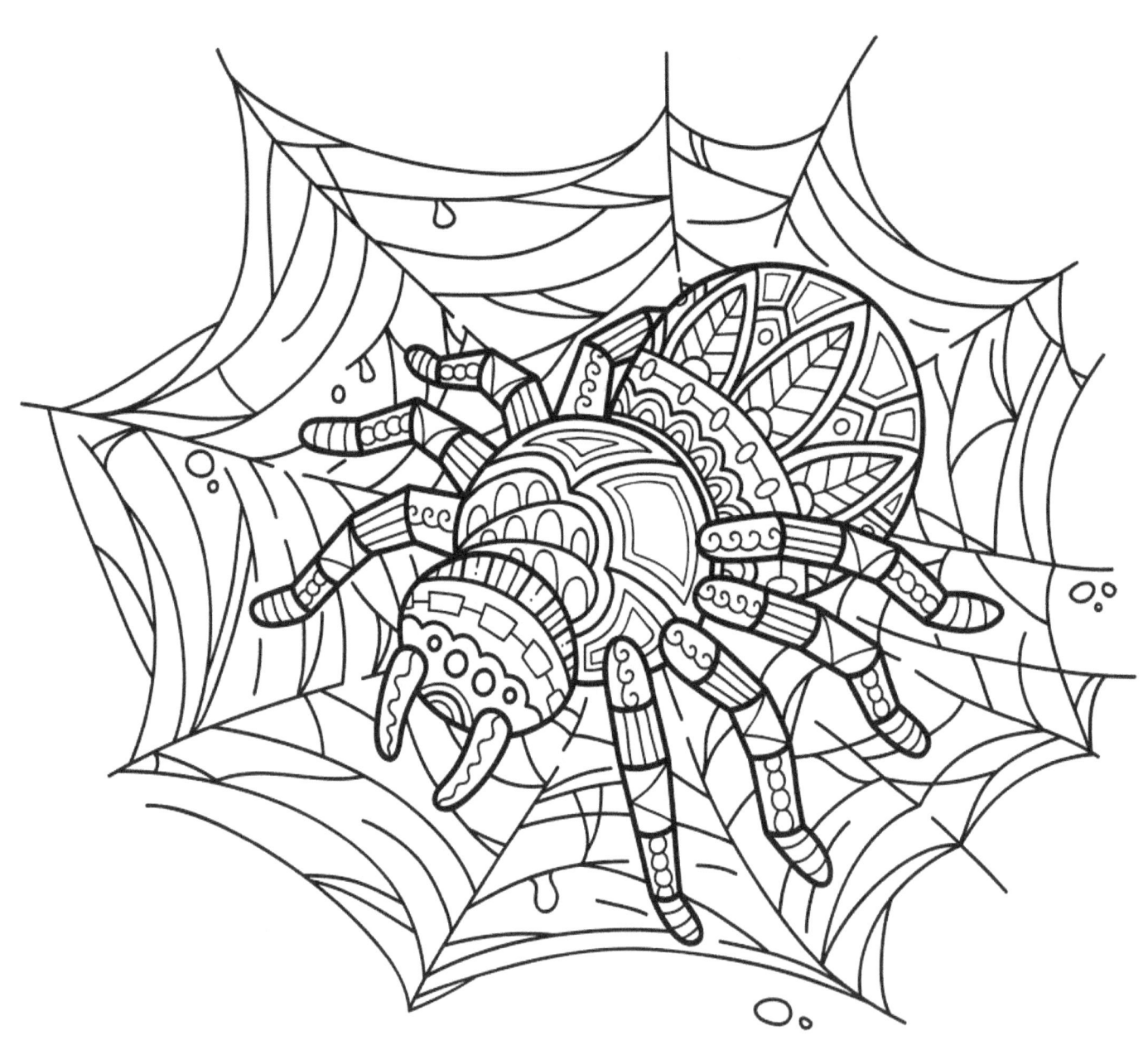

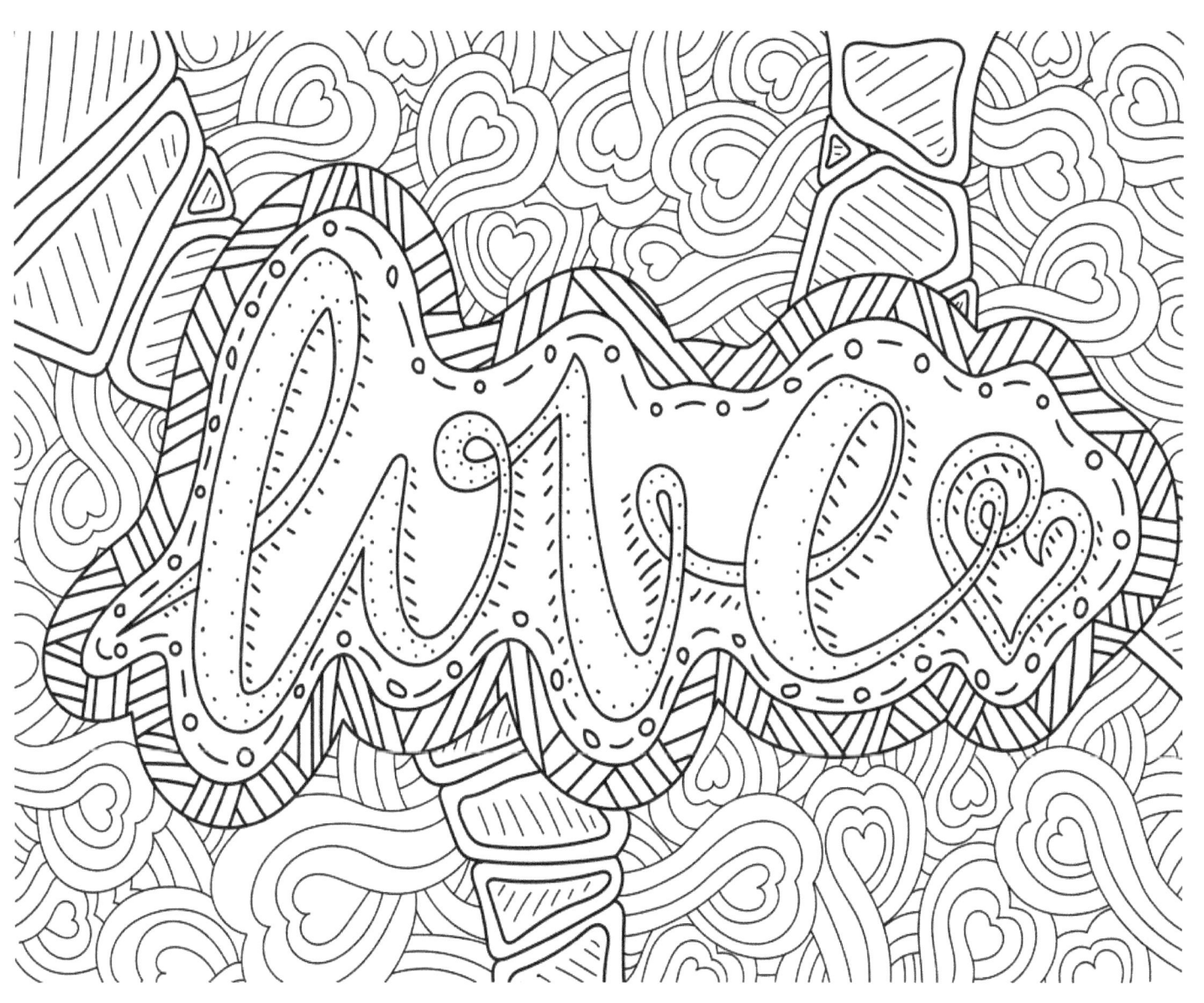

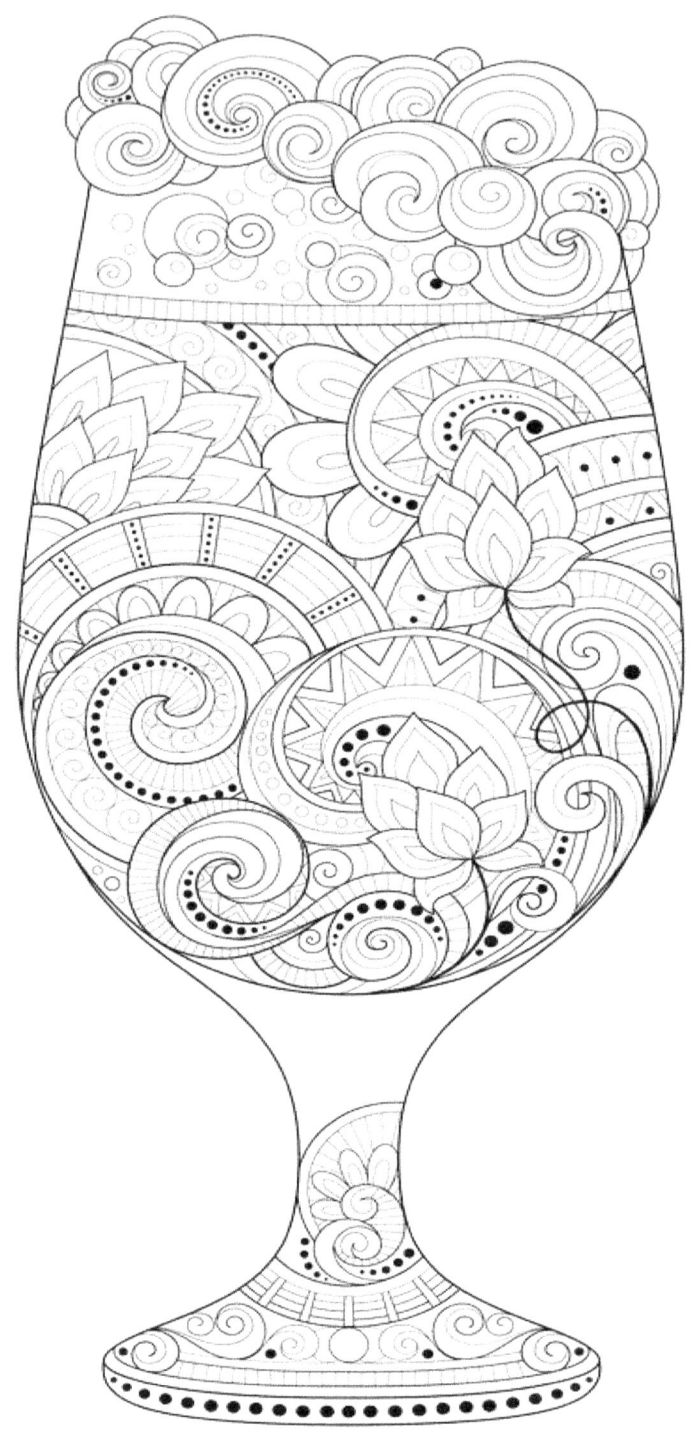

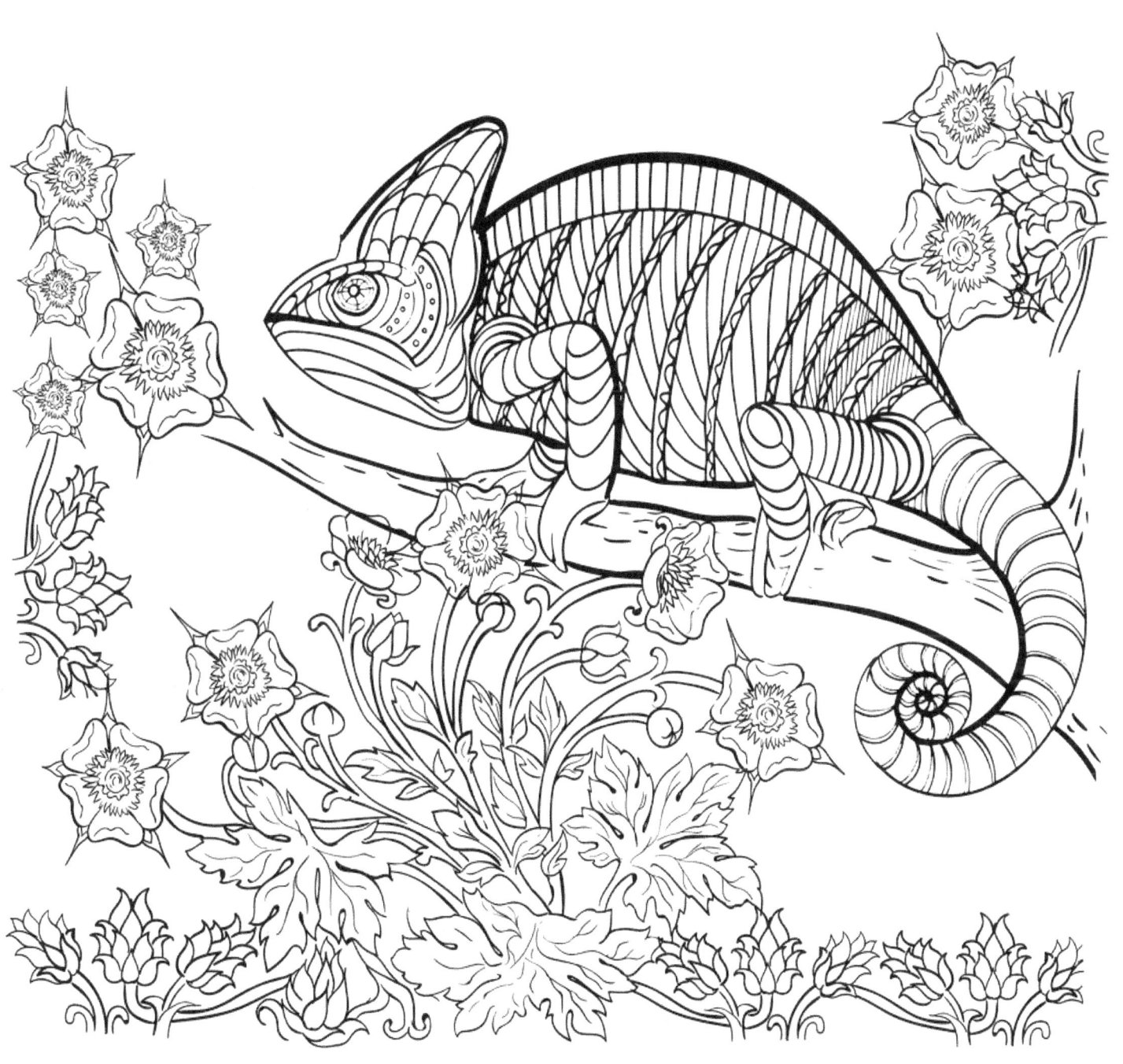

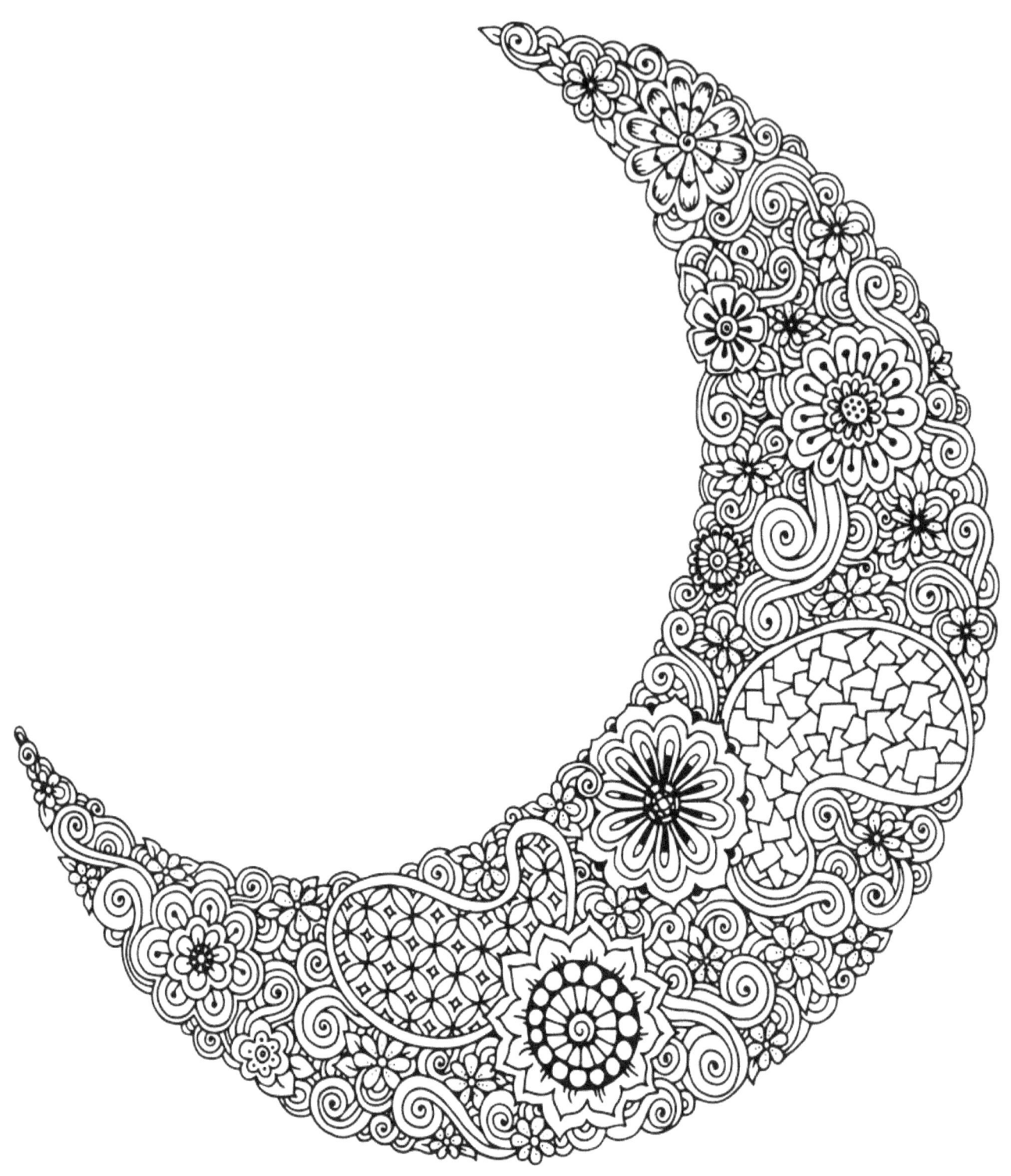

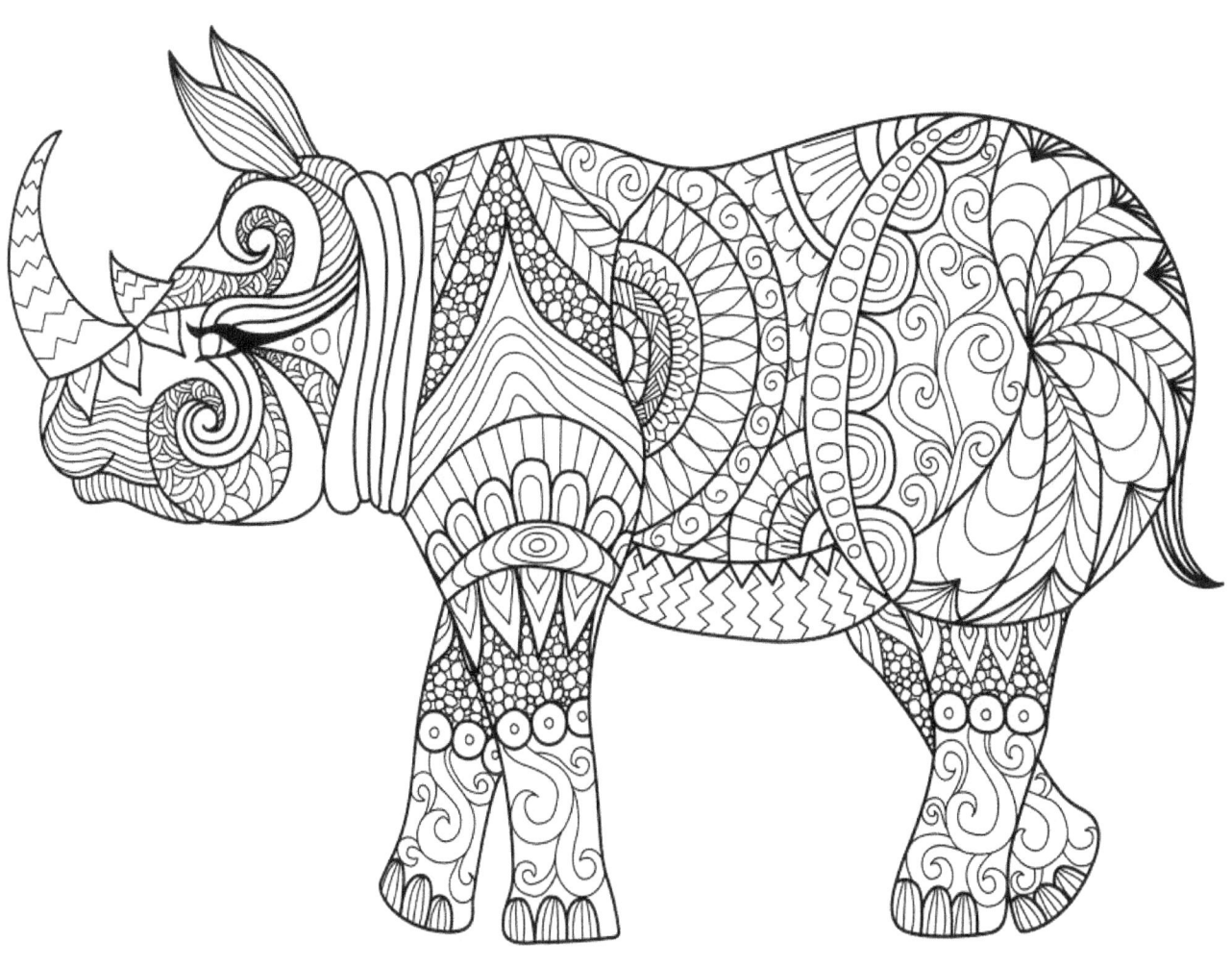

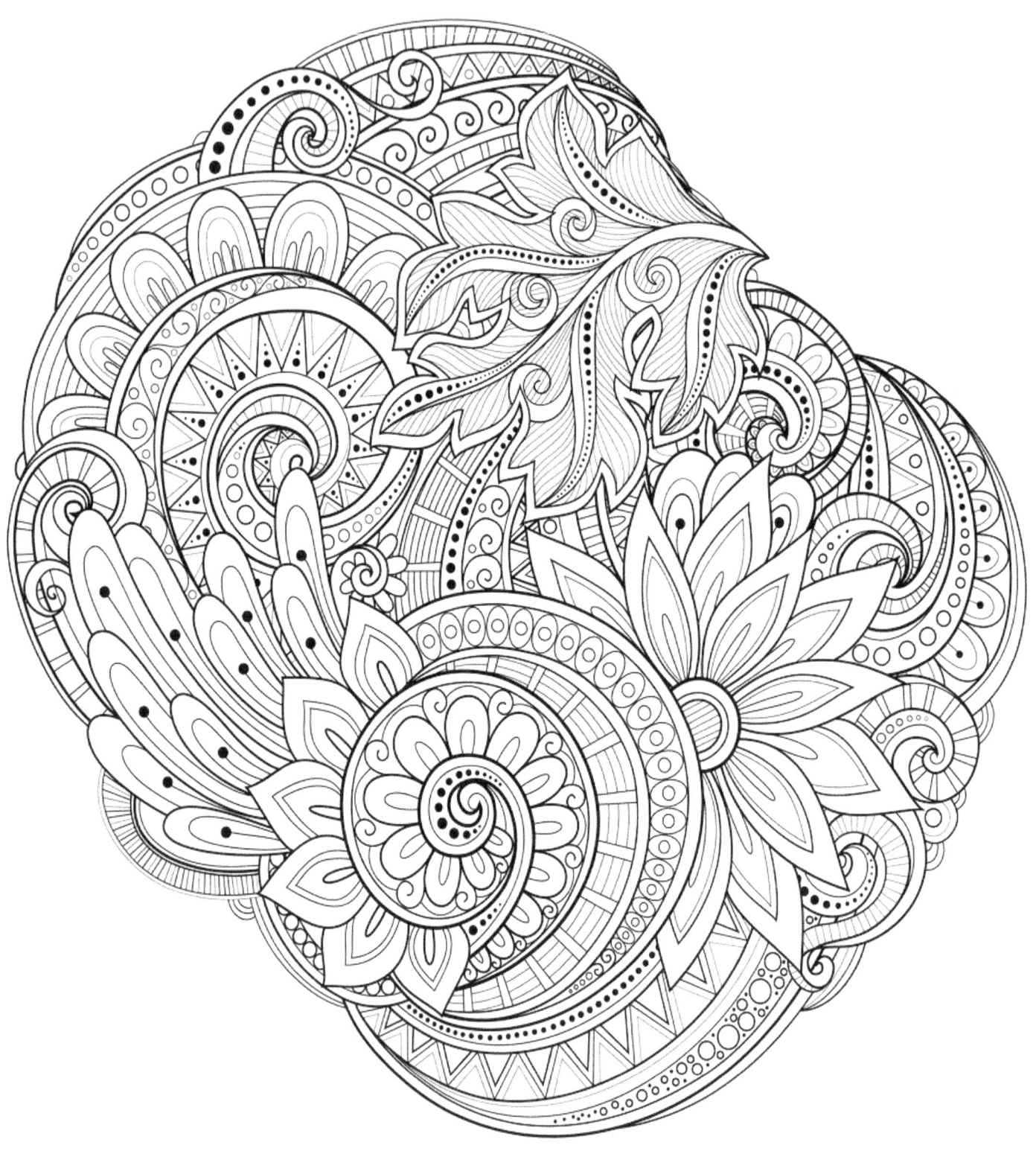

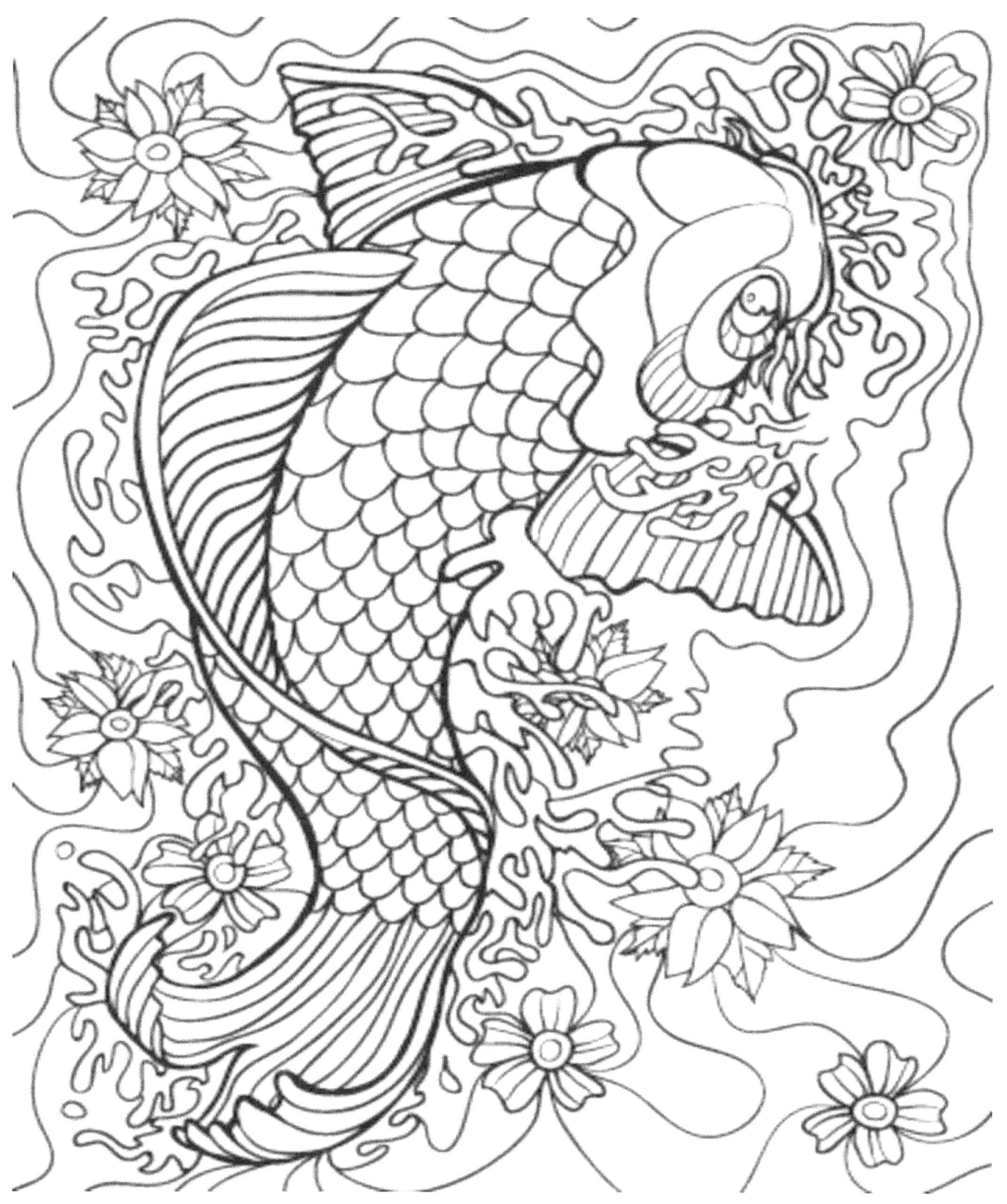

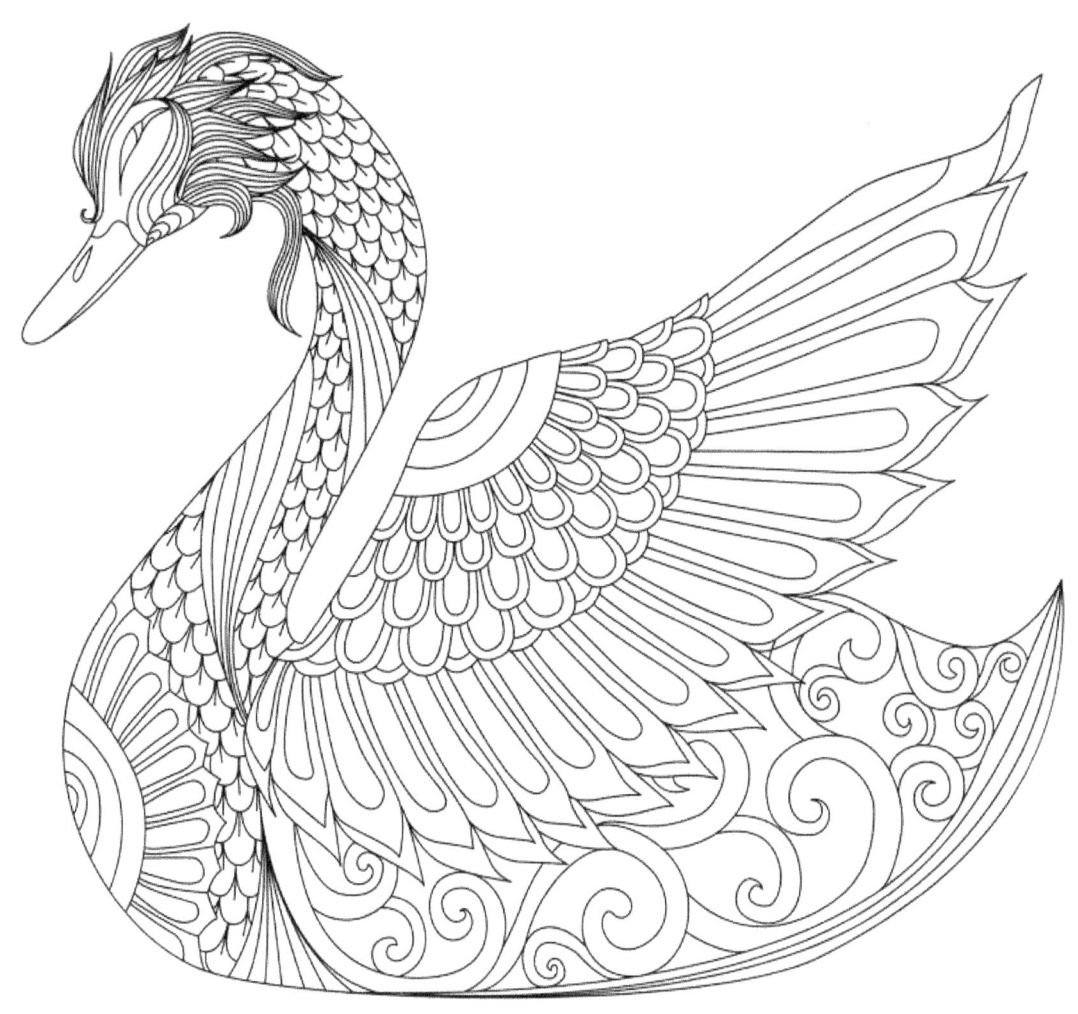

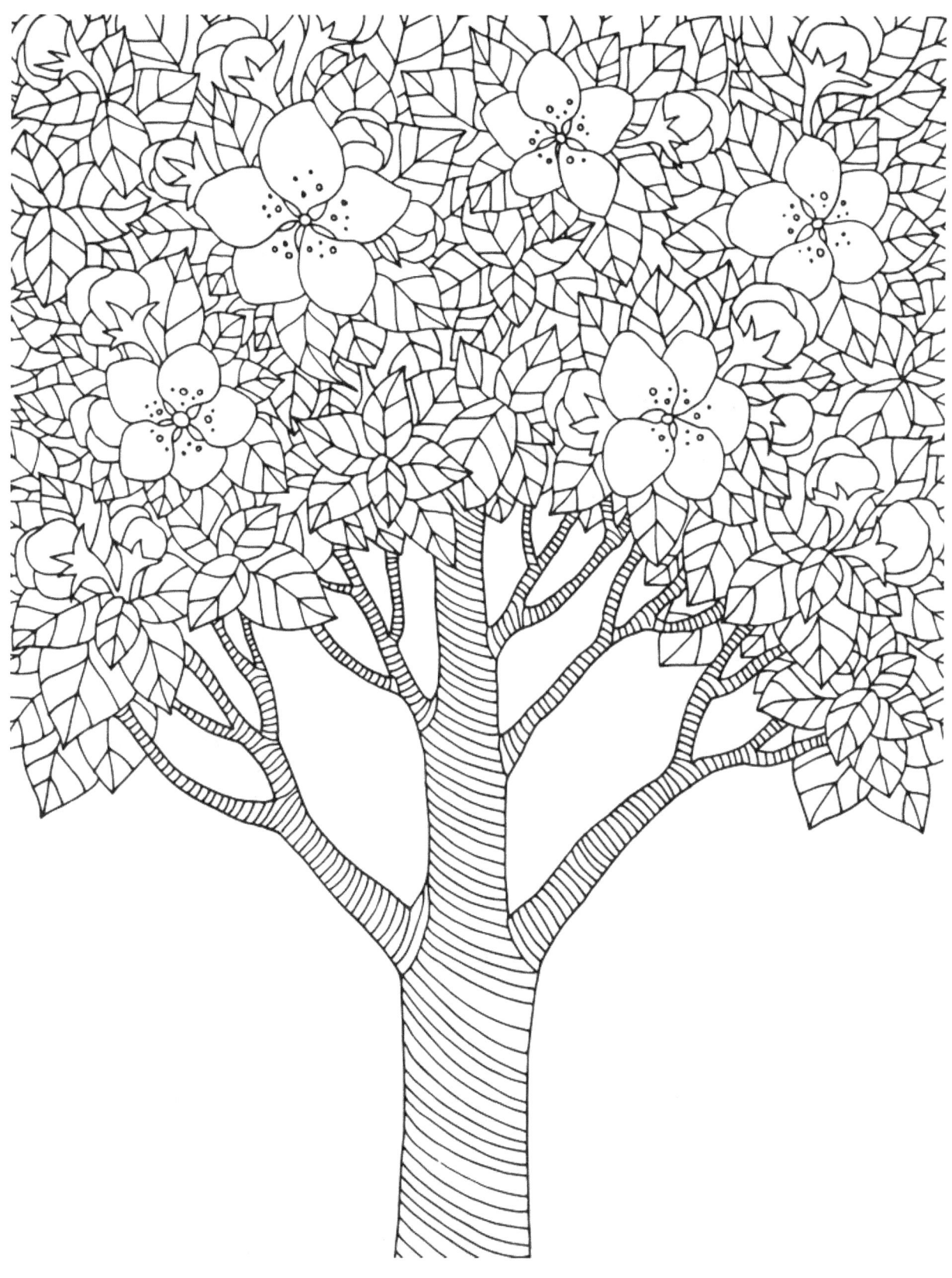

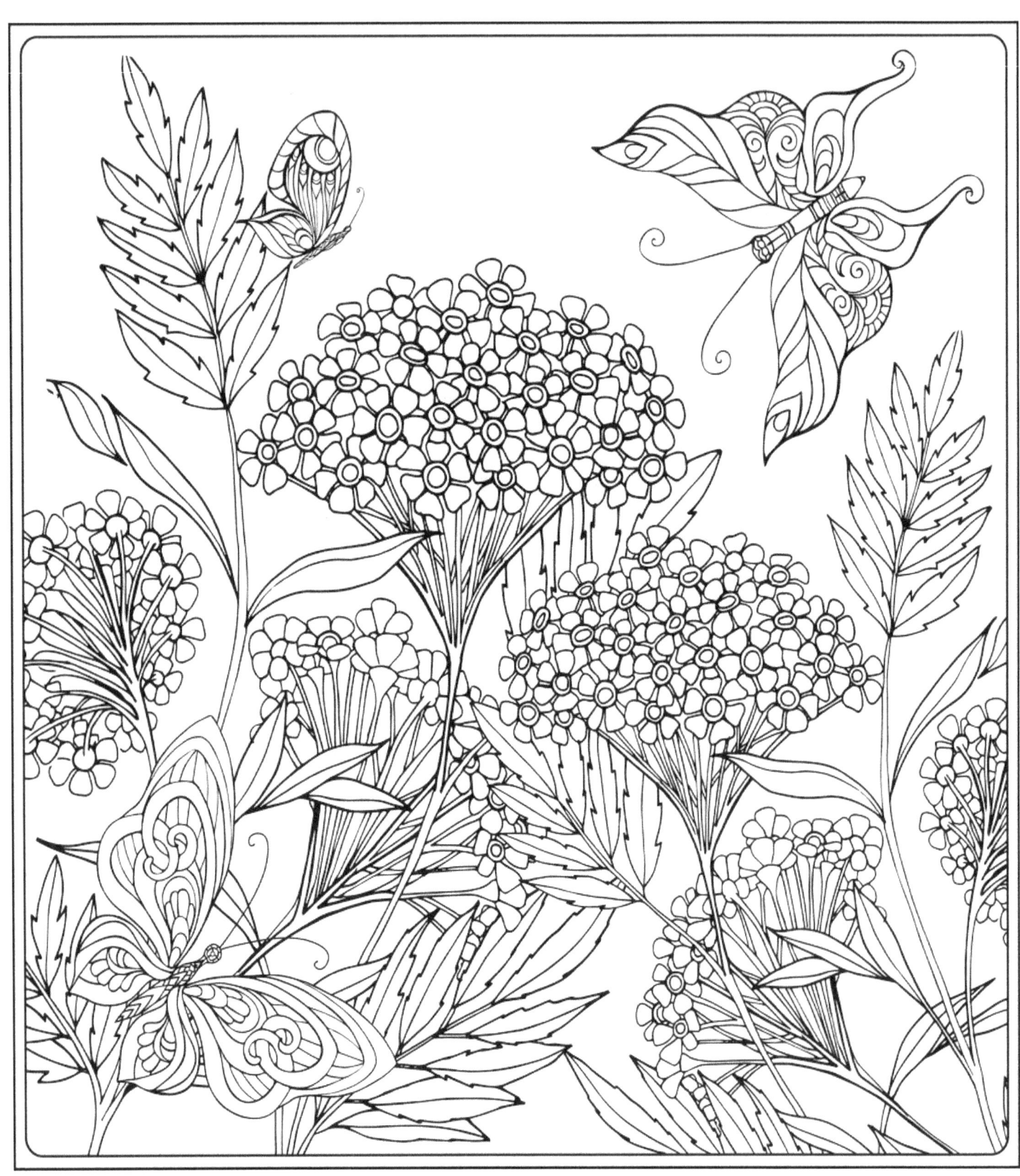

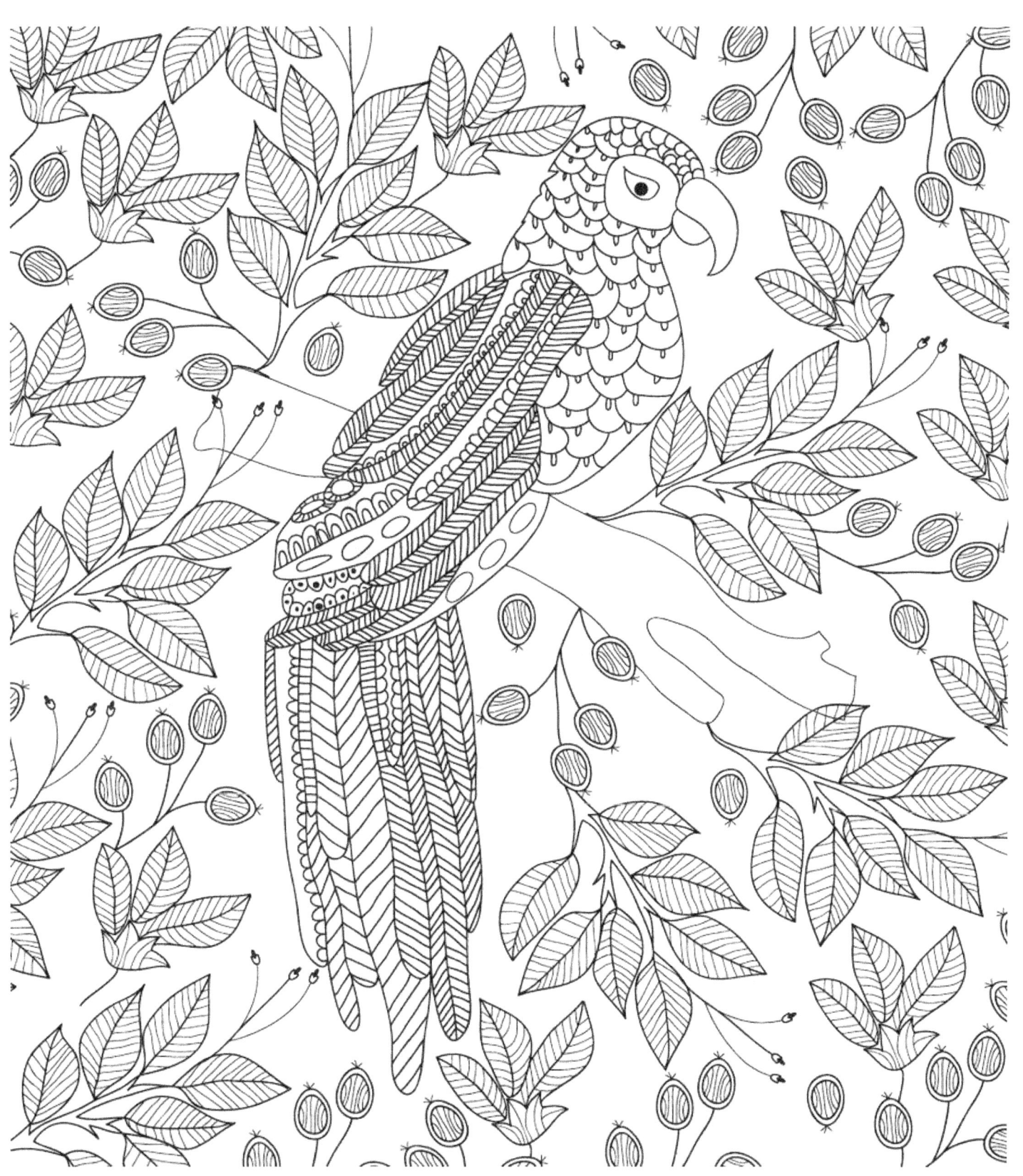

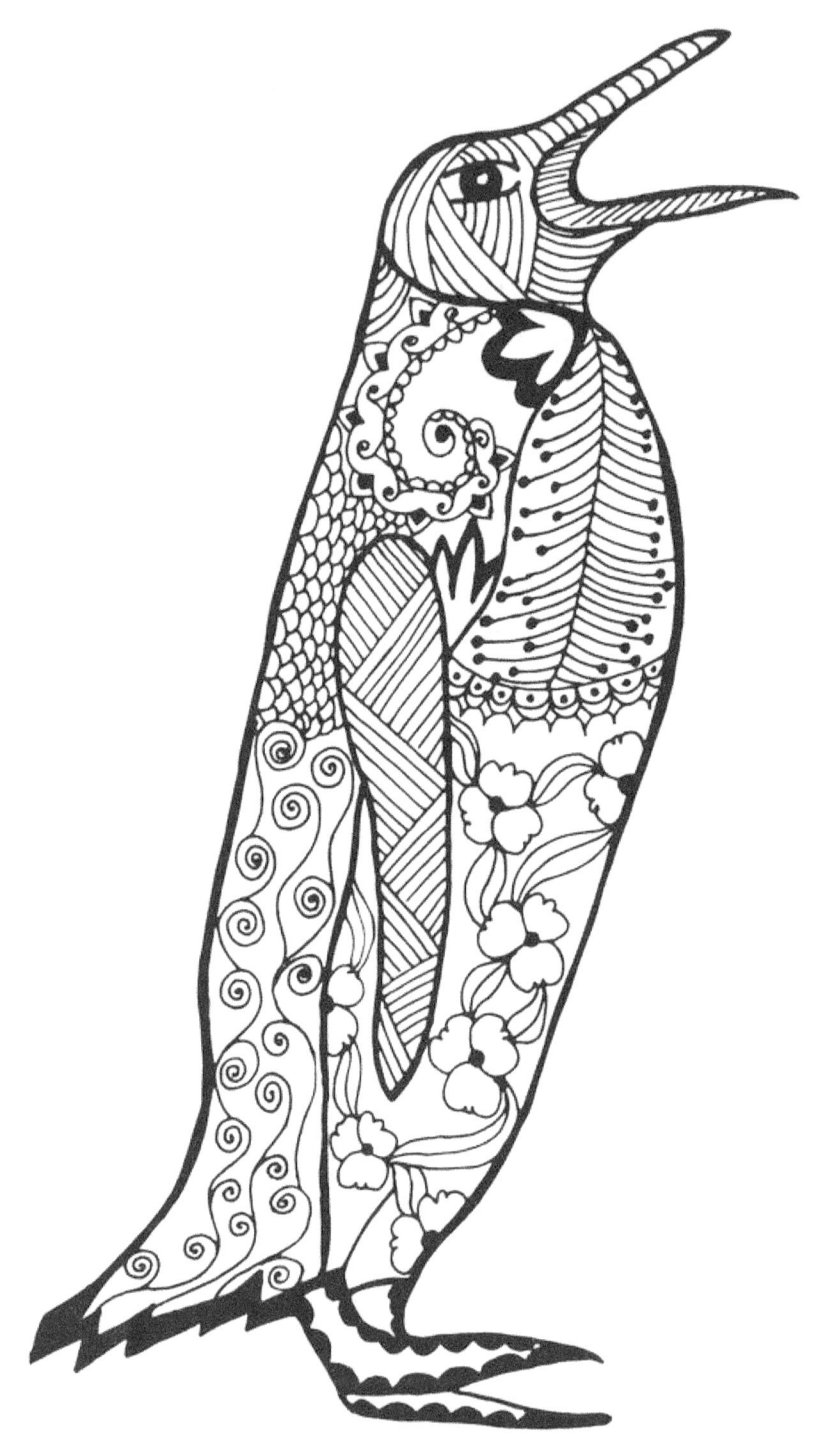

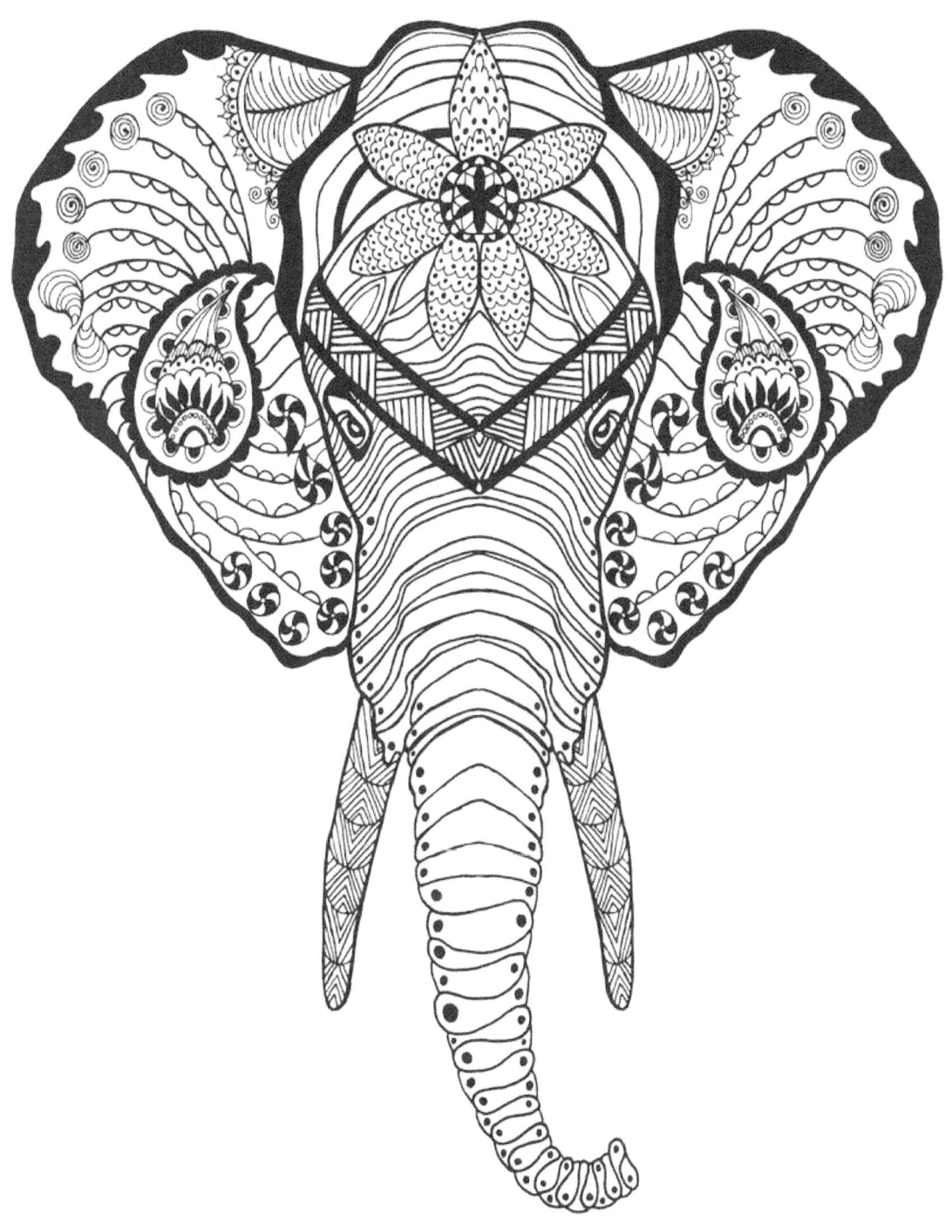

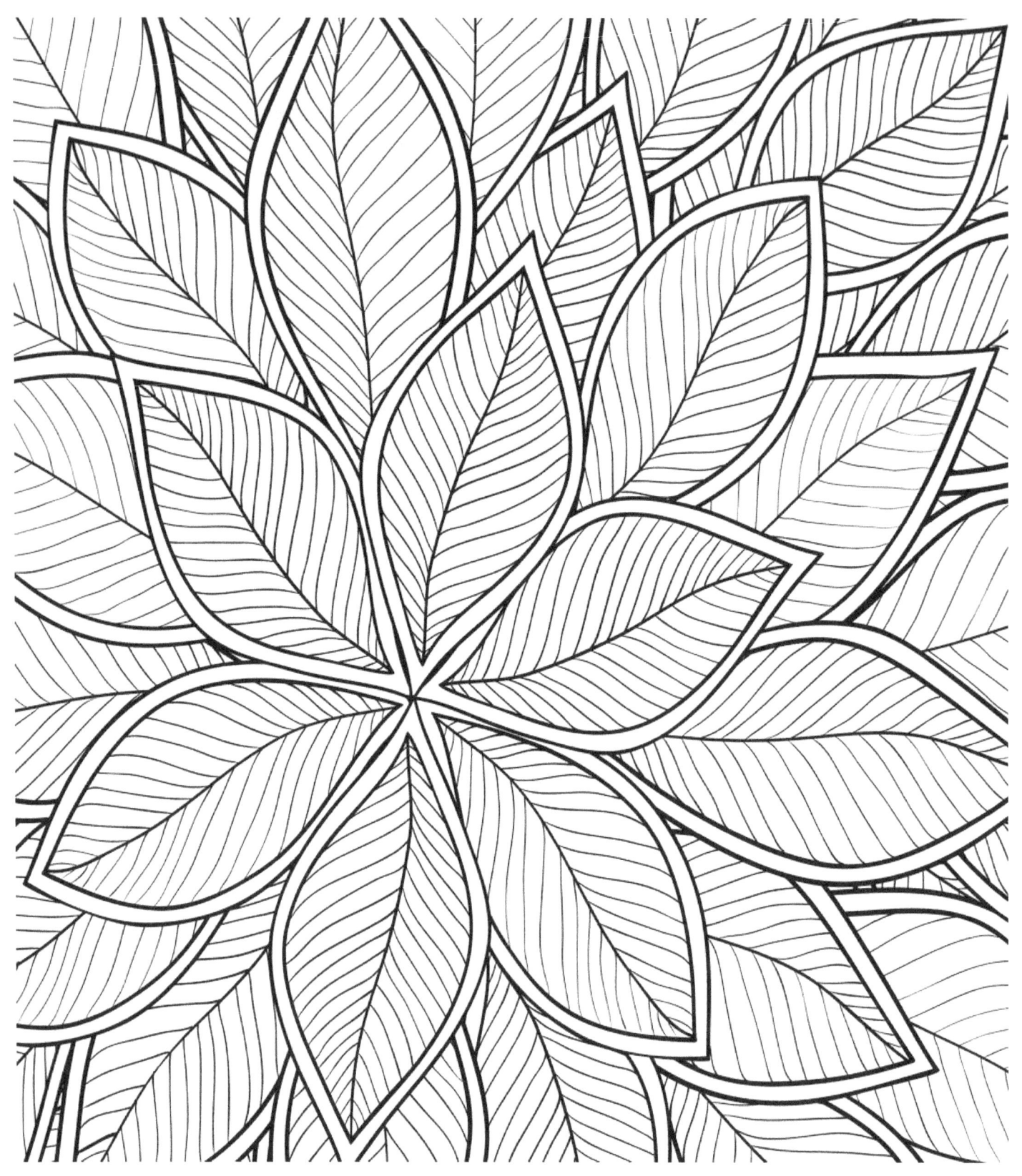

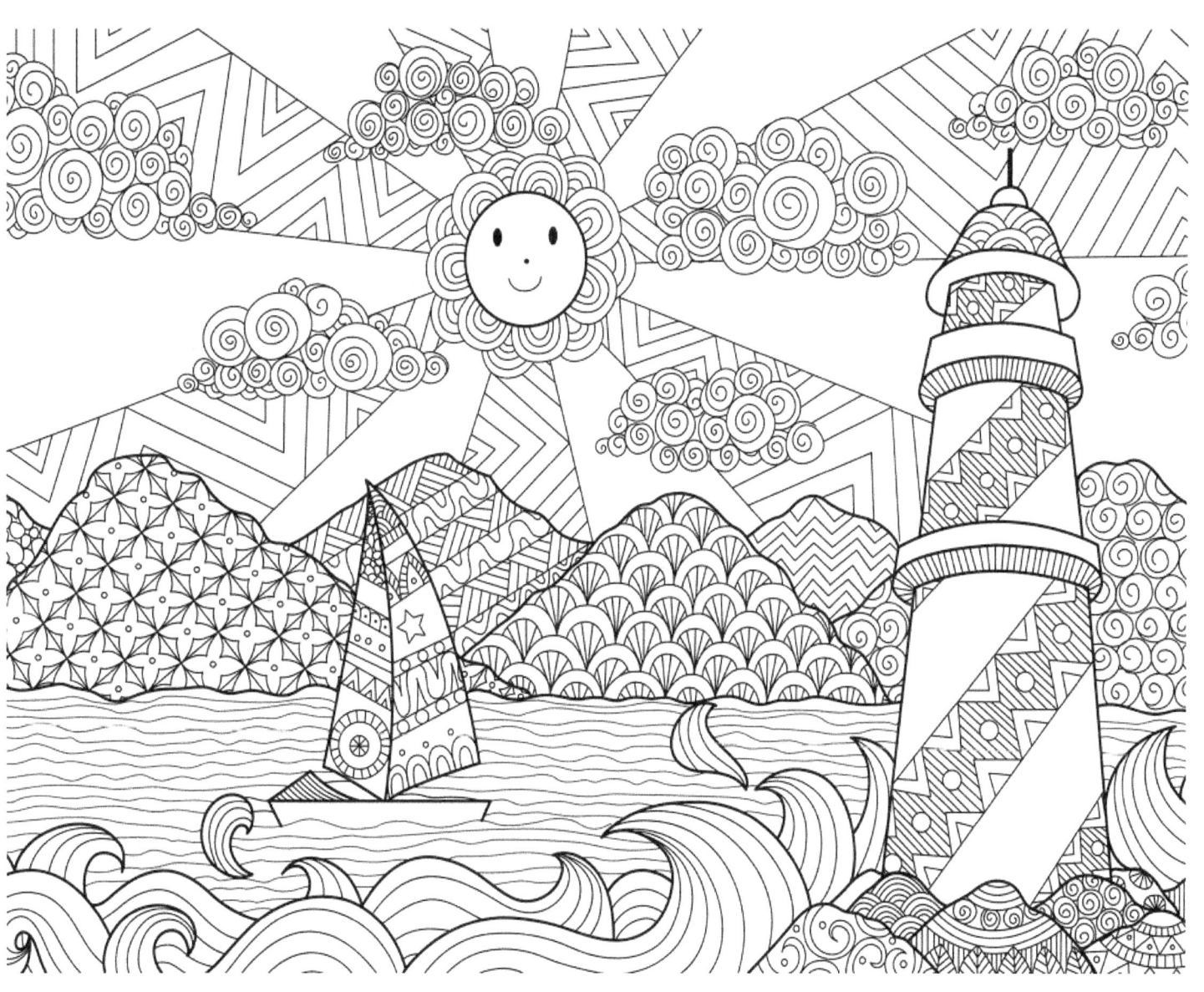

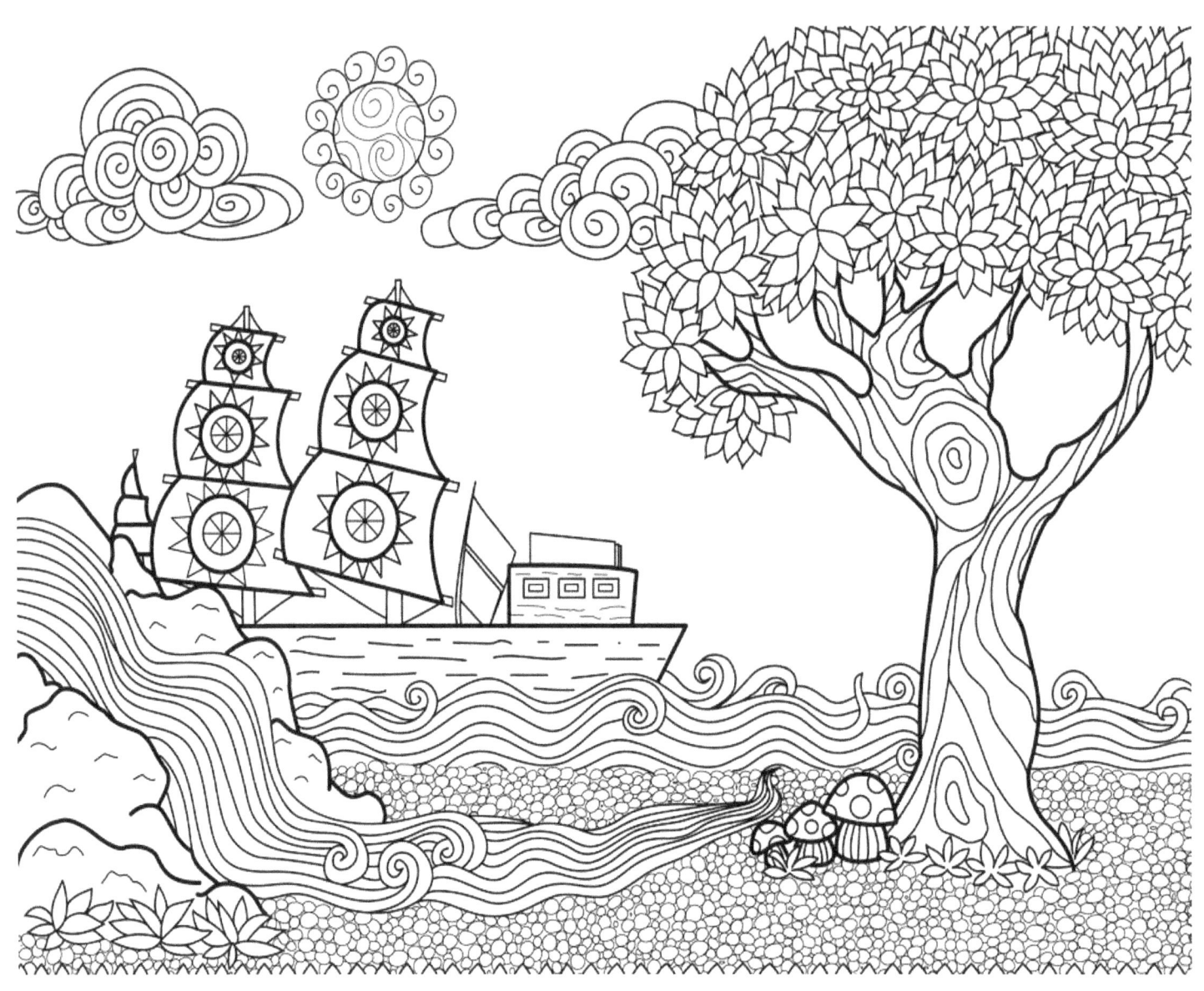